Art and Psyche

Art and Psyche

A Study in Psychoanalysis and Aesthetics

ELLEN HANDLER SPITZ

Yale University Press
New Haven and London

Designed by Nancy Ovedovitz and set in VIP Galliard
type by Rainsford Type. Printed in the United States of
America by Vail-Ballou Press, Binghamton, N.Y.

Library of Congress Cataloging in Publication Data
Spitz, Ellen Handler, date.
Art and psyche.

Bibliography: p.
Includes index.
1. Psychoanalysis and art. I. Title.
N72.P74S65 1985 701'.05 85–2281
ISBN 0–300–03372–9 (cloth)
0–300–04620–0 (pbk.)

Grateful acknowledgment is made to Alfred A. Knopf,
Inc., for permission to reprint lines from "Thirteen Ways
of Looking at a Blackbird" and from "Men Made Out of
Words," in *The Collected Poems of Wallace Stevens,*
copyright 1954.

Lines from "Meditations in Time of Civil War" are
reprinted with the kind permission of Michael B. Yeats and
Macmillan London, Ltd., and of Macmillan Publishing
Company, in *Collected Poems of W. B. Yeats,* edited
by Richard J. Finneran. Copyright 1928 by Macmillan
Publishing Co., Inc., renewed 1956 by Georgie Yeats.
Lines from "The Waste Land," in *Collected Poems, 1909–
1962* by T. S. Eliot, copyright 1936 by Harcourt Brace
Jovanovich, Inc.; copyright © 1963, 1964 by T. S. Eliot.
Reprinted by permission of the publisher.

The paper in this book meets the guidelines for
permanence and durability of the Committee on
Production Guidelines for Book Longevity of the Council
on Library Resources.

12 11 10 9 8 7 6 5 4 3 2

For my mother and father,
who fostered in me a love of
fantasy first,
and then of scholarship

For Harlan,
whose rare devotion
has sustained me

For Jennifer Beulah,
Nathaniel Geoffrey, and
Rebecca Sarah,
who have brought me joy, beauty,
and a richness of perspective

Contents

Preface

The general aim of this book is to make a modest contribution to what has been an ongoing dialogue between psychoanalysis and aesthetics for some seventy-five years. The study divides into two major sections. After the Introduction, chapters 2 and 3 deal with pathography, Freud's term for the psychoanalytic investigation of the relations between an artist's life and works and for interpretations based on these relations. This section, intended as a critique, is expository in nature. Chapters 4 and 5 look beyond pathography toward newer models, which are more open to speculation. My arguments in these two chapters are therefore more tentative and meant to encourage further investigations into many of the topics raised. In adopting this open-ended approach, I invoke the precept of Freud, who recommended that interdisciplinary studies relating psychoanalysis to other fields serve best as "an instigation, offering suggestions to specialists which they may [then choose to] take into account in their own researches" (1913, p. 75).

Almost from its origins, psychoanalytic theory has been applied outside the clinical sphere to works of art and used as a mode of understanding in at least three areas of major concern to aestheticians: namely, (1) the nature of the creative work and experience of the artist, (2) the interpretation of works of art, and (3) the nature of the aesthetic encounter with works of art. Unlike the clinician, the applied psychoanalyst does not undertake his project in response to a presenting complaint; he has no therapeutic goal; he lacks the interpersonal context for his own evolving transferences; in the absence of any live confrontational opportunities, his interpretations lack the intersubjective validation essential to clinical practice (and yet, as hermeneuticists argue, there is dialogue here as well). Thus, the applied psychoanalyst differs from the clinician in his motives (nontherapeutic), his methods, and his goals. Or does he? What is the rationale of the psychoanalyst who applies his theories in the aesthetic realm? What are his particular intentions? How are his methods determined? Are there criteria outside the clinical sphere for the evaluation of alternative psychoanalytic interpretations? Or can each alternative usefully critique the others?

One way of epitomizing this problem is to consider the *context* in which such nonclinical psychoanalytic interpretations take place. Frequently, psychoanalysts have met with an uncongenial reception by artists, critics, philosophers, and other scholars when they have ventured into the aesthetic domain. I submit that part of the reason for such misapprehension turns on this matter of context, on a failure to consider boundaries. Psychoanalytic authors are often unclear—both implicity and explicity—about precisely what aesthetic problems they are addressing. In the absence of such clarity—in the absence, for example, of stated criteria for what constitutes relevant theory or data—it is not unreasonable for outsiders to regard their interpretations as unilluminating or gratuitous.

My task then, is to present a survey of the shifting perimeters of psychoanalytic interpretation in the arts and to demonstrate that the ways in which analytic theory has defined context from early in the century up to now find striking parallels in both aesthetics and the history of criticism. If such parallels can be made explicit, if the context in a given psychoanalytic interpretation can be described and correlated with a specific aesthetic problem and a critical framework, then the foundations are further developed for future interdisciplinary dialogue. I offer here a series of three paradigms, each based on a specific definition of context. Each paradigm coordinates three variables: an aspect of psychoanalytic theory, an aesthetic problem, and a critical mode.

I have chosen to deal with mainstream theoreticians whose work can be traced directly to Freud and whose writings form the staple of what is currently taught and studied in the major American psychoanalytic institutes. I include no mention of divergent theories (for example, those of Jung, Adler, and Horney). Nor do I discuss the work of Lacan. Although it is currently much in vogue among certain literary critics, I feel that to treat his work adequately would be to go too far afield in the present study.

The first model, pathography, arose in the earliest stage of psychoanalysis, when Freud's major interest was in discovering the contents of the dynamic unconscious. Typified by the Leonardo da Vinci study of 1910, this model takes as its interpretative context the work of art plus whatever can be known about the artist's life and larger oeuvre. Emphasis is placed on conflict and repetition, and the theoretical base typically involves classical Freudian theory, that is, the analysis of drives and drive derivatives, reconstruction, and the oedipal constellation. This model is equipped to address such aesthetic issues as artistic creativity, the precise relations between an artist's life and work, and artistic intention and expression. Romantic criticism, with its emphasis on the centrality of the artist's experience—as opposed to earlier emphases on art's instructive or seductive capacity vis-á-vis an audience—correlates with this model.

The second model of psychoanalytic interpretation takes as its context the work of art conceived as autonomous and constituted by its own internal

relations. The artist's experience is deemed irrelevant. The theoretical base enlarges to include ego psychology, which analyzes the relatively autonomous functions of the ego, with its organized and stable patterns of defense and adaptation. This model is designed to interpret works of art experienced sui generis and, in particular, to address questions concerning the origin and function of artistic form and individual style. Objective or New Criticism correlates with this mode of psychoanalytic interpretation.

The context in the third model expands to include the work of art plus its audience. Object-relations theory, with its emphasis on self and other, preoedipal experience, themes of fusion and separation, loss and reparation, transitional phenomena, and early infantile transference, serves as the theoretical framework. The aesthetic issues addressed are questions of audience response and the nature and genesis of aesthetic experience. This model is correlated with phenomenological and reader-response criticism. Issues of transference and empathy, implicit in all three models, move into the foreground and assume appropriately central roles.

Because interpretation necessarily occurs in a context and interpreters exercise some choice in defining their contexts, part of the problem is that such contextual choices are often left unstated. Thus, one goal of this study is to clarify and examine these consciously chosen contexts. A further and more radical goal—to illuminate some of their disavowed aspects—puts me in the odd position of challenging the very models I have set up by showing that any given interpretative context is necessarily more extensive and complex than can be consciously known by an interpreter at a given moment. From this somewhat subversive—but quintessentially psychoanalytic—perspective of using the discipline to critique its own interpretative models, all three paradigms may be seen as holding more features in common than is readily apparent. In addition to this perspective, however, I also seek to explore ways in which psychoanalysis can expand its positive contributions to the interdisciplinary dialogue by juxtaposing new areas of psychoanalytic research, for example, with perennial problems in the philosophy of art.

It is important to state at the outset that psychoanalysis is taken here to mean, not a unified body of theory, but, rather, a heady compound of knowledge and speculation, a complex aggregate of theoretical and clinical constructs—in a discipline riddled today with inner turmoil. My own position is in no way meant to be that of an apologist. Yet I could not have written this book if my years of involvement with psychoanalytic ideas and techniques had not convinced me of their power to speak to areas of aesthetic inquiry ignored or blurred by other approaches. Nevertheless, I hope this study will be sharply distinguished from those in which "psychoanalysis takes on the appearance of an 'imperialistic philosophy' asserting itself with a jumbled, bloated terminology" (Iser, 1978, p. 39).

Readers may notice from a cursory glance at the contents that my discussion

cites examples drawn from a variety of art forms, shifting from the visual arts to literature, and occasionally to music and the dance as well. Although each art properly requires its own aesthetic and deserves a separate treatment, I have drawn on a diversity of examples because my principal concern has been to explore outstanding contributions to the dialogue between psychoanalysis and the arts in general, and therefore I have seized upon such examples wherever they could be found.

A perennial problem in interdisciplinary research is knowing how much can be taken for granted and how much should be set forth explicitly before going on to make one's points. I have probably erred on the side of presenting more basic psychoanalytic theory than is necessary, certainly for analytic readers. My rationale has been that familiar material often takes on new color and significance when rediscovered in altered contexts, and I believe that the theory I have included is of sufficient consequence to bear repeated scrutiny.

In writing this book I have called upon my early years of training in the visual arts, dance, and art history, as well as upon more recent and current professional experience. In part, this study represents a distillation of research undertaken in three divisions of Columbia University: Teachers College (the Division of Philosophy and the Social Sciences and the Department of Developmental Psychology), the Graduate School of Arts and Sciences (the Department of Philosophy), and the College of Physicians and Surgeons (the Center for Psychoanalytic Training and Research). Thus, it is truly interdisciplinary in genesis and could not have been accomplished without the enthusiastic support and assistance of many people. In particular, I owe appreciation to my former professors at Columbia University, each of whom has contributed to my perspective in a unique way, each of whom has guided and inspired me. I owe special thanks to Mary Mothersill, Richard Kuhns, Maxine Greene, John Broughton, and Jonas Soltis. In addition, I wish to express appreciation to the faculty of the Center for Psychoanalytic Training and Research, Columbia University, among whom Robert S. Liebert must be singled out for special mention, as well as to my fellow candidates, all of whom helped initiate me into the complexities of psychoanalytic theory and process and who have expressed their ongoing interest in my work. A very special word of gratitude is due to James E. Gorney, with whom I discussed a number of ideas that ultimately found their way into these pages. My acknowledgments would not be complete without an expression of deep appreciation to Leopold B. Bellak, with whom I encountered firsthand the depth and rigors of psychoanalytic work. The responsibility for what follows in these pages is, nevertheless, strictly my own.

Finally, I would like to extend my thanks to several dear friends, including Joanna and Peter Strauss, Joan Baudouine, Jane Celwyn, Geralding Brause, and Jennie Morgan, whose multifaceted help ranged from hours of

responsive listening to loving child care and reliable child transportation. For their indispensable professional assistance, I wish also to express gratitude to Doris Parker of the Center for Psychoanalytic Training and Research, who unstintingly made available to me dozens of articles for research, to Elizabeth King, who typed the original draft of the manuscript, to Tulin Duda and Barbara Folsom, whose meticulous readings have resulted in a more compactly written book, to my steadfast and sensitive editor, Gladys Topkis. To my beloved family, the dedication of this book suggests the depth of my gratitude.

1

Introduction: On the Dialogue between Aesthetics and Psychoanalysis

What should we be without the sexual myth,
The human revery or poem of death?
Castratos of moon-mash—Life consists
Of propositions about life. The human
Revery is a solitude in which
We compose these propositions, torn by dreams...
—Wallace Stevens, "Men Made Out of Words"

Psychoanalysts have made many forays into the aesthetic realm, particularly in their interpretations of literature and the fine arts and discussions of the particular or general pathology and/or ego strengths that predispose individuals toward artistic creativity. Likewise, smaller numbers of philosophers, art historians, and literary critics have commented on the usefulness of psychoanalysis as a way of approaching these areas of mutual interest. But there has been no thoroughgoing attempt to catalog or structure this dialogue between aesthetics and psychoanalysis.

In formulating this dialogue, I am addressing readers in both disciplines. To philosophers of art I propose a tripartite structure for understanding more clearly what different psychoanalytic authors are in fact doing when they approach the aesthetic and how their work mirrors or complements that of other disciplines; to psychoanalysts I offer ways of making their goals and methods more explicit and also more consonant with the modes of philosophy and criticism, which are the ultimate tribunals in affairs of the arts.

REVIEW OF THE LITERATURE

What sort of dialogue is possible between psychoanalysis and aesthetics? Before describing the structure of my own work, it will be instructive to

consider the contributions of a number of authors drawn from the several disciplines which have bearing on this inquiry. The following review of the literature is by no means exhaustive; rather, it provides a sample of issues raised by prominent participants in the dialogue.

In attempting to integrate philosophical and psychoanalytic aesthetics, Lawrence Friedman (1958), an analyst, speaks of the need for promoting "a conversation between philosophy and psychoanalysis" (p. 371). In his view, the philosopher and psychoanalyst approach the aesthetic from different points: traditionally, the philosopher either begins with concepts of beauty or art that he applies to particular works or localizes the aesthetic fact or object whose properties he attempts to describe and from which he then infers more general principles. The psychoanalyst, however, is interested in explaining the origins of aesthetic experience—that is, the motivation and genesis of the artist's creativity and the viewer's response. Thus Friedman indicates that the philosopher's approach is structural in that he describes the nature of aesthetic experience, of art or beauty, as it is already created or found; the psychoanalyst's approach is genetic, historical.

This distinction is not entirely convincing, for, clearly there are philosophers (for example, Susanne Langer) who are deeply concerned with the origins of aesthetic feeling; similarly, there are psychoanalysts (notably Freud himself, and certainly the ego psychologists) who think in structural terms—for example, about the relation between aesthetic pleasure and other aspects of mental functioning. In general such a distinction might be valid if we were to consider only the more recent psychoanalytic thinkers (object-relations theorists), who trace aethetic response back to the experience of early childhood, but even this is questionable; D. W. Winnicott (1966), for example, is as intensely interested in describing the nature of the aesthetic experience as he is in deriving its origins.

Another author, art historian Herbert Read (1951), discriminates sharply between processes and products, claiming that the psychologist/psychoanalyst is interested in the former whereas the critic/philosopher is concerned with the latter. Again, the contrast seems oversimplified, as does the formula that the psychoanalyst is principally concerned with persons whereas the philosopher's major involvement is with ideas and things. Especially today, when art is conceived by many artists as process, it is inevitable that philosophers and critics have been drawn into a process-oriented approach, if only to describe and account for the art that is actually being produced. Current experimentation in the visual arts (for example, the environmental sculptures of Christo), theater (the plays of Stoppard and Beckett), and even music (the works of Cage, Glass, and Crumb) is with the act of making, with synchronism and with complex rearrangements of time sequences, with the participation of the viewer and the manipulation of aesthetic distance. Hence, today a convergence of the psychoanalyst's and the aesthetician's approaches seems especially promising.

With respect to twentieth-century art, strong emphasis must be placed on the presence of ambiguity, on the deliberate exploitation of a multiplicity of meanings or perceptual possibilities inherent in a given work. Psychoanalyst Ernst Kris (1952) characterizes this aspect of the aesthetic experience and offers a rationale for it:

> The level of stringency in works of art—their degree of interpretability—varies markedly from period to period. In some cases ambiguity is fully exploited, and correspondingly great demands are made on the audience; in other cases, . . . the demands on the audience are minimal; the interpretations called for are rigidly limited. We may suggest that art is likely to be characterized by low stringency (i.e., high ambiguity and interpretability) where systems of conduct ideals are in doubt or social values are in process of transition. . . . The present period seems to be of this kind. (p. 262)

This description is especially apt if we consider current avant garde theater (for example, works by Richard Forman, Meredith Monk, Spalding Gray), in which words often are used not only as units of discursive speech, or as mirrors of a shared vision of external reality, but as final terms, as entities with properties of their own;[1] audiences become absorbed into the aesthetic whole of a work (as is the case also in contemporary visual art, dance, and music) so that possibilities for projective interpretation multiply; an audience becomes accomplice to, and then gradually conscious of, its own manipulation; the traditional modes of music, word, and movement are fused in unprecedented ways, creating synaesthetic effects; improvisation is valued, and the goal is to expand awareness at the risk of shock rather than to confirm the familiar and comfortable. A climate such as this fosters fruitful dialogue between psychoanalysis and philosophical aesthetics. Any philosopher who seeks to understand the art of our time must soon deal with aesthetic qualities that can be seen as isomorphic with psychoanalytic constructs, such as displacement, distortion, reversal, projection, and condensation. Therefore, as Friedman points out, an interdisciplinary conversation is much in order.

Ernst Gombrich (1963), an art historian with a special interest in psychoanalysis, has made many contributions to this "conversation." He offers, for example, a psychoanalytic perspective on connoisseurship in the visual arts. Looking to the stages of psychosexual development as formulated by Freud (1905) and Karl Abraham (1927), he sees oral gratification as a genetic model for aesthetic pleasure. He draws an analogy, for instance, between our response to easily readable, too immediately obvious or gratifying art and the most primitive stage of passive-oral instinctual development. He speculates that a repugnance to such art may serve as a defense against its regressive pull. By linking "the idea of the soft and yielding with passivity, of the hard

1. See Freud (1900): "It is true in general that words are frequently treated as though they were things, and for that reason they are apt to be combined in just the same way as are the presentations of things" (pp. 295–296). He is referring, of course, to the use of words in *dreams*.

and crunchy with activity" (p. 40),[2] Gombrich accounts for the preference of sophisticated critics for art that is "difficult," that demands action on their part, that offers an opportunity to act on what is presented, to experience a challenge in the process of re-creation. ("The biter who finds the pleasures of passivity barred to him finds his compensation in the indulgence of aggressive impulses" [p. 41].) Thus the critic's preference for difficult, demanding art may correspond to the second, aggressive stage of oral development (Abraham, 1927).

This view is particularly fascinating because it expands the applicability of psychoanalysis even as it warns psychoanalysts to heed social context. Gombrich ingeniously applies an aspect of the psychoanalytic theory of erotogenic zones to aesthetic enjoyment and preference but then goes on to elaborate this simple thesis by showing that there are many ways of experiencing the "soft" as well as the "crunchy." According to him these differing responses are dependent on what he calls "the social context of the aesthetic attitude" (p. 36). He illustrates the dependence of aesthetic experience on context by pointing out that after impressionism literary allusions no longer constituted the "crunchy" challenge for the critic (as they had in the more frankly erotic, sleek paintings of the French neoclassic academy). By contrast, in the post-impressionist world of modern art, literary deciphering came to be replaced by the challenge of, as he puts it, unscrambling color patches, which has in turn been compensated for by the pleasures of beholding crude splashes of paint and a regressive pull into the primitive domain of archaic imagery (for example, part-objects, in the worlds of cubism, surrealism, and abstract expressionism). Thus he demonstrates that what is experienced as "soft" or "crunchy" depends upon the cultural context.

Gombrich's major caveat to psychoanalysts who would approach the arts is that, at least in the visual arts, tradition and convention outweigh personal elements. He suggests that even if we could somehow reconstruct the private, personal meanings of specific paintings to their creators—disclose their unconscious meanings—this would not matter much unless the most important aspect of a work of art were in fact its aspect as a sort of "shared dream," which he doubts. Further, he shows that if we take seriously the fact that art has a history (unlike perception and dreams, which he claims have not [p. 34])[3] and recognize that this history is built through "a constant extension and modification of symbols"(p. 33), we must realize that all art is derivative, and that without recourse to the development of style, modes of represen-

2. This idea has sparked some fascinating research into aesthetic preference by the experimental psychologist Irvin Child at Yale University. His work was presented as research in progress at the National Symposium for Research in Art, University of Illinois, September 21–24, 1982.

3. Gombrich fails to distinguish between the latent and manifest content of dreams. It seems clear that, even if we cannot speak of a history of the former, we might and indeed can trace a history of the latter.

tation, and so forth, we cannot play Pygmalion to any Galatea (p. 35). Without, in other words, a prodigious knowledge of the history of art, we are unable to re-create any work of art in terms of its personal meaning. "Without," as he says, "the social factors, what we may term the attitudes of the audience, the style or the trend, the private needs could not be transmuted into art. In this transmutation the private meaning is all but swallowed up" (p. 43).

Thus Gombrich enters the interdisciplinary dialogue with a warning the psychoanalyst does well to heed. On the other hand, if all art is derivative of other art, it is surely also derived from the biological and psychological (psychosexual, developmental) aspects of human experience, and it is precisely these features of its origins that psychoanalysis is particularly well suited to trace. What is paradoxical about Gombrich's contribution is that he himself has illustrated, with the analogy between aesthetic pleasure and an aspect of genetic psychoanalytic theory, how psychoanalysis may be useful in understanding not only the all-but-digested personal meanings in specific works of art but also the larger trends and issues in both art history and aesthetics. If we focus on the "all but" of the above-quoted passage, we see that it is precisely this region—the "all but"—that is the province of psychoanalysis. For when we encounter works of art, we encounter works created by individuals who are more than passive carriers of a tradition. It is to the personal and private, the "all but" of feeling, conflict, and choice, that psychoanalysis most often directs its attention, offering insights that, when integrated with historical knowledge, can yield a level of understanding not accessible, I believe, to art history alone.

Ernst Kris, art historian and psychoanalyst, has offered perhaps the most comprehensive statement of the potentialities inherent in the dialogue between psychoanalysis and aesthetics. It is to him that we owe the best-crafted links that have yet been forged. Kris raises a number of his own caveats, points out areas for future research, and explores aspects of the existing dialogue. I shall enumerate only a few of his points which seem both sufficiently general and pertinent to present at this juncture.

Kris (1952) contends that many attempts to apply psychoanalytic theory to the aesthetic realm have suffered from a tendency to equate psychoanalysis with one or two isolated quotations from Freud's early work. It is perhaps unnecessary to dwell on this problem, which, however, persists today.[4] But Kris's characterization of psychoanalytic theory as an "open system" (1952,

4. At a meeting of the American Philosophical Association (Philadelphia, December 1981), in the Symposium on Psychoanalysis (see *The Journal of Philosophy*, 78:10, pp. 549–72) it was clear from the papers and the discussion that Kris's complaint is still valid. Many philosophers seem unaware of the complexity and development of Freud's thought and the vast body of psychoanalytic literature produced since his death in 1939.

p. 16) is here very much to the point: the Freudian approach is more elastic and less monolithic than is sometimes perceived, and alternative psychoanalytic models may both complement and contrast with Freud's yet grow solidly out of it.

Kris is seconded in his lament over the erroneous reductionism of Freud's views on art by Richard Wollheim, a philosopher who also has made major contributions to the interdisciplinary dialogue. Wollheim (1974) offers a reading of Freud's aesthetic that may be intended in part as a corrective for those authors who fail to accord to Freud the sophisticated understanding claimed for him by both Kris and Wollheim himself. Freud's view of the work of art, according to Wollheim, is by no means a simple equation with joke, dream, or neurotic symptom, with "a sudden vehicle of buried desires" (p. 218) that requires a lapse of consciousness and attention. Rather, he sees Freud as recognizing the work of art to be "a piece of work," "constructive" rather than purely expressive.

Wollheim credits Freud with the awareness "that part of understanding how it is that a work of art affects us is recognizing the confusion or the ambiguity upon which this effect in part depends" (p. 217). In other words, he attributes to Freud the view that a work of art that fully engages us involves us in complex mental activities, which include efforts at mastery as well as regressive pleasure, hiding as well as seeking, composing as well as hearing, flexibly moving backward and forward from manifest to latent, affectively as well as cognitively. According to Wollheim, Freud's aesthetic includes an awareness of mental functions that have subsequently been identified as synthetic, integrative, and adaptive (see Kris). Wollheim regrets the fact that Freud never developed this "constructive" side of his aesthetic in theoretical terms, a side that Wollheim believes is exemplifed as early as the *Moses* study of 1914. To develop it Freud would have had to include in his studies on art an expanded discussion of unconscious operations involving the ego. Instead, of course, he focused on unconscious repression and pleasurable regression in art. Wollheim, taking on something of the role of an apologist, seeks to explain this omission by observing that whereas during the early years, when the studies on art were written, Freud had sufficient leisure to pursue such nonclinical interests, by the time he had become interested in ego functioning he was no longer free to pursue his inquiries into the aesthetic and to develop them in accordance with his later theory (p. 219).

While agreeing with both Kris and Wollheim on the richness of Freud's contributions to our understanding in this domain, I must take issue with this last point. We need only note that, after his structural revisions of 1923, Freud went on to write such nonclinical works as *The Future of an Illusion* (1927), *Civilization and Its Discontents* (1930), and even *Dostoevsky and Par-*

ricide (1928) to assume reasonably that, had Freud any inclination to revise his earlier views on art to bring them more into line with his later structural theory and with developments in ego psychology, he could certainly have done so. In my view, Freud's prodigious contribution to our understanding of art requires, rather than an apology for what he did not say, a clearer and more comprehensive understanding of what he did say.

To this issue of the reading of Freud's aesthetic, an important contribution comes from philosopher Paul Ricoeur (1970), who prima facie seems to offer a reading contrary to that of Wollheim. Ricoeur strongly stresses not the discontinuity but rather the continuum between dreams and art in Freud's work. Arguing for what he calls "the generalization of the oneiric model" (p. 160), he in no way feels that Freud's emphasis on dreams is reductionistic or, indeed, that interpretation based on the continuity of dream with art is reductionistic vis-à-vis works of art themselves. He claims, rather, that an analysis of this sort can lead both to an awareness of the richness, even the inexhaustibility, of the psychoanalytic interpretation of art and paradoxically to an understanding of what may be the limits of psychoanalytic interpretation itself. My own view inclines toward Ricoeur's rather than Wollheim's, for I am convinced that, though Freud was certainly not innocent of the contribution of complex ego functions to artistic activity and aesthetic response (ego functions that were later labeled and described by such theorists as Anna Freud, Heinz Hartmann, and Kris), the genius of his contribution lies squarely where Ricoeur places it, namely, in the recognition of multiple, intimate links between the realms of art and dream.

Ricoeur states that the interpretation of dreams stands as paradigmatic in Freud's oeuvre for all interpretations in the cultural sphere. He accounts for this by pointing to the continuities between dream and art from the psychoanalytic perspective: (1) for Freud dreams have meanings that are continuous with waking meanings and, hence, deeply imbedded in the cultural context (a point that Gombrich would have to dispute); (2) these meanings concern the disguised fulfillment of repressed desires that must be unmasked, brought to light via interpretation; (3) disguise is brought about by the complex mechanisms of dream-work, which, for Ricoeur, constitutes a paradigm for all "strategems of desire" (p. 160); (4) the desires disguised by dreams are necessarily infantile and, therefore, interpretation based on analogy with dreams must not only unmask hidden meanings but also unearth archaisms of various types and on many levels; and (5) dreams require the exquisite elaboration of "the language of desire" (p. 160), the representability by symbol of man's fundamental sexuality; hence they serve as an appropriate model for myth, legend, and folktale, the "great popular daydreams" (p. 160), as Ricoeur puts it. Yet, he does not fear that such a "generalization of the oneiric model" commits us to uninteresting repetition. On the contrary,

he points out that the problem of fooling the censor involves a continual effort to find new solutions, new imagery, new vocabulary for the language of desire.

Ricoeur does not fail to mention, however, the difficulties inherent in applying this oneiric model to art, which he calls "the first figure of the daytime nocturnal" (p. 160). Among these is the question of whether, since dreams are the guardians of sleep, we must assume some sort of analogue in art for the wish to sleep that is the necessary precondition for dreams. This question raises the very point that bothers Wollheim and constitutes his objection to the model: Wollheim implies, by contrast, that to be aesthetically engaged one must be fully awake, attentive on many levels. Ricoeur offers no solution to this dilemma. Yet I suggest that there are moments in aesthetic experience when one can be fully transported into a work of art—not inattentive, but quite uncritical and unreflective. One can willingly suspend disbelief. Perhaps we might think of aesthetic experience in terms of alternations of dreaming and waking states. In any case a problem exists. Later on (chapter 5) I shall deal with the nature of these aspects of aesthetic experience from a post-Freudian perspective.

Ricoeur's most serious difficulty with the art-as-dream model arises from his view that art looks forward as well as backward, that "the work of art is ... both a symptom and a cure" (p. 174). He approaches, in this case, Wollheim's point concerning the importance of mastery. But Ricoeur goes further:

> Works of art are not only socially valuable ... they are also creations which, as such, are not simply projections of the artist's conflicts, but the sketch of their solution. Dreams look backward, toward infancy, the past; the work of art goes ahead of the artist; it is a prospective symbol of his personal synthesis and of man's future, rather than a regressive symbol of his unresolved conflicts. (p. 175)

Ricoeur suggests that perhaps one value of art lies in its mobilization into new meanings, within the cultural context, of the fundamental psychic energy originally invested in archaic objects. This formulation restates the so-called economic theory of sublimation, which works only, it seems to me, if we keep shifting perspectives, now viewing the work of art from the artist's vantage point, now seeing it as part of a cultural matrix. From the individual's point of view, the solutions, cures, and "new meanings" externalized in his art are only temporary, transitory: (conflicted) investment in the primary objects is never fully transferred from the intrapsychic to the cultural realm. From the point of view of society and culture, on the other hand, the work of art serves as a highly valued transformation of narcissistic instinctual energy into products that have a life of their own and that derive added and continuous overlays of meaning from their successive cultural contexts.

To interpret the work of art as dream is to discover "all that is nocturnal in man, the nocturnal of his waking life as well as of his sleep" (p. 162), but

it is not to exhaust the possibilities of the work of art. For Ricoeur the psychoanalytic interpretation of art on this oneiric model leads to a threshold but not to a terminus, not to any real thing—even any real psychic thing—but, rather, to a rich abundance of symbolism, which, as he suggests, we must subject to other theoretical systems as well.

Kris, on the other hand, takes his own description of psychoanalysis as an "open system" to heart; granting the complexities of Freud's aesthetic, he develops its potential further. He holds a theory of art as communication that involves such notions as senders, messages, and receivers (1952, pp. 16ff.) The theory is especially significant because, as a scholar who came to psychoanalysis from art history, Kris reveals similarities between the two disciplines that might otherwise have remained unnoticed.

It is Kris's view that art constitutes a special kind of message. Rather than (or in addition to) a call to action, a call to spiritual experience that implies an ideal to which both audience and artist submit, or a fund of information of whatever sort, "the specific meaning in which the word '*art*' is used in our civilization refers to another function: the message is an invitation to common experience in the mind, to an experience of a specific nature" (p. 39). This notion of a common yet specific experience in the mind that can be shared between artist and receiver in the presence of the work of art links Kris to aesthetician Arnold Isenberg, who, writing at nearly the same time, encompasses the relations among critic, message, and audience in a strikingly similar passage:

> And if communication is a process by which a mental content is transmitted by symbols from one person to another, then we can say that it is a function of criticism to bring about communication at the level of the senses, that is, to induce a sameness of vision, of experienced content. (1973, p. 163)

Kris elaborates this view of aesthetic experience by describing a circular process which he conceives in three stages: recognition, identification with the work, and then identification with the way in which the work was produced. To participate we must to some extent change roles. In his words: "We started out as a part of the world which the artist created; we end as co-creators: We identify ourselves with the artist" (p. 56). It is interesting to note the parallel here with psychoanalytic process itself, in which the patient, through gradual identification and insight, becomes capable of understanding and interpreting his own behavior, becomes, on the analogy, his own analyst, his own artist. Kris goes on, however, to present this experience as a paradox:

> This sequence will not develop if we miss the aesthetic illusion; it will be impeded by both "overdistance" and "underdistance." It is, we believe, dependent on and—in a circular fashion—frequently responsible for the appropriate distance,

and seems a most significant component of the specificity of the aesthetic response. (p. 56)

Again there is a parallel to the psychoanalytic situation in which, without an optimal distance that includes both empathy and therapeutic neutrality, countertransference and the maintenance of an evenly suspended attention on the part of the analyst, the process is impeded.

Kris originated several concepts, emanating from his clinical work, that bear directly on the aesthetic, but, for now, I should like to touch on one further point. In explaining the acknowledged relevance of psychoanalytic theory to modern art, Kris claims that "during the last decades psychoanalytic insights into the processes of artistic creation have themselves become part of art" (1952, p. 30). As for examples, he cites the use of free association in the training of artists or as a method for inspiring the creative process, the surrealists' interest in documenting their own mental processes (for example, André Breton's automatic writing), and, more superficially, the frequent appearance (often as an ambivalent character) in modern drama, novels, and films of the psychoanalyst himself. Devoting a paper to this topic, Kris sees it as an interesting "reversal of functions; psychoanalysis and its discoveries act[ing] as a social force upon art and artist" (p. 31). Implied is the difficult question of the complex influences and counterinfluences of theory on human behavior. Thus Kris invites us to speculate on the larger historical and philosophical issues involved in a zeitgeist that is distinguished by psychoanalytic theory, art of a highly ambiguous nature, cultural pluralism, ethical relativism, and a preoccupation with matters of interpretation.

Kris and the other psychoanalytic authors I have chosen to cite by no means represent all the questions worth considering. But they do address five areas of inquiry I have borne in mind while formulating my own contribution to the dialogue: (1) the nature and terms of a possible dialogue between psychoanalysis and aesthetics; (2) the relation between private (intrapsychic) meaning and public (social) factors—that is, tradition or culture in art; (3) the difficulties of coming to an agreed-upon reading of Freud's aesthetic; (4) the resonances between aesthetic and psychoanalytic experience in the context of a general theory of art as communication; and (5) the special connection between psychoanalysis and modern art.

THE TERMS OF THE DIALOGUE

Psychoanalytic theory has, since the earliest years of this century, been applied to works of art and used as a mode of understanding in three major areas of concern to aestheticians, namely, (1) the nature of the creative work and experience of the artist, (2) the interpretation of works of art, and (3) the nature of the aesthetic encounter with works of art.

Psychoanalysis *in general* offers both a highly refined map of the mind and a method for investigating its functioning. It is thus a metapsychological and a clinical theory. The model it provides is at once dynamic (involved with conflicting forces of expression and repression), economic (concerned with the distribution of psychic energy), topographic and, later, structural (offering a schema for the mind's component parts and their organization), genetic (furnishing developmental stages for the origin and maturation of psychic structures and dynamics), and adaptive (considerate of the fundamental need of the human organism to adapt to its environment and vice versa, a need that is not met—as in nonhuman species—by complex inherited behavior patterns [see Rapaport, 1967]). Its method involves radical skepticism, the metamorphosis of meanings, the probing of each aspect of a context with another and yet another of its own aspects, and the technique of paying heed with evenly suspended attention. It is therefore a rich, multifaceted conglomerate that, when applied to the three areas of aesthetic functioning distinguished above, has the capacity to yield insights unobtainable in any other way.

Freud (1922) said that the best way to understand psychoanalytic theory is to study its origins and history. Following his counsel, we may consider the evolution of psychoanalysis as falling into a three-stage sequence beginning with *Studies on Hysteria* (1893–95) and *The Interpretation of Dreams* (1900–01), in which Freud discovered the dynamic unconscious, developed his notions of repression (mental conflict), repetition, and transference, and mapped out a topographic model of the mind. In this first stage Freud views artistic form as a pleasurable disguise, however elaborate, for content originally derived from forbidden wishes of an erotic (or aggressive) nature. With the development of ego psychology (stage two) by Anna Freud, Hartmann, Kris, and others, the viewpoint changes, and the elaboration of artistic form is considered to represent the relatively autonomous functioning of the ego. Here the position taken is that artistic form can develop more or less independently of drives and instinctual energy. More recently, with the advent of object-relations theory (stage three), as exemplified by the writings of Margaret S. Mahler and such British authors as Melanie Klein and her followers, D. W. Winnicott, Hanna Segal, and Marion Milner, aesthetic experience is traced back to the young child's first relationship, to the stages of symbiosis and separation-individuation (Mahler), to play, and to transitional objects and phenomena (Winnicott)—things and sounds that evoke the qualities of that early relationship. In this model, the aesthetic object represents an "intermediate area of experience" (Winnicott) between the self and the outside world; artistic form and content are seen as fused; any attempt to separate them is considered tantamount to depriving the work of art of its status as aesthetic object.

Within the psychoanalytic establishment there are strong differences of

opinion as to whether these three approaches are susceptible of satisfactory integration or are fundamentally incompatible. Those theorists who have attempted to unify them (for example, Otto Kernberg, 1976) have not thus far altogether succeeded, and it would go beyond the scope of my project to enter into this debate. However, I believe that integration among the various modes of psychoanalytic interpretation is possible, though clearly some are more apposite to certain aesthetic questions than are others. In the case, for example, of the artist's relation to his work, the classical Freudian approach seems most pertinent in that it traces—via pathography—the way in which the artist's intrapsychic conflicts appear disguised in works of art. In the case of interpretation, ego psychology and object-relations theory seem most relevant in that they are concerned with unconscious fantasy involving both id and ego. Object-relations theory also has much to contribute, from a developmental perspective, about aesthetic response.

The three aesthetic areas to be discussed (artistic creativity, the interpretation of works, and audience response), are not, it is clear, ultimately separable categories but rather mutually interdependent modes. As artist, one must continually step back from work in progress to appraise it critically; as critic, one's perceptual acuity, inventiveness, general knowledge, and unconscious fantasy determine to a large extent the character and quality of aesthetic encounters and judgments; as audience, one must re-create in imagination, resonate in fantasy, with aspects of the works perceived. Hence, to separate these contingent categories of aesthetic functioning is to serve the needs of philosophical discourse rather than to describe accurately what actually takes place in creation, criticism, or aesthetic encounters, where the real differences are in emphasis only and where each mode is implicit in the others.

Without developing it in detail, I want to suggest a parallel interdependence among the various aspects of psychoanalytic theory. In ego psychology, for example, there is implicit an awareness of and concern with id analysis—with the drives and their derivatives, the wishes out of which unconscious fantasies are made and against which defenses are mobilized. Likewise, early drive theory involves a recognition—as yet unformulated—of an agency in conflict with the drives, later to be developed into ego psychology. Further, the full analysis of drives includes concern with their objects as well as with their aims, impetus, and source; thus object-relations theory is inextricably tied to the earlier theory out of which it came. It may be possible, therefore, to regard the analysis of drives, ego psychology, and object-relations theory, like their counterparts in aesthetic theory, not as separate approaches but as parts of a whole with varying stresses or accents. Similarly, in art criticism as well, the boundaries shift among expressive, objective, and phenomenological modes.

In exploring correspondences between the disciplines of aesthetics and

psychoanalysis and among the various aspects of psychoanalytic theory (an intra- as well as interdisciplinary endeavor), I do not wish to create the impression of unnecessary fragmentation on the one hand, or of idealistic concordance on the other. My aim is to emulate the most satisfying aesthetic experience (and optimal psychoanalytic experience as well): namely, to attend to each topic as a whole, to differentiate its aspects for purposes of analysis, then to return to it with a more intense and thoroughgoing sense of its wholeness, born out of a new awareness of complexity.

REFLECTIONS ON FORM AND CONTENT IN MODERN ART[5]

The particular topical aesthetic issue of form and content lends itself to a brief survey of how the three psychoanalytic approaches differ—and where they coincide. Their contributions to this aspect of the interdisciplinary dialogue are especially valuable when applied to the study of modern art.

The Contribution of Freud

Freud's love of and interest in art are well documented by his sizable art collection and by the many papers and books he devoted to the topic, as well as by the numerous incidental references to art scattered throughout his other work.[6] His views on art apparently underwent change during the years, and, as has been observed by others, he never systematized his cultural theories with as much care and precision as he accorded to his clinical work. However, my purpose here is not to review exhaustively his remarks bearing on the aesthetic but rather to characterize his general approach.

Freud's major concern was with the relation between the artist's inner life and the artistic product rather than with the aesthetic object per se. It is difficult to select one among the many passages that epitomize his view, but the following is succinct and perspicuous:

> Art brings about a reconciliation between the two principles [pleasure and reality] in a peculiar way. An artist is originally a man who turns away from reality because he cannot come to terms with the renunciation of instinctual satisfaction which it at first demands, and who allows his erotic and ambitious wishes full play in the life of phantasy. He finds the way back to reality, however, from this world of phantasy by making use of special gifts to mould his phantasies into

5. Much of this section is adapted from my article of the same title published in *The Psychoanalytic Study of the Child*, vol. 37, 1982. Permission to include this material has been granted by Yale University Press and is here gratefully acknowledged.

6. For a complete listing of Freud's writings on art, see *The Standard Edition*, vol. 24, pp. 187–94.

truths of a new kind, which are valued by men as precious reflections of reality. Thus in a certain fashion he actually becomes the hero, the king, the creator, or the favorite he desired to be, without following the long roundabout path of making real alterations in the external world. But he can only achieve this because other men feel the same dissatisfaction as he does with the renunciation demanded by reality, and because that dissatisfaction, which results from the replacement of the pleasure principle by the reality principle, is itself a part of reality. (1911, p. 244)

Freud stresses communication: the value of the aesthetic experience for audience and artist comes from a process of identification. But he does not say that the specific latent content of the artist's work must resonate with, be mirrored in, or be revealed to the audience; he indicates, rather, that it is identification with the general process of circumventing renunciation, of outwitting the censor by gratifying wishes in fantasy, that constitutes the essence of the aesthetic experience. He sees instinctual *content* as the core of the artist's product but intimates that its elaboration into *form* by the "special gifts" of the artist makes possible a conciliation of pleasure and reality and thus grounds for communication with others.

Earlier (1908), Freud traces a line of continuity from children's imaginative play through daydreaming and fantasy to the work of the artist, in this case the writer. He stresses that the impulses which lie at the very heart of art-making activities exist in all of us and underscores the continuity of art with other modes of mental functioning (for example, jokes and dreams) and of the artist with the ordinary person. He asks rhetorically,

Might we not say that every child at play behaves like a creative writer, in that he creates a world of his own, or, rather, re-arranges the things of his world in a new way which pleases him? . . . The opposite of play is not what is serious but what is real. . . . The unreality of the writer's imaginative world, however, has very important consequences for the technique of his art; for many things which, if they were real, could give no enjoyment, can do so in the play of phantasy, and many excitements which, in themselves, are actually distressing, can become a source of pleasure for the hearers and spectators at the performance of a writer's work. (pp. 143f.)

What interests me here is that Freud insists on the seriousness, the value to the child/artist of his illusory, make-believe world. In so doing he paves the way for Winnicott and more recent writers who have elaborated on the derivation of artistic activity from childhood play. Clearly Freud's notion of the child/artist putting things together in new ways has relevance also to the experience of audiences of art for whom such new orderings may take on the status of new truths and highly valued images of a fused inner and outer reality. There is a continuity in the psychoanalytic literature between these early insights and the contributions of contemporary authors; for although

Freud has been attacked for viewing highly elaborated artistic form *merely* as a disguise or as a "way of paying a bonus to the censor in order to gratify a forbidden wish in a somewhat attenuated form" (Rose, 1980, p. 353), he also recognized the potential of content transformed to bring us in touch with a more fundamental inner reality.

Freud was not, however, unaware of his rather cursory treatment of form in art. In the opening paragraph of *The Moses of Michelangelo*, for example, he admits,

> I may say at once that I am no connoisseur in art, but simply a layman. I have often observed that the subject-matter of works of art has a stronger attraction for me than their formal and technical qualities, though to the artist their value lies first and foremost in these latter. I am unable rightly to appreciate many of the methods used and the effects obtained in art. (1914, p. 214)

Nonetheless, in *Creative Writers and Daydreaming* he speculates on the pleasure of artistic form. Were the ordinary man, he suggests, to tell us his daydreams, we would feel bored or repelled. When we encounter the daydreams of the artist transformed into poetry or drama, we experience intense pleasure. To account for this difference, Freud offers the notion that the formal elements in a work of art constitute a "bribe,"

> [an] incentive bonus, or a fore-pleasure, ... which is offered to us so as to make possible the release of still greater pleasure arising from deeper psychical sources.... In my opinion, all the aesthetic pleasure which a creative writer affords us has the character of a fore-pleasure of this kind, and our actual enjoyment of an imaginative work proceeds from a liberation of tensions in our minds. It may even be that not a little of this effect is due to the writer's enabling us thenceforward to enjoy our own daydreams without self-reproach or shame. (p. 153)

Thus, even in this early work, Freud hints that form and content work hand in hand, and that art can function to liberate audiences by empowering us to come into more intimate contact with our own inner reality, thus unlocking boundaries that formerly seemed fixed. This notion is not far from much that is highly valued in our current thinking about aesthetic experience—the sense of opening, of possibility, of risk-taking, of shocking into new awareness, the sense of a fluctuating self that can adopt multiple perspectives (Greene, 1980–81).

The Contribution of Ego Psychology

Since Freud's time, several psychoanalytic authors have dealt with the problem of form and content and made significant contibutions to our understanding—notably, Ernst Kris. In "Aesthetic Ambiguity" (1952), Kris raises the question of the relation of artistic activity to aethetic response. He tackles this important question briefly, relating it (as Freud does not) to the form/

content problem. He explains that he wishes to "develop the conception of art as a process of communication and re-creation in which ambiguity plays a central role" (p. 243).

> Aesthetic creation is aimed at an audience: only that self-expresion is aesthetic which is communicated (or communicable) to others. This is not to be taken as implying the existence of a content separable from the aesthetic form—a message, in other words—which the work of art must get across.... What is made common to artist and audience is the aesthetic experience itself, not a preexistent content.... Communication lies not so much in the prior intent of the artist as in the consequent re-creation by the audience of his work of art. And re-creation is distinguished from sheer *reaction* to the work precisely by the fact that the person responding himself contributes to the stimuli for his response. (pp. 254ff.)

This passage suggests the familiar realm of contemporary aesthetics, which denies a split between form and content and emphasizes the need for active effort on the part of the audience in a re-creative process. Kris is, however, quite close to Freud in his formulation of communication in the aesthetic experience. Kris's approach depends on a similarity between the processes of artist and audience, not an identity. By turning away from the artist's prior intent and from a preexistent content that must be unearthed, Kris implies that, in order for communication to occur, what is (or was) emotionally charged for the artist at the time of creation may not be so for the audience; thus, certain information about the man and his purposes may be irrelevant to our aesthetic experience of a particular work.[7] Emphasis is upon that which is given to us in the work itself. The paintings of Magritte, for example, possess images so highly charged and symbols so rich and potent that we are compelled to respond emotionally, yet the circumstances that caused him to create them may have no manifest connection with our own lives. (See, for example, *The Rape* [Le viol], *The Explanation* [L'explication], and *Philosophy in the Boudoir*, discussed in further detail in chapter 3.)

Kris next introduces the notion of the "potential of a symbol," which is "the obverse side of its overdetermination" (p. 255). In other words, a symbol that has resulted from the condensation of many psychic (and external) causes in the artist also can produce a multiplicity of effects in the audience. But these two phenomena are not necessarily correspondent. The crucial factor is that a symbol which is to have aesthetic potential must stimulate in its

7. Prior to this, almost all psychoanalytic applications to art consisted in pathographies of the artist, following the prototype of Freud's *Leonardo da Vinci* (1910). Kris's shift of emphasis from artist to work of art reflects a similar shift in nonpsychoanalytic critical writing on art, where primary focus on the artist (typical of the Romantic critical tradition) has given way to the more autonomous view of the art object as a "heterocosm" best seen as unique and distinct from its maker's intentions. (See chapter 4.)

audience the functioning of the primary process. In other words, it must put us in touch with our own unconscious. This idea is very close to that of Freud (1908), who suggests that the work of art may enable us to enjoy our own daydreams without self-reproach. Thus, for both Kris and Freud, art offers the audience a safe realm in which boundaries may be crossed.[8] For Kris, the symbol, if it is to function aesthetically, must involve us in this shift of psychic level from secondary to primary process.

Yet, though this condition is necessary, it is not sufficient (for one can easily imagine situations that involve precipitous shifts in psychic level with no accompanying aesthetic pleasure). Kris adds to it the notion of psychic distance, familiar to philosophers as "aesthetic" distance. Form and content must be so wedded as to create a distance that is neither too close, lest art be reduced to propaganda, pornography, or magic, nor too far, lest the audience be unable to participate, lest we withdraw, overintellectualize, or dismiss the work in question as incomprehensible and worthless. The most effective images or symbols, then, must be able to effect in us changes in both psychic level and distance, and they will be redolent of ambiguity that can be interpreted from within the context created by the work. The highest value or best chances for survival belong to those works that possess, by virtue of the union of form and content, "as high a degree of interpretability [ambiguity] as is compatible with containing within themselves their own sources of integration" (p. 264).

Anatomizing formal ambiguity, which is the theme of his paper, Kris suggests that poetic form serves the function of pointing out latent ambiguities to us; for example, meter and rhyme in poetry give us license to depart from our usual method of reading and to attend differently. Kris quotes a footnote of Freud's that is relevant not only to the possible multiple readings of traditional poetry but also, for example, to contemporary avant garde theater:

> in a line of associations ambiguous words (or, as we may call them, "switch-words") act like points at a junction. If the points are switched across from the position in which they appear to lie in the dream, then we find ourselves upon another set of rails; and along this second track run the thoughts which we are in search of and which still lie concealed behind the dream. (Freud, 1905, p. 65)

This concept of *switch-words*, if applied to the reading of poetry, indicates how form can stimulate primary process functioning. One highly condensed

8. Anna Freud, in a recent paper on *Insight* (1981), makes a similar point, claiming that the creative artist in whom "the unconscious and consciousness are not closed off from each other by the usual barriers" (p. 248) possesses a greater capacity for insight than do others. I suggest, following Kris, that this heightened capacity for insight might extend also to the perceiver of art in his re-creative moments of aesthetic experience.

symbol can take on a variety of discrete meanings depending on shifts in the context into which it is placed. Wonderful interpretative possibilities emerge for modern works that exploit ambiguity. If *visual image* is substituted for *word*, this concept might also be applied to the paintings of Magritte, in which the connections among images may lie along verbal, visual, emotional, religious, and philosophical tracks, and where as many threads of linkage as possible must be explored to unravel levels of meaning.

Another aspect of the aesthetic that Kris touches upon is particularly relevant to Magritte's work—namely, tension. Unlike Freud, Kris understands tension not so much in sexual terms but as arising out of the teeming ambiguity of the poetic symbol. He speaks of intension and extension, and I take him to be indicating the stress of the rational mind, accustomed to discrete meanings, when confronted with metaphoric language. Gilbert Rose (1980, 1980a) has yet another explanation for aesthetic tension, which involves the developmental stages of childhood. He derives tension from the rapprochement subphase of separation-individuation (Mahler, 1968), during which the young child is learning to balance closeness and distance to the mother, the familiar and the new; tension arises when the unfamiliar becomes overwhelming or, alternatively, when the familiar threatens to engulf. In aesthetic terms an audience can experience tension when there are discrepancies in spatial representations, an absence of familiar usages and meanings, irregularities in expected patterns, anxiety about the loss of structure altogether (Rose, 1980a, p. 359).

In the paintings of Magritte tension abounds; and the insights of Kris and Rose account for it in part. In addition to the disturbing ambiguity, the alternating presentation of the familiar and the unfamiliar, however, the tension must be attributed to what Freud (1919) has called the "uncanny"— that is, the return to consciousness of what has formerly been repressed. In Magritte's work we also experience the tension of the visual taboo—the wanting to look, yet fearing to look, which Wolfenstein (1973) has convincingly traced to specific, highly traumatic visual experience in the artist's early childhood.

In his exploration of form and content Kris builds upon the pioneering work of Freud but goes far beyond him in examining the structure of symbolic ambiguity. At no point does he contradict Freud; rather, Kris explicitly states that in aesthetics access to primary process involves not only form (that is, the presence of ambiguity and metaphor) but also content, which he identifies classically as "the fundamental needs and desires of the personality . . . the 'id' in Freud's sense" (p. 263). Kris is somewhat of a transitional figure, standing between Freud on the one hand and the more heterodox ego psychologists on the other.

Kris's original concept, "regression in the service of ego," not only paved the way for other ego theories, but also addressed the relationship between

artistic activity and emotional response. This idea, the relaxation of ego functioning to permit access to primary process, is, according to Kris, "in the case of aesthetic creation—in contrast to these other cases [fantasy, dream, states of exhaustion]—... purposive and controlled" (p. 253). In other words, the artist is not a prisoner of regressive forces within himself: his "inspired creativity... involves a continual interplay between creation and criticism, manifested in the painter's stepping back to observe the effect. We may speak here of a shift in psychic level, consisting in the fluctuation of a functional regression and control" (pp. 253ff.) Thus the artist also functions as an observing ego; he is his own audience while he works.

In a later paper (1955), Kris describes the stages in a young child's experience with easel painting. At first the child is motivated by instinctual impulses to smear and to mess, but gradually he becomes fascinated by what is happening on the paper, by the colors themselves, the process of using the brush, and so on. It is at this point in the process, claims Kris, that instinctual energies are left behind and the ego begins to function semiautonomously. What happens from this point on, though originally motivated by the "id," cannot be interpreted in terms of id impulse. In clinical and developmental terms, Kris suggests "that as maturation proceeds, as the inner world grows, as new pleasures in fantasy and mastery become accessible, *the structure of the activity itself influences the process* of neutralization" (p. 37; emphasis added). The relevance of this new formulation of the artistic endeavor to modern art is evident; we have only to consider Albers's exploration of color relationships, Mondrian's concern with structure, Pollock's play with freedom and control through the medium of calligraphic line, Nevelson's rearrangements of three-dimensional shapes on a plane surface. It seems reasonable to describe the activity of these artists as involving in large measure skill, technique, and problem-solving capacity—in short, functions of the ego.

Worth recalling in connection with the subject of modern art are the views of Otto Rank and Hanns Sachs, contemporaries of Freud. Briefly, Rank (1932) conceived of form as representing the "ego ideal." According to his theory, form embodies man's desire to transcend his biological and social determinants. Thus, for Rank, artistic form reveals man's attempt to gain control over certain aspects of his environment. Yet Rank seeks to explain recurring elements in aesthetic form by tracing them to biological origins. He derives, for example, the spiral, a primitive and widely used design, from the human intestines; other examples are not difficult to find (the sense of rhythm may emanate from infantile somatic sensations, and emotional response to music may correlate with the affinity between its tempo and the pulse).[9] Sensitive to this principle, certain modern artists, I believe, play with it, manipulating

9. It is interesting to note in this connection that Greenacre (1957) derives a predisposition toward later aesthetic experience from a heightened and broadly based sensuality in early childhood.

our expectations by contriving formal elements that run counter to the familiar, the biologically derived, and thereby achieve reactions of shock and dissonance in their audiences. (For example, in a recently performed piece, "Credo in Us" by John Cage, sequences are spasmodically, suddenly, interrupted, thwarting our sense of confident expectation.) Thus, by the manipulation of biologically derived form, the artist can exert control over his material, his audience, and himself and so achieve a sense of independence. Likewise, his audience, participating in such a piece, can identify with this ego ideal and experience pleasure without having expended the energy necessary for original creation.

Another analyst, Hanns Sachs (1942), has written on the way in which a successful work of art can restore to its perceiver aspects of experience that were previously unavailable, invisible. This happens "when the interrelation of form and content is vital and organic, when the façade reveals that a constructive force dominates the work" (p. 46)—when, in other words, form reveals process. What interests me is his emphasis on perception as well as process. Perception is a key concept in contemporary aesthetics, and I believe it is toward our perceptual faculties rather than to the deeper levels of the psyche or even to our cognitive faculties that many of today's artists are directing their communication.[10] When we look at paintings by Barnett Newman, Robert Motherwell, or Mark Rothko, we are having principally perceptual encounters, and a large measure of the pleasure gained must come from our deepening awareness of and sensitivity to the creation of form—that is, line, shape, color, dynamics. I doubt that such experiences, no matter how intense, can function integratively vis-à-vis the rest of the psyche, as does the experience of psychoanalysis, but the larger issue, the value of the heightened perceptual moments offered by the contemplation of works of art, is an open and unresolved question.

Building on concepts introduced by Kris (1952) and Hartmann (1964), Marshall Bush (1967) presents the following formulas for aesthetic form: "The psychoanalysis of form seems to eventually reduce itself to the psychology of the 'ego' " and "the basic paradigm is that form stands to content as the ego stands to the id, the superego and reality" (pp. 27 ff.) He uses Kris's insight to describe how, in the aesthetic realm, activities originally motivated by intrapsychic conflict and employing libidinal energy can change in function and assume a relatively autonomous status. According to Bush, as these new interests become more independent from drives they generate new pleasure, which is to be distinguished from the original instinctual pleasure. These interests, now fueled by the energy of the ego, "become a part of the 'conflict free' ego sphere which pursues aims for its own enjoyment (i.e.,

10. However, it is important to bear in mind that the perceptual faculties are not altogether independent but are themselves influenced by unconscious factors (see Freud, 1925).

not in response to instinctual demands or superego commands)" (p. 29). Bush restates this principle as follows:

> What derives from need and becomes relatively free of its origins, sets ideals of its own based on the upper reaches of its own limits. . . . artists must, in general, be those individuals in whom their artistic interests assume a high degree of autonomy from their conflict-born origins and are transformed into an ideal constructed out of the ego's own functions. The successful artist uses his unconscious to enhance his artistry, and not vice versa. (p. 32)

Rose (1980a), though he inherits insights from some of the authors discussed above, develops a somewhat different line of thought:

> If the aesthetic experience is regarded as essentially a regression of one kind or another and aesthetic form primarily a defense against content, much of the challenge of aesthetic experience and the constructive elements of aesthetic form— in short, what is most creative about creativity—must necessarily leave the psychoanalyst untouched, as indeed Freud said he was. . . . Nonmimetic, abstract art held no interest for him. Impressionism, symbolism, pointillism, cubism, expressionism swirled in the air; Monet, Seurat, Cezanne, Picasso, and Matisse were revolutionizing man's view of reality. Freud, revolutionizing along different lines, ignored them. (p. 8)

Subsuming content under form by asserting that form carries meaning, Rose builds his theory on a model of the psyche in which id and ego each employ organizational principles, albeit differing ones; for simplicity's sake, he ascribes the primary process to id and secondary process to ego. He views aesthetic form as relating to both principles and utilizing them simultaneously. As the mind functions in these two different ways, so aesthetic form reflects their contradictions. The ambiguity of aesthetic form thus reflects the mind's double system of processing, in which two frameworks of orientation for time, place, and person operate concurrently (for example, we reexperience the past in the present, rediscover ourselves in other persons, must continually reorient ourselves in the world of fluctuating spatial coordinates).

For Rose, orientation to reality is central to the aesthetic experience, which, he believes, expands the present moment for us by offering us an intimate contact with the past *without* regression. As we bring our own past feelings and desires to bear upon the work of art, we have an intensified and extended encounter with the present; hence, a more integrated adaptation to reality. Rose describes the process of the viewer of art as moving from a temporary sense of fusion with the work to reseparation and then, finally, to a redefinition of boundaries. He traces this alternation of fusion and differentiation to the earliest stages of mother-child interaction (infantile symbiosis and separation-individuation), thereby echoing the theories of Mahler and Winnicott (discussed below):

> The structure of the aesthetic object has to do with the dialectic between sep-
> aration and fusion, control and ambiguity, tension and release, thought and
> feeling or action, change and constancy, present and past.... The art work reflects,
> mirrors a self which exists across boundaries, between dualities.... This process
> [aesthetic re-creation] repeats the first step in the construction of reality.... At
> the same time, an adaptive purpose is served, that of a reorientation as to time,
> place, and person in a current reality. (pp. 211ff.)

Rose's theory is, of course, highly synthetic, containing elements culled from
Freud and Kris, from Hartmann, Rank, Phyllis Greenacre, Mahler, and Win-
nicott. It is also remarkably idealistic. Yet his theory is based on an informed
acquaintance with modern art in many media, including literature, music,
and the visual arts, and its applicability, its interpretative strength, is tested
in his sensitive reading of Faulkner's *Light in August* (1980, 1980a).

Theories that consider aesthetic activity as exemplary of high-level inte-
grative ego functioning and would deny to it the presence of id impulse and
conflict are clearly apposite to some manifestations of modern art, such as
those in which artists and audiences seem to be exclusively employed in
exploring form and deriving pleasure therefrom. My difficulty with this ap-
proach is that I cannot help believing that the aesthetic process "involves
more than the pleasure derived from sheer exercise of ego functions. It is
true we enjoy a synthetic solution to a problem, but the pleasure is not great
if the problem is trivial" (Bush, 1967, p. 32.) This is my stumbling block
with respect to both a pure ego approach and some modern art. Formal
problems can be diverting, their solutions fascinating, but it seems to me
that not all form carries meaning; for a work of art to be great, there must
be content in Freud's and Kris's sense—not merely perception, but a reaching
down into the depths of the unconscious. Aristotle understood this when he
spoke of a catharsis of pity and fear, and perhaps the greatest artists of every
age have known it. Although we may profitably spend hours dwelling on
form in Rembrandt, Goya, or Van Gogh, their works have survived because
their content is nontrivial, because they have painted the deepest fears and
wishes of mankind.

The Contribution of Object-Relations Theory

Winnicott's approach to aesthetics is prototypically developmental (for fur-
ther discussion see chapter 5). In a seminal paper (1953), he describes the
way in which a small child during the practicing subphase of separation-
individuation (Mahler, 1968) attaches to a transitional object (a blanket, soft
toy, or teddy bear) certain qualities of the intimate and soothing relationship
with his mother. The transitional object, which is perceived by the child as
part self and part outside world, is taken by Winnicott to be the precursor
of the adult's investment in cultural objects of many types, including, of
course, works of art.

Winnicott regards the cathexis of a transitional object as normal, healthy, and universal in infant development. The highly personal significance of the attachment to this object grows out of whatever reciprocal cuing has developed in the mother-child partnership during symbiosis (Mahler, 1968). From this attachment, Winnicott derives the individual's later capacity not only to invest in cultural objects of all kinds but to forge creative links between his inner and outer worlds. Imaginative play forms the bridge between the child's illusion or fantasy, objectified initially in a transitional object, and his investment in cultural and specifically aesthetic experience in adulthood (a line of thought also pursued in Greenacre, 1971).

I believe that Winnicott regards aesthetic form and content as fused. He does not recognize in the transitional object, which is the archetype of the aesthetic object, two distinct levels of truth or interpretation. He stresses that the prohibited question about transitional objects, the question we must never ask the child is: did you *make* this object or did you *find* it? Because the child's experience includes both of these modes, to pose such a question would be to challenge the child in a way that could inhibit him from further elaboration of his fantasy. We must be knowingly complicit in his "madness," which transforms the ragged blanket into a supremely valued thing. If the transitional object is paradigmatic of our relationships to works of art, it becomes apparent that a separation of form and content would destroy the work as art; it would involve moving outside the aesthetic experience in a way that would reduce it to something less or other than what it actually is. In Winnicott's model the art object is not independent of the aesthetic experience; both actual and symbolic, both mental—dependent upon the prior existence of internal objects—and external object, the aesthetic comes into being during an encounter, an enactment.

In addition to the transitional object, Winnicott's theory includes the notion of transitional phenomena, embracing the category of sounds initiated by the child and, by extension into later cultural life, of music. Winnicott (1953) identifies the infant's impulse to babble or sing to himself before falling asleep (p. 89) as serving a dual function: the child attempts to soothe himself at a time of anxiety (loss) and also to practice newly developing skills.

Among the many musical works that can be illuminated by Winnicott's ideas on transitional phenomena is a composition by George Crumb entitled *Ancient Voices of Children* (1970) (see Spitz, 1980). This work is redolent of the developmental themes of symbiotic fusion and magical omnipotence, separation, practicing, loss, and rapprochement. It is a work that, to be fully understood, almost compels a psychoanalytic approach based on concepts originated by Winnicott and Mahler.

One of the most distinctive features of Winnicott's theory is that, whereas Freud and most of the other psychoanalytic theorists are exclusively concerned with intrapsychic processes, he (1966) posits a third area of experience in

which inner and outer, fantasy and reality, are commingled. He is alive to the "thing-ness" of the art object. He stresses that the transitional object is not simply an internal object or mental construct, that it can therefore never be under absolute control, because it also exists as an object in the external world. Thus, the artist must deal with paint, with stone, with a harp, or with the human body moving in space. Winnicott (1966) underscores the importance of transitional phenomena:

> Psycho-analysts who have rightly emphsized the significance of instinctual experience and of reactions to frustration have failed to state with comparable clearness or conviction the tremendous intensity of these non-climactic experiences that are called playing. Starting as we do from psycho-neurotic illness and with ego defences related to anxiety that arises from the instinctual life, we tend to think of health in terms of the state of ego defences.... But when we have reached this point we have not yet started to describe what life is like apart from illness or absence of illness. That is to say, we have yet to tackle the question of *what life is about....* We now see that it is not instinctual satisfaction that makes a baby begin to be, to feel that life is real, to find life worth living. In fact, instinctual gratifications start off as part-functions and they become *seductions* unless based on a well-established capacity in the individual person for total experience, and for experience in the area of transitional phenomena. (p. 370)

It seems to me that Winnicott's theory, briefly summarized here, presents rich possibilities for interpretations of modern art in all media—in dance (two pieces come to mind: Anthony Tudor's *Little Improvisations* and Donald McKayle's *Games*, in which everyday objects are transformed on stage by children—dancers—for purposes of play; that is, these objects become whatever is required at a particular moment by the child's fantasy); in literature, where the poem itself may occasionally be experienced as a transitional object, the object that preserves what will be lost, the embodiment of illusion, the external object that survives as a testament to the way things were, "mixing memory and desire," bridging the lacuna between isolation and fusion; and, par excellence, in the visual arts.

2

On Pathography: The Individual Artist and His Work[1]

only an aching heart
Conceives a changeless work of art.
—William Butler Yeats,
"Meditations in Time of Civil War"

Freud's psychoanalytic investigations, growing initially out of his dissatisfaction with the use of hypnosis as a method of treating neurotic patients in the last decade of the nineteenth century,[2] have given rise to widespread cultural changes in our institutions and overt behavior, as well as in the ways in which we think about many aspects of human functioning. Insights into the structure and workings of the psyche gleaned from psychoanalysis have been applied to nearly every aspect of human experience. With respect to art, as Kris has noted, the influences have been pervasive, not only on the forms art takes but on artists, audiences, and critics.

Attempting to trace the myriad ways in which Freud's ideas have affected the aesthetic realm would therefore be rather like trying to catch the fluff of a dandelion after a child has blown it from its stem. Within the field of literary criticism, for example, Freud's ideas on parapraxes and jokes, dream symbolism, the myth of the primal horde, the Oedipus complex, and the concept

1. Material is this chapter is expanded from my article, "A Critique of Pathography, Freud's Original Contribution to Art," *Psychoanalytic Perspectives on Art*, ed. Mary M. Gedo, vol. 1 (forthcoming). Permission of The Anayltic Press is gratefully acknowledged.

2. See Freud and Breuer (1895) and Freud (1894), in which the dynamic model of the mind is presented, with its concepts of repression, cathexis, mobile and bound energy, and the splitting of idea from affect. Shortly thereafter, Freud developed the notion that the repressed idea could be a fantasy rather than a memory and developed the technique of "free association" as opposed to "suggestion."

of overdetermination have all been used as ways of approaching poems and novels. In this chapter I am concerned with the approach to art that Freud developed in *Leonardo da Vinci and a Memory of His Childhood* (1910) and named *pathography*. Clearly Freud did not limit his applications of psychoanalysis outside the clinical setting to this model. He also, for example, applied his ideas directly to the texts of certain of Shakespeare's major plays (including *Hamlet, King Lear,* and *Macbeth),* as well as to myths, nursery rhymes, and fairy tales.

Freud's tastes in art were limited and conservative, albeit enthusiastic. He did not enjoy music, for example (1914, p. 211), and took no interest in the stirring avant-garde movements of his time in the visual arts, music, theatre, or dance. He ignored such contemporary geniuses as Kandinsky, Picasso, Schoenberg, Joyce, and Isadora Duncan and likewise avoided twentieth-century European philosophy. Thus, supremely gifted and original and daring as he was in his own bailiwick, his cultural preferences were rooted in the nineteenth century.

FREUD AND THE ROMANTIC CRITICAL TRADITION

The views on art that formed the background for Freud's work have been characterized as the Romantic or expressive critical tradition. Although M. H. Abrams (1953, p. 22) opines that to fix a terminus a quo for this tradition would be tantamount to determining the precise point at which yellow turns to orange on the rainbow, he nevertheless does suggest the year 1800, which is among other things the year of publication of Wordsworth's *Preface to the Lyrical Ballads,* generally considered the prototypical document of Romantic criticism.[3] In this work Wordsworth defines poetry as "the spontaneous overflow of powerful feelings"—feelings, that is, of the poet. Thereby he shifts the focus of critical attention dramatically from audience or work of art to the psyche of the artist who created it.

Freud's approach, pathography, may be seen as emerging from this larger context rather than as an isolated phenomenon. In describing this Romantic context, Abrams (1953, p. 48) points out that when art is viewed as " 'the expression or uttering forth of feeling' " (as John Stuart Mill put it in his essays on poetry of 1833) certain questions and notions follow. A critic will want to ask, for example, how and to what extent a particular work yields insights into the psyche of its creator: whether it is genuine, spontaneous,

3. My examples of Romantic criticism will be drawn largely from English sources. My point is not that Freud read these authors (he probably didn't) but rather that his interests and emphases can be analogized with theirs. My effort is to draw a parallel rather than to make a specifically historical statement.

sincere.[4] Furthermore, if the external world is depicted in visual art or described in poetry, it must under this approach be seen primarily as a *projection* of the artist's state of mind, an idea that eventually found its most felicitous formulation in T. S. Eliot's notion of the "objective correlative" (1932). The notion of works of art as externalizations of psychic states paved the way for the advent of the late nineteenth century symbolists and a host of other styles, the postimpressionists, expressionists, fauvists, surrealistics, and abstract expressionists.[5] The relevant question for the critic in each case is: what is the underlying feeling, psychic state, conflict, or desire that is finding expression here, possibly disguised? A model such as this necessarily implies an interpretative mode that involves the "looking through" of Abrams's metaphor. The mirror that the artist had formerly held up to nature becomes transparent in the Romantic novel, thus enabling an audience to look through it to the mind and heart of the artist himself.

This Romantic viewpoint, centering on how an artist's inner life of feeling finds expression in his works, informed the climate into which Freud's first works were released, and it may have played a role in shaping both the development of his ideas and their reception. Kris (1952) reports, for example, the intriguing phenomenon that when Freud published his *Studies on Hysteria,* in 1895, to mixed reviews from the scientific and medical communities, one reviewer only, not a clinician but the literary critic and poet Alfred von Berger, director of the Imperial Theater in Vienna, recognized the significance of the new work and saw it as a "herald" of a new psychology. Kris believes it is no accident that the greatness of Freud's discoveries should have been recognized first by a literary rather than a scientific scholar, for "Freud's predecessors in the study of man were not the neurologists, psychiatrists and psychologists, from whom he borrowed some of his terms, but rather the great intuitive teachers of mankind [that is, the artists]" (1952, p. 265). Yet Kris adds that the influence of Freud's discoveries on the literary mind "would be inexplicable had not the previous development of literature turned in a direction which created favorable predispositions for this influence (p. 270)." Thus, the Romantic tradition that Freud inherited not only provided fertile soil for the reception of his ideas but also nourished, it seems, the growth of these very ideas, particularly as he began to apply them directly to the arts.

The Romantic or expressive mode, which appeared in various guises in European fine arts, literature, music, and criticism of the nineteenth century,

4. Obviously, for a psychoanalytic critic these categories must somehow expand in meaning to include unconscious intention—for example, the artist's unconscious wish to hide certain things from himself.

5. A propos of these styles, we might note also the connection between the "stream of consciousness" novel and the psychoanalytic notion of "free association."

gave rise by its focus on the artist to myths and cults of the artist, to views of the artist as different from other people, as hypersensitive, fragile, "possessed," and so forth, reviving in modern times Plato's notion of the artist's madness.[6] Indeed, it is not uncommon today for psychoanalysts (and others) to regard artists as persons with particularly intense or persistent conflicts, as even the term *pathography* connotes.

Actually, after coining the term in his study of Leonardo and promising to "stake out in a quite general way the limits to what psycho-analysis can achieve in the field of biography" (1910, p. 134), Freud defines pathography only by making exclusions. He says, for example, that "we should be glad to give an account of the way in which artistic activity derives from the primal instincts of the mind if it were not just here that our capacities fail us" (p. 132), and that "pathography does not in the least aim at making the great man's achievements intelligible" (p. 130). He tells us what pathography cannot (yet) do and what psychoanalysis cannot (yet) explain. In the absence of a more explicit account of his aims, we must fall back on the obvious connotations of the word. A less inclusive term than biography, pathography implies writing about suffering, illness, or feeling, with important overtones of empathic response on the part of the author for his subject. It suggests *selected* aspects of a life, precisely , in fact, those aspects that pertain to (mental) disease and to intrapsychic conflict, its symptoms, and their etiology. Thus the conception of the artist implicit in Freud's terms grows solidly out of the Romantic tradition, in which artistic creativity is variously associated with moments of intense emotion, altered states of consciousness, and pain.

A view of the artist as uniquely endowed emotionally, as chosen or cursed, leads to speculations about what possible therapeutic value the making of art might have for its creator. Psychoanalysts in recent years have debated this issue, and the term *art therapy* betokens a positive side to the controversy. Most pathographers tend, however, to see the solution of artistic problems as contributing little of lasting value to the resolution of intrapsychic conflict; in fact, this viewpoint is fundamental to their interpretative method, which depends on the reappearance of certain persistent motifs throughout the artist's life.

For example, Robert Liebert proposes a view of art and artists similar to that Abrams has formulated as characteristic of the Romantic critical tradition:

> We expect that the underlying forces [of conflict] will be expressed repeatedly as a reflection of continuous internal pressure within the artist. This expectation grows out of the view that the manifest solution of the latent and unconscious conflict in the artist, the work of art, does *not* have the effect of "working through"— that is, of permanently altering the central mental representation of himself and

6. See Kris and Kurz, 1979, for a fascinating excursion into the ancient roots of this topic.

others and bringing about basic changes in other aspects of his internal psychological organization and outlook. Thus, as each artistic endeavor inevitably fails in this respect, the underlying conflict will reappear. Each new artistic solution to it will be somewhat different from the previous one, but still motivated toward a similar end. (1982, pp. 448, 449)

Abrams has stated that:

A work of art is essentially the internal made external, resulting from a creative process operating under the impulse of feeling, and embodying the combined product of the poet's *perceptions, thoughts,* and *feelings.* The primary source and subject matter of a poem, therefore, are the attributes and actions of the poet's own mind; or if aspects of the external world, then these only as they are converted from fact to poetry by the feelings and operations of the poet's mind. (1953, p. 22, emphases added)

The parallels between Abrams's summary and Freud's pathographic approach—minimally (or only secondarily) concerned with how art either mirrors the outside world, affects its audience, or possesses a formal internal structure, but maximally concerned with the narrative of an artist's inner life as it can be inferred from a careful study of his works (and other biographical material)—are striking. Insofar as pathography seeks also to define the nature and origin of the artist's "perceptions, thoughts and feelings," it represents a final flowering in the twentieth century of Romantic criticism.

Although Romantic critics generally viewed the work of art as an expression of the artist's feeling, it is interesting to note that, even before Freud's seminal work of the 1890s, there were literary critics who understood that works of art may function not merely to express feelings but also to disguise and conceal them. One such critic was John Keble, a leader in the Oxford movement and holder of the Oxford Chair of Poetry. In the 1840s, Keble had formulated a theory of poetry—dedicated appropriately to Wordsworth, who can also be seen as proto-Freudian in his developmental thinking which embodies the notion that art is an *indirect* expression of "some overpowering emotion, or ruling taste, or feeling, the direct indulgence whereof is somehow *repressed*" (quoted in Abrams, 1953, p. 145, emphases added). Keble speaks of art as giving "healing relief to secret mental emotion" (p. 145), as "paint[ing] all things in the hues which the mind itself desires" (p. 147), and as "a safety-valve, preserving man from actual madness" (p. 146). Thus, for Keble, art involves not simply the direct, spontaneous expression of feeling but rather internal *conflict* between the artist's need to give utterance to his emotions and his "instinctive delicacy which recoils from exposing them openly" (p. 147).

It must be clear to any reader of Freud how close the views of Keble (and other Romantics)[7] are to those of classical psychoanalysis.

7. Note William Hazlitt, who compares poetry with dreams and even suggests that art may arise from a need to compensate for physical deformity: "Do you suppose we owe nothing to

Freud's views and Wordsworth's are strikingly similar concerning the Romantic notion that artists are uniquely endowed with a capacity to tap into the deepest wellsprings and hidden secrets of the human heart:

> What is a Poet?...He is a man speaking to men: a man, it is true, endowed with more lively sensibility, more enthusiasm and tenderness, who has a greater knowledge of human nature, and a more comprehensive soul than are supposed to be common among mankind.... (Wordsworth, Preface to *Lyrical Ballads* of 1800, 1950, p. 684)

> ...creative writers are valuable allies and their evidence is to be prized highly, for they are apt to know a whole host of things between heaven and earth of which our philosophy has not yet let us dream. In their knowledge of the mind they are far in advance of us everyday people, for they draw upon sources which we have not yet opened up for science. (Freud, *Delusions and Dreams in Jensen's "Gradiva,"* 1907, p. 8)

I have, of course, blurred certain distinctions between pathography and Romantic criticism in order to establish parallels between the two. Whereas the Romantic critic employs biographical and other information in order to interpret the work of art, his prime object of inquiry, in pathography the movement is reversed. According to Freud the works of art or aspects thereof are taken as starting points "for discovering what determined [the artist's] mental and intellectual development" (1910, pp. 130–31). Thus, in pathography the psyche is the prime object of inquiry. It might therefore be possible to rule out pathography as a critical mode entirely, to see it as a purely psychological study, as the search for a man. Dismissing such a quest as not only extraneous to critical inquiry but also quite absurd, the aestheticians William K. Wimsatt, Jr., and Monroe Beardsley offer a mischievous quote from Thomas Hardy: " 'He's the man we were in search of, that's true,' says Hardy's rustic constable, 'and yet he's not the man we were in search of. For the man we were in search of was not the man we wanted' "(1978, p. 295).

However, my reasons for maintaining that pathography *can* be seen as a viable critical mode recall Isenberg's metaphor (in arguing for a somewhat different point): "It is as if we found both an oyster and a pearl when we had been looking for a seashell because we had been told it was valuable. It *is* valuable, but not because it is a seashell" (1973, p. 163). The pathographer

Pope's deformity? He said to himself, 'If my person be crooked, my verses shall be strait' " (quoted in Abrams, p. 142).

Note further the following passage by Thomas De Quincy: "In very many subjective exercises ...the problem before the writer is to project his own inner mind; to bring out consciously what yet lurks by involution in many unanalysed feelings; in short, to pass through a prism and radiate into distinct elements what previously had been even to himself but dim and confused ideas intermixed with each other" (quoted in Abrams, p. 144).

may pursue the pearl, but because he is looking so intently about him, may discover many beautiful coral reefs and underwater flora.

In order to *do* pathography, one must look carefully and read slowly. One must dwell on detail. One must attend with utmost sensitivity. Because something of the artist has found its way into each work of art (and this is granted even by Wimsatt and Beardsley, 1978, p. 294), to seek the former we must deal pari passu with the latter. Hence, pathography, in its effort to penetrate to certain sorts of psychic meaning in works of art is bound to attend to these works aesthetically and, if well done, even to contribute to our awareness and understanding of them. I am suggesting, in other words, that although the directions of emphasis are different, the lines do run parallel; since works of art are perceived as wholes, since what the artist meant by the poem is in some sense the poem, the pathographer, the psychoanalyst, may be considered as partaking in critical inquiry, as contributing (even if he conceives this as only a minor or secondary function) to the critical enterprise.[8]

It is also worth noting that, contrary to Freud's formulation in the Leonardo study, in actual practice pathography works both ways: works of art are used to penetrate the psyche of the artist, but hypotheses about the artist's inner life are also used to interpret his works. In the latter case, certainly, the analyst can be seen as speaking with a critical voice. One important way of judging the value of such remarks is to return to the works of art in question and reexperience them in the light of the preferred psychoanalytic interpretation. Such a reexperiencing or "second moment" is fundamental to the concept of criticism held by at least some philosophers (compare Isenberg, 1973, p. 163), and its centrality to the pathographic approach is manifest by the usual inclusion in pathographic texts of reproductions of the works of art under consideration—note the inclusion of several plates in Freud's *Leonardo*. More tellingly, however, with respect to literature, Freud instructs his readers "to put aside this little essay and instead to spend some time in acquainting themselves with *Gradiva* [the novella with which the essay deals] ...so that what I refer to in the following pages may be familiar to them" (1907, p. 10). Compare this passage with the following from Isenberg: "Reading criticism, otherwise than in the presence, or with direct recollection, of the objects discussed, is a blank and senseless employment" (1973, p. 164).

A counterargument to my claim that pathography should be considered as a critical mode could be made by citing differences in how psychoanalysts and critics listen, look, and read. Such differences certainly do exist, and the issue bears further study. I maintain, however, that these variations are no different in kind from those one might encounter among individual critics or representatives of particular schools. For example, it might be argued that

8. To grasp the poet, one must undergo the poem. Note the convergence between this view and Kris's ideas of the progressive identifications in aesthetic experience.

a psychoanalyst approaches a text with an eye or ear for only certain kinds of gaps or inconsistencies. Yet, similarly, the formalist critic may approach a painting oblivious to its iconography, his eye attuned merely to nuances of line, shape, and color, to perhaps a "steeply rising and falling curve" (Isenberg, 1973, p. 162). A drama critic may be principally concerned with language rather than with psychological subtlety or dramatic fulfillment. One music reviewer may listen for the guest conductor's particular interpretation of tempo and dynamics and attend to his rapport with the orchestra, whereas another critic attending the same concert may have score in hand, intently listening for the balance of sound, his focus on the arrangement of voices within the music. In each case, including the psychoanalytic, what is seen, read, or heard will be somewhat different but may, under particular circumstances and for a particular audience, become critically relevant.

The circumstances under which a remark becomes critically relevant can be highly variable. Even an art dealer's pronouncement about the relative worth of two seemingly fine impressions from the same lithographic plate could be crucially relevant to the prospective buyer if such a pronouncement spurred him to look more carefully, more discriminatingly at the two impressions. On the other hand, comments on the monetary value of works of art are generally taken to be critically irrelevant (and usually are). Isenberg says that the essential condition of the aesthetic experience is that attention should rest on a certain content (1973, p. 52). Any remark that serves "to expand the field on which attention rests" (p. 52) would seem to be critically relevant.

Thus, I can find no better reason for excluding one critical approach (formal, historical, psychoanalytic, and so forth) over an other. It even seems plausible that under most circumstances, except in the case of normative criticism, these modes would come into conflict only when exponents of one or another claim to have exclusive or prior hegemony over a work or works of art, to possess, in other words, "the *true* interpretation."[9]

INTENTION, EXPRESSION, AND PATHOGRAPHY

In my opinion, what grips us so powerfully can only be the artist's *intention*, in so far as he has succeeded in *expressing* it in his work... what he aims at is to awaken in us the same mental constellation as that which in him produced the impetus to create.... [The work of art must admit of the application of psychoanalysis] if it really is *an effective expression of the intentions and emotional activities of the artist*. (Freud, 1914, p. 212, emphases added)

Granted that one can, under some circumstances, consider pathography a critical mode, one must also consider the criticisms advanced by modern

9. See Stuart Hampshire's argument against such a notion in "Types of Interpretation" (1966), which Monroe Beardsley (1970) rebuts on the grounds of what he calls "critical rationally" and "public semantic facts" that antecede interpretation.

aestheticians with respect to Romantic theories of art. Broadly speaking, their critique falls into two parts: (1) it accuses Romantic criticism of incorporating the so-called intentional fallacy—that is, of assuming unjustifiably that knowledge of the artist's intentions is (*a*) available and (*b*) desirable as a standard for how a work of art should be interpreted, read, responded to; and (2) it claims that Romantic theory takes a wrongheaded view of the expressive qualities of art. The work of Wimsatt and Beardsley is representative of the first of these critiques (with Frank Cioffi as their principal opponent), and O. K. Bouwsma, Alan Tormey, and Peter Kivy are exponents of the second critique.[10]

The psychoanalyst who writes on art using Freud's *Leonardo* as a model may be unaware of the ways in which such aestheticians have questioned the validity of his enterprise. If in addition to advancing or illustrating some aspect of psychoanalytic theory for an audience of peers the analyst seeks to make an interdisciplinary contribution to our understanding of the works discussed, he is bound to entertain the arguments of such philosophers as those cited above, not with the end of refuting them so much as of understanding and attempting to incorporate the valid insights they offer.

My own view is that the anti-intentionalist arguments have sufficient weight to be taken seriously; they offer (at least) good reasons why intentionalist critics (pathographers) cannot pretend to have both necessary and sufficient claims on how works of art ought to be read. By insisting on the autonomy of the art object, they provide an important caveat for the pathographer and suggest at least one direction in which he might look for what he senses might be missing in his approach. On the other hand, the arguments in favor of intention and expression are strong enough to establish these modes as viable, critically relevant ways of approaching works of art.

The first charge made against the intentionalist critic is that an artist's intention, defined as in some sense other than or more than the resultant work of art, is ultimately unknowable and hence a poor criterion on which to hang an interpretation. This charge bears on the problem of freedom and determinism in human behavior, an issue over which Freud wavered, though he usually held to the view that even if intention could not be entirely explained by current theory, it is determinate and hence susceptible to full explanation at some future time.[11] However, in *Leonardo,* which came under heavy attack when first published and has provoked periodic attack ever since, he demurs on this point:

10. Lest it be thought that such debates are passé, Denis Dutton read a paper entitled "Why Intentionalism Won't Go Away" to the American Society for Aesthetics, Banff, Canada, as recently as October 29, 1982.

11. Freud deals with the issue of determinism and predictability in "The Psychogenesis of a Case of Homosexuality in a Woman" (1920), where he points out that, though with hindsight the results always seem inevitable, the reverse is not obvious: "in other words, from a knowledge of the premises we could not have foretold the nature of the result" (p. 167).

But even if the historical material at our disposal were very abundant, and if the psychical mechanisms could be dealt with with the greatest assurance, there are important points at which a psycho-analytic enquiry would not be able to make us understand how inevitable it was that the person concerned should have turned out in the way he did and in no other way.... We must recognize here a degree of freedom which cannot be resolved any further by psycho-analytic means. Equally, one has no right to claim that the consequence of [a particular] wave of repression was the only possible one. (1910, p. 135)

Yet, later in the same work he stresses the opposite claim, that a person's fate is ultimately determined by "the accidental circumstances of his parental constellation" (p. 137). His ambivalence aside, Freud would certainly argue, against Wimsatt and Beardsley, that we can know *something* about the artist's intentions from sources external to the work of art and that this "something" will be not only relevant but central to our understanding of the work in question.

Wimsatt and Beardsley, however, want to define intention in terms of the work the artist has created. They justify this by pointing out that a work of art is usually defined by what it excludes as well as by what it contains (1978, p. 299). Therefore, intention must be equated with result, and we are free to deal exclusively with the latter on its own terms. If, however, pursuing some alternative chimera of intention we are driven outside the work into a morass of conflicting, incomplete, and altogether troublesome data, none of this will have critical bearing on the work of art, which, by definition, we have already claimed as the embodiment of intention.

Thus, Wimsatt and Beardsley argue, whereas a designing intellect caused the work of art to come into being, we cannot turn back and make that designing intellect (or whatever we can fathom of it) into the standard by which we interpret the work. The poem must "work" like a pudding, they claim (p. 294): all lumps have to be stirred out before the dish is served. To elaborate on their image, offering the recipe or information about the chef's past personal circumstances and present humor would not (they seem to maintain) improve the flavor of the pudding. They are eager to draw a sharp line between what they call "personal and poetic studies," between "internal and external evidence" (p. 299). Internal evidence is public and discoverable through *reading* the poem.[12]. Therefore, it is admissible, whereas external evidence (found in journals, letters, and so forth) is private and not a part of the work itself. To follow it is to be led away from the work of art and thus to make extracritical judgments that devalue the existing body of the

12. Beardsley describes what is admissible as evidence for interpreting works of art in a later paper, "The Testability of an Interpretation" (1978): "public semantic facts, the connotations and suggestions *in* poems, are the stubborn data with which the interpreter must come to terms" (p. 382, emphasis added).

work as a sufficiently rich source of immanent, consistent, suggestive meanings. To do pathography as criticism would be, for these authors, to violate the given boundaries of the work of art, to fail to respect it as a realized whole.

Wimsatt and Beardsley clearly base their anti-intentionalist protest on the grounds that to do pathography is to deprive the work of art of its special ontological status in the culture and to reduce it to a window, or to tamper with its frame, or to treat it as if it were an ordinary message. I believe it is important for psychoanalysts to confront this particular issue and to recognize that for most aestheticians and art critics, even amateurs of art, and above all for artists, the work represents an end and not a means. It is importantly bracketed or framed. Consequently, there is a necessity in doing pathography to return frequently to the work of art. For example, one must return to Leonardo's *Madonna, Child and St. Anne* to reexperience the painting in the light of Freud's hypothesis about the artist's two mothers. One must test the interpretation by seeing whether the painting looks different, whether new aspects of it come into focus, whether, in Wimsatt and Beardsley's language, it *works* differently. In this sense the anti-intentionalist argument must be taken seriously by the pathographer: his interpretations must bear the test of a second moment of aesthetic experience or he cannot claim, whatever else he may be doing, to be making critical statements about works of art.

The pathographer must also accept the anti-intentionalists' challenge to show the *coincidence* of aesthetic and psychological needs. He needs to question, for example, the relationship between the psychological and aesthetic demands that a growing piece places on the artist as he works. When a pathographer attempts to discuss intention, he must not neglect this aspect of intention—the needs, dictates, strictures, and seductions of the work of art—its form, its internal structure. He must, in short, remember that the artist is after all an artist, and that in the process of creation, the created work enters into its own dialogue with its creator.

Nevertheless, the distinction Wimsatt and Beardsley make between internal and external may be difficult to uphold. They reluctantly admit to cases in which it is hard to draw a line between the public history of a word or phrase and the usage or associations of that word for a particular author. Rebutting them, Cioffi (1978) points out that when we know something biographical about a poet, we often tend to read it into the poem; the intended meaning thus seems to inhere in the poem. Likewise, when we learn that something was *not* intended, we are apt to reject an interpretation that ignores this even though such an interpretation may previously have seemed legitimate.[13] In

13. A classic example of this phenomenon is Freud's mistaking "vulture" for "kite" in Leonardo's report of his dream (see chapter 3). Knowing that the word was mistranslated cannot

other words, what we know about a given work of art tends to become "unobtrusive" for us as regards that work (L. Stern, 1980). In Cioffi's words, "A reader's response to a work will vary with what he knows; one of the things which he knows and with which his responses will vary is what the author had in mind, or what he intended" (1978, p. 315). Cioffi goes on to make the point stressed above: namely, that the reader cannot know whether remarks are merely biographical or whether they are critical "until after [he has] read the work in the light of them.... If a critical remark fails to confirm or consolidate or transform a reader's interpretation of a work it will then become for him just evidence of something or other, perhaps the critic's obtuseness. Biographical remarks are no more prone to this fate than any others" (p. 316). Hence Cioffi attempts to collapse Wimsatt and Beardsley's distinction between internal and external evidence by translating it into the problematic distinction "between what we can and cannot be expected to know" about a given work of art (p. 311). He claims that, because art is above all a human product, "there is an implicit biographical reference in our response" to it and that this "is, if you like, part of our concept" of art (p. 318).

Furthermore, for Cioffi, as for me, interpretation arises in a heterogeneity of contexts.[14] He speaks of throwing a "field of force" around the work of art such that, once certain biographical data are known, it becomes increasingly perplexing to discern the boundaries of the work. An ontological problem arises: how we can we "appeal to the text" when its edges have become blurred? Cioffi's argument runs into difficulties, however, when it comes up against certain familiar counterexamples in which what we know about the author seems to have little or no effect on our perceptions of the work of art.

Are we justified in assuming "a necessary link between the qualities of the art work and certain states of the artist"? Tormey asks (1971, p. 350). He answers with a resounding "no" but proceeds to draw his examples exclusively from the art of music, as does Bouwsma (1954) in his paper on the theory of art as expression. Because music is perhaps the most difficult art to discuss biographically,[15] it well serves the anti-expressionists' cause. In any case,

help but affect our attitude toward the interpretation. As Cioffi says, "there are cases in which we have an interpretation which satisfies us but which we feel *depends* on certain facts being the case" (p. 311).

14. On the importance of context, see also B. Lang, 1982, p. 411. He points out that fundamental elements of style are *context-bound*, that they reveal themselves only by acting with and on other units within a fluctuating whole or context chosen by the creator and then by the audience.

15. Although I am not prepared to argue this matter here, I would point out the relatively smaller number of pathographies of composers and musicians than of writers and artists. One noteworthy pathographer working in the area of music is Stuart Feder, however, and a list of his recent works is included in the bibliography.

Tormey claims that his arguments hold for other art forms as well, and I would expect Bouwsma to claim the same. Tormey asserts:

> the expressive qualities of a work of art are logically independent of the psychological states of the artist, and humor (or sadness) in a madrigal is neither necessary nor sufficient for amusement (or despair) in a Monteverdi.... the presence of an expressive quality in a work of art is never sufficient to guarantee the presence of an analogous feeling state in the artist. (p. 358)

Tormey basis his argument in part on a distinction he draws between the transitive and intransitive uses of the term *expressive*. He points out that some performances are called "expressive," that "*espressivo*" is a common marking on musical scores, that a human face can be termed "expressive," in each case without the implication of an intentional object, without, in other words, any expectation of the further question, "of what?" His claim is that a work of art, to be expressive, need not imply a prior act of expression (p. 350), and that to conflate these two usages is the fundamental error of the Romantic theory of art. For Tormey, "acts of expression" are common to all forms of human behavior, so that to discuss art in such terms is to say something trivial at best, since it is to say nothing that distinguishes a work of art from any other product of human activity (p. 356). To say, however, that a work of art or a performance is expressive in the intransitive sense is quite different. This implies that the work or performance possesses certain aesthetic qualities our perception of which depends on our ability to discriminate among a "highly complex set of predicates and . . . their logical relations to one another" (p. 355).

Tormey offers an example in which knowledge of the personal tragedy of a composer's life "has little to do with the aesthetically relevant expressive qualities of the music itself" (p. 357). If, for example, we should discover that a composer felt anxious and humiliated at the time he wrote a certain piece, even though his music when played sounds spritely, carefree, and tuneful (often the case with Mozart), we might infer that the composer had attempted to distance himself from his pain in creating such a piece. From a psychoanalytic point of view, we might suggest that the gaiety of the music served as a defense against anxiety and depression in the composer. However, what Tormey urges is that we may not claim on that account to *hear* the music differently, to hear it as "humorous but disguisedly bitter," and so on. It is not clear, in the case of music at any rate, that, except where the music is integrated with a verbal text, extramusical information of a biographical nature can make us hear the music differently at all. What we hear when we are sensitive to music are the aesthetic qualities of a particular composition in performance.

And performance is important here, especially if, with Langer (1953), we conceive it as a "completion" of the musical work. Langer says that "real performance is as creative an act as composition . . . a logical continuation of

the composition, carrying creation through from thought to physical expression" (pp. 138, 139). Thus, she pays full homage to the "sonorous imagination" of the performer who must give "utterance" to the "conceptual imagination" of the composer. According to this view, we must extend the notion of expression to cover the feeling-states of performers. Clearly, this is untenable.[16] To say, for example, that a rendition of Tchaikovsky's Violin Concerto in D by Jascha Heifetz was more expressive than a performance of the same work by Isaac Stern is to make no psychological statement about either of the two performers. Tormey's point is that to speak about a work of art is not necessarily to speak about a man, and vice versa.

Kivy has written recently (1980) on expression in music, borrowing heavily from Bouwsma's earlier paper. Kivy quotes Bouwsma's remark that "the sadness is to the music rather [more] like the redness to the apple, than it is like the burp to the cider" (Bouwsma, 1954, p. 265). Kivy's own images of this difference in the ways we understand expression include a man with a clenched fist, and the face of a Saint Bernard dog. Commonly, we would describe the former as "angry" and the latter as "sad." Kivy argues that when we say the dog has a sad face we do not mean that its face expresses sadness in the same way in which the fist-clenching man expresses anger. He holds that when we refer to a passage in a musical composition as sad, we mean it in the former rather than in the latter sense—as a description of the feeling conveyed by the music rather than of the mental state of the composer. His thesis thus involves an effort to divorce biographical reference from musical criticism, though not absolutely, for, as he says, music *can* occasionally express genuine sadness or terror on the part of the composer. What he claims is that, generally speaking, when we characterize a piece of music as "brooding" or "spritely" we do not mean to so characterize its composer, nor do we mean that the music causes us to brood or to caper. By claiming that these qualities belong to the music, he also avoids getting into the psychology of the listener, and his position is not unlike that of Arnheim (1954) in the visual arts. Kivy offers historical, physiological, and iconographic accounts for the qualities we perceive in music that are not only possible but plausible.

Tormey, on the other hand, agrees with the pathographic viewpoint that there must be some connection between what an artist does and the expressive qualities of the work of art he produces. But like Wimsatt and Beardsley, he stresses the uniqueness of the aesthetic object and asserts that there is no simple, logical, or consistent relation between what the artist feels, thinks, knows, or does and the expressive qualities of the work. The artist, Tormey insists, is, over and above expressing himself, "making an expressive object" (1971, p. 359), an object which has the power to make others feel. This may

16. For an interesting discussion of how biographical knowledge about the composer *can* affect performance, see E. Rothstein, 1983.

involve some expression of the artist's state of mind, but to say this is scarcely to begin to address the complexity of the creative act which results in what we perceive as an "expressive" work of art.

Freud betrayed his awareness that intention alone may not provide an adequate theory of art in *The Moses of Michelangelo* (1914), where he initially claims that "it can only be the artist's intention, in so far as he has succeeded in expressing it in his work and in conveying it to us, that grips us so powerfully" (p. 212), but later concludes with doubt:

> What if we have taken too serious and profound a view of details which were nothing to the artist, details which he had introduced quite arbitrarily or for some purely formal reasons with no hidden intention behind? What if we have shared the fate of so many interpreters who have thought they saw quite clearly things which the artist did not intend either consciously or unconsciously? I cannot tell. (pp. 235–36)

There are of course two issues here: one is whether psychoanalysis can adequately account for the artist's intention, and the other is whether we must allow for aspects in a given work of art that are extraintentional, even given the psychoanalytic concept of intention, which includes far more than the artist's conscious purpose or design. If, with Wimsatt and Beardsley, we define the work of art as equivalent to the artist's intention, then we must interpret Freud's passage above to mean that psychoanalysis simply fails to give a complete account of intention, of the internal workings, dynamics, structure of the work of art. If, on the other hand, we conceive the work of art as a cultural object existing in its own space and time and continuously affected by forces outside the artist's purview (see Cioffi), then we can interpret Freud's passage as indicating his awareness, not of the limitations of psychoanalytic theory in accounting for works of art as intentional objects, but rather of its limitations vis-à-vis art seen as that which transcends intention.

Freud's equivocation has to do partly with his emphasis, in the early stages of the development of psychoanalytic theory, on the investigation of the id. Prior to 1923, with the publication of *The Ego and The Id,* which established a new direction for psychoanalytic investigation (and it is true that several of Freud's major contributions in the direct application of psychoanalysis to the arts were written in this period), the focus of his interest was on the nature of repressed wishes and drives; he saw this as the "real" material for interpretation. The countervailing forces were acknowledged, but only one side of the intrapsychic conflict was deemed important. Hence, his view of intention was strongly weighted toward id-dominated unconscious factors. Not yet having developed his structural theory into its final form, he was not interpreting from a perspective that included in fair measure the effects of id, ego, superego, and reality on behavior. Only later, with the work of Anna Freud (1936), Hartmann (1939), Rapaport (1967), and Kris (1952) was a more equal balance established.

I am suggesting that one reason for Freud's view of art as puzzling and for his at times rather baffled attitude toward it lies in part in the narrow perspective he took during the early years of the development of psychoanalytic theory (see chapter 1, above, on Wollheim and Ricoeur). In *Jensen's "Gradiva,"* he seemed to sense this:

> It may be that we have produced a complete caricature of an interpretation by introducing into an innocent work of art purposes of which its creator had no notion, and by so doing have shown once more how easy it is to find what one is looking for and what is occupying one's mind—a possibility of which the strangest examples are to be found in the history of literature. (1907, p. 91)

A few lines later, however, Freud reasserts his faith in the explanatory value of the psychoanalytic notion of unconscious intention and hence in the deterministic intentionalist theory:

> Our opinion is that the author need have known nothing of these rules and purposes, so that he could disavow them in good faith, but that nevertheless we have not discovered anything in his work that is not already in it.... He need not state these laws [of unconscious intention], nor even be clearly aware of them; as a result of the tolerance of his intelligence, they are incorporated within his creations. (pp. 91, 92)

And again he equivocates, in a famous line from *Dostoevsky and Parricide* (1928), when he exclaims: "Before the problem of the creative artist analysis must, alas, lay down its arms" (p. 177). In the same work he refers to the artist's "unanalysable gift" (p. 179).

In *Creative Writers and Day-Dreaming,* 1908, Freud again expresses his inability to explain both the creative and the aesthetic experience but also indicates his awareness of the transforming power of art. He begins by asking how the artist manages to impress us and arouse in us emotions of which we had not realized ourselves capable. He notes that querying the artist will not result in satisfactory explanations. Then he offers the following formulation:

> [The artist] creates a world of phantasy which he takes very seriously—that is, which he invests with large amounts of emotion—while separating it sharply from reality.... The unreality of the writer's imaginative world, however, has very important consequences for the technique of his art; for many things which, if they were real, could give no enjoyment, can do so in the play of phantasy. ... (p. 144)

In the remainder of this passage, previously quoted on page 14, Freud comes close to a classical view of art as imitation. He develops a connection between art and children's play, emphasizing the seriousness, the value to the child/ artist of his illusory, make-believe world. Thus, as I pointed out in chapter 1, he paves the way for some more recent psychoanalytic authors, such as

Winnicott, who have greatly elaborated on the derivation of artistic activity from childhood play.[17]

In light of Freud's shifting views, the pathographic interpreter of art may benefit from the admonition of anti-intentionalists and anti-expressionists to respect the integrity of a work of art as a consciously framed cultural object, to consider the technical and aesthetic demands this autonomous object makes on the artist (which are not necessarily traceable by depth psychology), and to bear in mind that to make statements about the the creator is not always to comment on the creation—and vice versa.

Psychoanalysis, for its part, has an obvious contribution to make to the debate on intentionalism: the notion of the dynamic unconscious. This construct significantly broadens the concept of intention. By appeal to unconscious motivation, the most apparently far-fetched intention may be attributed to an artist, his strenuous denial only serving to support rather than disprove the allegation. Theoretically, the psychoanalyst could attribute all aspects of the work of art to intention, if art is considered a psychic product. Because psychoanalytic theory offers no clearly designated limits as to what can and cannot be ascribed to unconscious intention (and each case must be treated individually), the analyst is free to press for as inclusive an interpretation as he can supply, by, for example, tracing specific imagery to universal unconscious fantasy. Interpretations of this sort cannot be refuted with the kinds of confirmatory evidence one might produce in the case of conscious intention. Hence, if we accept it, the concept of unconscious intention adds weight to the platonic claim that artists do not stand in any privileged position with respect to the criticism of their own works, even as it supports the intentionalist doctrine. I do not think, however, that psychoanalysis can bolster the intentionalist cause in any other sense than in thus expanding the kinds of intention we may expect to find embodied in works of art. For if, with Wimsatt and Beardsley, one rules out as critically irrelevant all external evidence of artistic intention, one is even less likely to be convinced by descriptions of hidden or disguised intention than by that which is openly avowed.

In the case of expressionist theories, however, psychoanalysis has somewhat more to offer. Philosophers like Tormey and Kivy, who wish to deny simple or direct relations between what, for example, a piece of music expresses and the feeling-state of its composer, are nevertheless willing to grant that *some* connection does exist. Psychoanalysis, by giving a complex account of intrapsychic processes, can contribute toward an understanding of the way in which an artist's changing moods, thoughts, and percepts are transformed

17. Bouwsma seems to understand this derivation too, for he says: "In art the world is born afresh, but the travail of the artist may have had its beginnings in children's play" (1954, p. 265).

in the process of creation into what finally emerges in the completed work of art.[18]

THE ELEMENTS OF PATHOGRAPHIC INTERPRETATION

Pathography has contributed to Romantic criticism by partially fulfilling its tacit promise to penetrate more deeply than any previous approach into the psyche of the artist. Abrams, in summarizing Romantic criticism, has referred to the work of art as the "combined product of the [artist's] perceptions, thoughts, and feelings." Psychoanalytic theory, not content with superficial description, offers a multidimensional account of these mental processes, in terms of their genesis and interactions, and in so doing goes far beyond conventional Romantic discussions. In the best examples of pathographic literature, three major psychoanalytic viewpoints are carefully developed and interwoven. These are (1) the genetic or developmental viewpoint; (2) the dynamic, structural, and economic viewpoints, which are interdependent; and (3) the adaptive viewpoint. I shall briefly summarize these perspectives here, but their contributions to the interpretative process will become clearer in chapter 3, where specific examples from the literature are examined.

The developmental perspective sees all human behavior as richly colored and heavily determined by early life experience. In writing on artists, therefore, the pathographer will stress such developmental themes as the nature of the subject's primary relationships to mother, father, and siblings, as well as early experiences of trauma—especially loss, including fantasized loss, fear of loss—and reparative fantasies. A fundamental concept in psychoanalytic theory is that the human psyche never "gives up" anything; what is lost is, in fact, not lost but retained in another form, substituted for by something else. This notion is especially important when we are interested in tracing the transformations that occur in an artist's mind with respect to the derivation of his imagery. The pathographer will assume that the most persistent themes and imagery with which an artist is preoccupied ultimately derive, though in endlessly changing forms, from the first five or six years of life.

According to classical psychoanalytic theory, the vicissitudes of the sexual, aggressive, and self-preserving instincts follow an inner timetable of psychosexual stages through which all human beings, irrespective of time and place, period and culture, must pass to reach maturity. These instincts or drives are acted upon by, and respond to, both facilitating and obstructive environmental factors, primary among which are, of course, the child's parents, the so-called primary objects. Through a complex and highly idiosyncratic sequence of partial and more complete introjections and identifications, these first objects are gradually internalized by the child. Eventually, just prior

18. For an excellent discussion of these issues, see Kris, 1952.

to and during the oedipal stage (Freud, 1923, p. 34), at about the age of five or six years, aspects of these internalized objects coalesce into a relatively stable structure[19]—the superego (Sandler, 1960; Sandler, Holder, and Meers, 1963), with its counterpart, the ego ideal—which then functions to regulate the balance of pleasure and guilt. In order to gain some understanding of the artist's psyche, therefore, the pathographer must attempt to reconstruct a developmental history in such terms, ideally tracing the tortuous paths of the various instincts as they were once expressed in terms of impulses, aims, and objects, through their transformations in the oral, anal, phallic, and genital stages of development.

The task is intricate, and I have risked oversimplification by sketching it schematically. Within each stage there is variability of aim so that, for example, in a visually oriented child who might later develop into an artist, the oral-incorporative motive might be displaced onto looking (note the ordinary expression "he devoured it with his eyes"), as might the anal-sadistic motive ("a killing look"), or the phallic ("a penetrating glance"). Roy Schafer (1970) points out that, in trying to understand how disturbances or distortions of the function of looking come about (see also Freud, 1910, on the psychogenic disturbance of vision), we must inquire into "the latent *meaning* of looking. We would say that having taken on the significance of certain drive activities and gratifications, looking was being dealt with as if it [were] these very activities and gratifications—*which, in psychic reality, it is*" (p. 439). Likewise, and perhaps more obviously, there is often variability of objects. The most apparent example of this is fetishism, in which various objects may take the place of a fantasized maternal phallus (Freud, 1927). In addition to variation by displacement, substitution, reaction-formation, and so on, there are fixations of both the aims and objects of the drives at one level or another.

Thus, the complex web of behavior patterns, coping strategies, and subjective experience that constitutes a person's character or personality[20] is seen largely as the outcome of compromises made in dynamic response to the unfolding of the drives. Such a model as this, highly simplified, is central to the interpretative work of the pathographer. In other words, with respect to

19. It is important to note the divergence from this view on the part of Melanie Klein and her followers, who trace the formation of the superego to the first year of life and derive it from anxiety accompanying infantile oral sadism (see Isaacs, 1929; Klein, 1933; Glover, 1930).

20. As will be elaborated in chapter 4, there is a great deal of recent work on character stemming from infant observation, which stresses factors omitted above, particularly difference in constitutional endowment in such areas as activity level, thresholds of response, and intensity of reactions. Note especially Escalona, 1963; Korner, 1964; Metcalf, 1977; and the ongoing research of Chess and Thomas. In their studies of artists, pathographers often omit factors such as these because of their relative inaccessibility; however, in a full account they should be included. It would be interesting to see whether the research on infant observation corroborates Greenacre's theory (summarized below).

developmental issues, he or she will be particularly concerned with (1) reconstruction of the artist's early childhood experience and fantasies; (2) analysis of drives and drive derivatives as they evolve according to the predetermined sequence of psychosexual stages, with whatever variations or blocks are introduced by the environment; and (3) the oedipal constellation as a focal point, the developmental stage during which, according to classical theory, the fundamental, permanent character traits are laid down in the psyche.

Two authors in particular have made outstanding contributions to the developmental approach to understanding artistic creativity. Foremost is Phyllis Greenacre (1971), whose papers in this area include both pathographic and theoretical studies on selected aspects of an artist's life and work. Her classic article on the childhood of the artist makes a number of points that bear directly on issues under consideration here.

Greenacre, citing her indebtedness to Kris, stresses the centrality in the lives of artists, as well as of unusually creative persons in many fields, of the so-called family romance (Freud, 1909). This fantasy, in which the child's real parents are replaced by noble and exalted ones, is created defensively out of the child's developmental need to decathect the parents in the postoedipal stage, to punish them for their sexuality, and to return in imagination to the halcyon, relatively guilt-free days of the preoedipal period. Both Freud and Greenacre make the point that family romances and related fantasies of being chosen or special seem to flourish in the minds of highly gifted and imaginative persons and deeply imprint their lives. Meyer Schapiro (1956), in his critique of Freud's *Leonardo,* discusses the meaning of Leonardo's memory of the bird who flew down to him in his cradle and struck him on the mouth with its tail, specifically relating this story to numerous "myths" in which the fortunes of a genius are foretold by some omen or episode from childhood. Greenacre stresses the pathographer's need to be aware that fantasies of this sort frequently shape and distort the self-representations of artists as they occur later in the form of journals, letters, autobiographies, and works of art. Furthermore, such fantasies may later find expression in noms de plume and in the artist's search for, and stormy dependent relationships with, his patrons (Greenacre, 1971, p. 495).

Remarking on the well-known fact that artistic talent may be variously present in a child prodigy and then rapidly deteriorate, or show in promising early growth that gradually flowers, or occur in a late-blooming version that does not appear until advanced adolescence or adulthood. Greenacre divides the early-developing talents into three further categories: (1) those in whom "a spontaneous, rapid unfolding of the inner demanding pressure for unusual growth [is] in some way inherent in the child himself" (p. 488); (2) "those in whom the prodigy performance is mainly the result of the demands of adults, usually the parents," in their effort to use the child to satisfy some frustrated ambitions of their own (p. 488); and (3) "those in whom the

remarkable performance is the result of neurotic conflict" (p. 488). In Freud's work and that of many pathographers, it is the last etiology that is stressed, often to the exclusion of the other phenomena outlined by Greenacre. Constitutional endowment and direct environmental influence are, however, heavily relied on by nonpsychoanalytic biographers, so that a case could be made that the pathographer, in order to mark his territory, chooses psychic conflict, the area relatively ignored by other authors.

Greenacre's major contribution to the developmental approach involves her hypothesis that artistically gifted children are endowed with a more intense sensitivity to sensory stimulation, so that their experience with the primary object (the mother) widens out to include a greater field of sensory impressions than is the case for less gifted infants:

> To illustrate this with a hypothetical example, we might conceive that the potentially gifted infant would react to the mother's breast with an intensity of the impression of warmth, smell, moisture, the feel of the texture of the skin, and the vision of the roundness of form, according to the time and the situation of the experience—but more than might be true in the less potentially gifted infant. Such an infant would also react more widely and more intensely to any similar smells, touch or taste sensations or visions of rounded form which might come his way. (p. 489)

Her name for this extended range of experience is "collective alternates" (pp. 490, 494), and the term connotes her sense that such experience, though originating in the infant's relationship to the primary object, may become detached and substitutive. She speaks of this extension as a "love affair with the world" (p. 490) and considers it an indispensable facet of the development of artistic talent. She points out that such collective alternate relationships may adversely affect an artist's capacity to form and maintain enduring, stable object relations in the more usual sense by offering him a kind of freedom (which in turn must bring its own thralldom). She suggests that a gifted two-year-old undergoing toilet training, for example, might turn imaginatively to mud or clay or dough, thus diluting or altering the meaning of the developmental task. She suggests that the availability of such collective alternates produces in the gifted child a fluidity whereby developmental stages shade into one another and do not possess the fixity or abruptness they may have for the less artistic child. If, according to Greenacre's theory, gifted children may solve their problems in the oedipal phase less decisively and indeed seem in some cases to bypass them through recourse to their collective alternates, then certain well-known behavioral characteristics of some artists, such as erratic love relationships, alcoholism, and marked bisexual strivings, might be better explained.

Greenacre emphasizes the aggressive component of artistic creativity along with its libidinal aspects. She sharply distinguishes her position from those

who see the creative process in terms of "neutralization" (p. 500), and in so doing, I think, parts company with Kris. In Greenacre's view, because of the unusual development of the artist as she has described it, artistic activity "may carry the whole gamut of mixed libidinal phase pressures, genital and pre-genital, more diffused and with wider and deeper range than is true in the less gifted person" (p. 499). She speaks also of the work of art as a "love gift" (p. 490) on the part of the artist and believes that there are serious limitations to the approach that would derive artistic creation from narcissism alone. Her theory, which emphasizes the artist's "predisposition to an em-pathy of wider range and deeper vibration" (p. 485) than the ordinary, points toward object-relations theory and to a perspective compatible with Win-nicott's (see chapters 1 and 5).

Another major contributor to the developmental approach in pathography is William G. Niederland (1967), whose theory, like Greenacre's, is drawn from clinical experience in the analysis of artists. Niederland links creative activity to reparative efforts after loss, proposing that "a permanent and usually severe injury to infantile narcissism" (p. 7) is common to artists and gives rise to a relentless but vain effort to reconstitute the damaged or lost body part, congenital defect, or pseudo-object relationship. (He extends the meaning of narcissistic loss to include this last category on the ground that, in the early symbiotic stage, the primary object is experienced as part of the infant's own body and supplies narcissistic replenishment; hence, in the case of early infancy, Niederland believes that it may not be valid to distinguish between narcissistic and object love—though of course Freud (1914) at-tempted to do so by means of the term *anaclitic*.[21] It seems reasonable to assume that any child who has experienced early loss of whatever type will be sensitized to later occurrences that evoke it. Niederland's point is that such early loss drives the artist to "a constant search for rebirth via a kind of magical, reparative transformation" (p. 13).

Although his language is given to hyperbole and his claims too inclusive, Niederland's views are well worth considering. Superficially disagreeing with Greenacre's position that innate endowment is primary and that creativity cannot be considered as a transformation of narcissism, he persuasively argues that subjective body-ego experiences deriving from infancy contribute sig-nificantly to creative activity. Illustrating his work with clinical examples, he demonstrates that the felt experience of the artist's body, with its particular discrepancies and distortions often involving focal zones of hypo- and hy-

21. In "On Narcissism" (1914), Freud distinguishes four types of narcissistically derived object choice from another type, the "anaclitic," which is not based on identification but derived, rather, from the infant's earliest needs for food and protection. This distinction has been widely challenged. On this hotly debated issue of primary narcissism or infantile autism, see chapter 5, where I summarize D. Stern's (1983) recent infant research.

percathexis enters into both process and product. He is concerned with the artist's subjective experience of the body-ego while actually painting, for example, as well as with the artistic expression of fantasies woven around such derivative themes as birth injuries and rebirth. I maintain that his disagreement with Greenacre is superficial because, though his theoretical formulations differ in emphasis, his findings generally corroborate hers. Both stress the importance of intensely cathected sensory modes stemming from infancy, Niederland seeing the reparative effort or striving for wholeness as focal whereas Greenacre presents a picture of the artist's development that emphasizes the fluidity of libidinal stages arising from heightened bodily sensitivity from birth.

To support his theory, Niederland parades before us an array of artists in many media who suffered serious defects, injury, illness, or loss in their early years, including Byron, Keats, Chopin, Toulouse-Lautrec, Mozart, and Hugo. He quotes an artist-protagonist in Thomas Mann's *Royal Highness* as follows: " 'My health is delicate. I dare not say unfortunately, for I am convinced that *my talent is inseparably connected with bodily infirmity*' " (p. 32). Such examples do not explain creativity, of course, for infantile loss, even in a limited sense, includes persons who do not on that account become artists. However, they reveal Niederland's continuation, in psychoanalytic terms, of the Romantic theory of art. Though limited, Niederland's theory enriches our understanding of at least some of the wellsprings that impel artists to create.

The second viewpoint the pathographer contributes to the analysis of art combines dynamic, structural, and economic aspects. Works of art are seen as the outcome of conflicting energic forces, as the result of compromises among these forces. The issue is to define the terms of the compromise, to elaborate on Keble's perceptions about the artist's need to express certain things that he cannot permit himself to say or do openly. Using Freud's understanding of the several defense mechanisms secondary to repression, as well as of regression to the different stages of psychosexual functioning, the pathographer attempts to pinpoint specific areas of intrapsychic conflict and to trace such conflict to (and from) its expression in certain aspects of the artist's work. Although in each compromise there are multiple factors (Waelder, 1936) drawn from the psychic structures, types of energy involved, mechanisms in play (A. Freud, 1936), and developmental stage predominating, the pathographer tends to emphasize drives over ego in his work, taking Freud's original work in applied psychoanalysis (1910) as his model.

An exquisite example of the way in which psychoanalytic theory refines the understanding of Romantic theory and makes good its claim to probe the psyche of the artist more fully is Edmund Bergler's work on sublimation (1945). Bergler, decrying earlier formulations of this rather murky but central psychoanalytic notion about the acceptable transformations and externalizations of intrapsychic conflict, begins by pointing out that Freud defined

sublimation as the desexualization and transformation of libidinal wishes into socially approved channels. He adds, however, that although Freud stressed the equal importance of the aggressive instincts in his later writings, he failed to revise his theory of sublimation to include them. In Bergler's formulation, on the other hand, aggression plays a significant role. Further, he calls attention to the fact that sublimation has been variously considered both an erotic trend that persists in altered form and a defense mechanism. In short, Bergler deplores the simplistic and confused manner in which he feels that this concept, so vital to an understanding of how art comes about, has been treated by his colleagues in the literature. He suggests, by way of example, that Freud's characterization of Leonardo's Mona Lisa and *Madonna, Child and St. Anne* as subliminated expressions of the infantile gratification once afforded the artist by his mother and stepmother is simplistic and facile, a "direct translation," as he puts it, "of a desexualized id wish into sublimation" (1945, p. 79).

For such simple, direct, and idyllic notions of sublimation, which, I have suggested, grew initially out of the Romantic tradition, Bergler seeks to substitute a more complex theory. Claiming that the process of sublimation is at once "more dramatic and tortuous" (p. 80) than was previously thought, he proposes a five-layer structure that includes the component of aggression. Returning to Freud's *Leonardo*, he posits that

> Leonardo had a preoedipal *aggressive* conflict with his mother which resulted in the defense mechanism of homosexuality. [Thus] in his madonnas he did not express the direct continuation of the mother's love but rather the defensive denial of her *lack of love*. The sublimation represented not the loving mother, but the defense against the hating and damaging mother to whom he was masochistically attached and whose aggression he tried to nullify because it was a narcissistic injury. He executed his hatred of his mother in his homosexuality— and repaired his mortified narcissism in his madonnas who loved the child. At the same time by thus warding off her hatred and sublimating the secondary defense, he denied his own masochistic attachment toward her. (p. 81)

Without going into the question of the precise nature of Leonardo's pathology and the debates concerning it (which will discussed in the next chapter), the point Bergler emphasizes is that what has been taken for the original drive may be the result of an even deeper one. He thus evokes the fecund image of a palimpsest with its partially erased layers revealing ever earlier representations. For me, this image is somehow central to the psychoanalytic enterprise itself, with the proviso that one may never reach the bottom layer.

Bergler's five strata include first the starting point, which is itself the result of conflict, not an id wish but the result of regression in response to an id wish. This conflict is then counteracted by a reproach on the part of the superego (second layer), which gives rise to the establishment of a defense mechanism (third layer), which is in turn reproved by the superego (fourth

layer), which finally causes the unconscious ego to sublimate (fifth layer), thus establishing a secondary defense or a defense against defense (pp. 81–82). Illustrating this model with a number of examples drawn from his clinical practice, Bergler initiates us into the depths of "depth psychology" as it is plumbed by what he calls the "analytic microscope" (p. 96). He claims that "what is sublimated is neither the id wish nor the defense against the id wish, but the defense against the defense against a conflict originating historically in an id wish. Sublimation is therefore not the child but the modified grand-child of the original conflict" (p. 97). Thus he reminds us that what we see when we look at an artist's work may be far more complex in its relation to that artist's psyche than we might at first suppose. Therefore, the value of Bergler's work for the pathographer who approaches art from a dynamic, structural, and economic perspective is that, at best, he offers a useful par-adigm for the sublimating processes, and at least serves as a corrective or deterrent to those who would risk facile translations of drive into behavior or of mind into art.

The third viewpoint, the adaptive or constructive mode, is little stressed by pathographers, again because Freud's work is taken as principal model. Adaptation involves twin notions: (1) that the creation of works enables an artist, through a process of release and satisfaction (Kris, 1952, p. 317), to adjust to or endure his internal and external environment; and (2) that the creation of works of art serves also to transform the environment itself in myriad ways so as to make it more viable—to bring it into conformity, that is, with intrapsychic needs. Since, according to classical psychoanalytic theory, there is a given amount of psychic energy, adaptation as a function of the ego is considered to be relatively more available to artists whose ego energies are less bound in defensive maneuvers of various sorts (Hartmann, 1958), who are, in other words, *relatively* free of intrapsychic conflict. Although artists whose productivity can be seen as arising from the conflict-free sphere of ego functioning (Hartmann, 1939) are rarely chosen as the subjects of patho-graphic studies, the adaptive approach to pathography is nevertheless at least theoretically possible.

The three pathographic perspectives, developmental, dynamic, and adap-tive, are clearly not undertaken sequentially by the pathographer any more than the mind grows in discrete segments. Furthermore, the pathographer's task is immeasurably complicated by the problematic nature of the data to which such a theoretical structure must be applied. Also, as was noted in chapter 1, Freud sees an important and close connection between art and dreams; thus, the pathographer following Freud will often have recourse to technique and theory derived from the interpretation of dreams. He will therefore utilize such notions as the mechanisms of primary-process men-tation (that is, the mobility of cathexes via displacement, condensation, re-versal, identification, and so on), and well as universal dream symbolization.

To summarize, what the pathographer contributes to Romantic criticism is a complex system for explaining the nature and origin of those combined perceptions, thoughts, and feelings that are incorporated in a work of art. He explores the multiple determination of these psychic functions, and he does so largely by reconstructing the artist's early childhood years, supporting his hypotheses by appeal to repetition and to the scope of material for which any one hypothesis can account. He demonstrates, in other words, the nature of the artist's individual underlying intrapsychic conflicts by tracing their reappearance, albeit in disguised and distorted forms, in successive works throughout the artist's oeuvre. He attempts, likewise, to derive the artist's percepts, choices, and solutions from these conflicts and from the compromise formations to which they give rise. His expectation is that there will be an ongoing presence of such motifs, and his effort will be to get as much explanatory mileage out of such material as he reasonably can.

Before going on to suggest some of the limitations inherent in this model of psychoanalytic interpretation, it seems pertinent to ask whether a pathographic interpretation is meaningful only to an audience that is predisposed to accept psychoanalytic theory. My own conviction is that pathographic interpretation can in fact be meaningful to a much wider audience.

I have suggested, citing Kris, that modern artists and audiences are in some sense denizens of a psychoanalytic world, that we have assimilated much that is central to the psychoanalytic point of view. That this is so is not refuted by the observation that when psychoanalytic theory is brought to our attention we frequently object not only to specific aspects of the theory, but also to its applications. The reasons for this may be that, as Freud was wont to point out, as individuals we are certainly not free of unconscious resistance, and that the theory itself is by no means unassailable; to accept its general perspective is not to relinquish the capacity for rational criticism. Thus, in our own era, for reasons elaborated earlier, psychoanalytic interpretations of art, pathographic or otherwise, have the potential to be deeply meaningful even to those who are formally unacquainted with or skeptical of either the theory of psychoanalysis or its use in therapeutic practice.

THE LIMITS OF THE PATHOGRAPHIC MODEL

What are the limitations of this psychoanalytic approach to art? What sorts of questions does it fail to address? What issues does it raise but only partially succeed in comprehending?

Pathography, although it represents an advance over other forms of biographical interpretation in helping us to fathom the workings of the artist's mind, ultimately fails to solve its own implicit problem. It never completely succeeds in showing us how it is that the transformation actually occurs, how it is that what is in the mind becomes the finished work of art: the *Last*

Supper, *The Possessed*, the Sistine Chapel ceiling, *Le Jockey perdu*. Freud did not, it is true, claim that he could do this, and in fact he explicitly said he could not. Nevertheless, this is obviously the hoped-for outcome of studying the artist's psyche at all. I have intimated that one way of explaining this limitation is to see pathography as dealing well with regressive and derivative trends in the artist and less well with the adaptive, constructive, and progressive facets. A pathographer will, for example, be more adept at explaining the etiology of Van Gogh's intrapyschic disturbance than at helping us to grasp what it was that enabled this artist to paint at all, to continue painting, to paint with such brilliance, originality, and passion, to paint pictures that continue to live and to be loved a hundred years after they were created.

Pathography presents an artist-as-patient paradigm of psychoanalytic interpretation. It assumes that creative activity does not represent for the artist a real "working through" of basic conflict. This assumption permits the pathographer to search for the continuing presence of certain themes throughout the artist's oeuvre. Thus, he is committed to a view that works of art do not represent solutions to unconscious conflict or, if they do, that such solutions can have only temporary therapeutic value for the artist. This view severely limits the pathographer's capacity to deal with aspects of creating that are relatively conflict-free and prejudices him in favor of the Romantic notion of the artist as deeply troubled, as limited in some way. John Hospers (1959, pp. 353–59) has argued that such a position may be due to a lack of reflection on the values implicit in psychoanalytic constructs such as "adjustment," "cure," and "mental health." He points out that "much that is valuable and important in human achievement [would] go down the drain with what is unproductive and wasteful" (p. 357) if we espouse in practice such narrow norms for human behavior as are implicit in some psychoanalytic definitions of the normal versus the pathological.

Pathography does not sufficiently take into account the countertransferential aspects of the interpretative process. Although the author of a pathographic interpretation must make a series of critical choices, beginning with the choice of artist and works to be studied, frequently he or she does not examine these choices, does not reflect on the factors that determine them, fails to consider that such factors must also serve to delimit the direction of the ensuing work. In clinical practice, on the other hand, such factors are in principle analyzed as countertransferential material, and a consideration of their contaminating effects constitutes an integral part of a good analysis. Since this is rarely the case in works of pathography, one is forced to conclude that pathographic interpretations frequently involve considerable "reading-in," finding "what one is looking for and what is occupying one's own mind," to quote Freud himself (1907, p. 91).[22]

22. By contrast, Barchilon, in his psychoanalytic study of Camus's *The Fall*, insists on going beyond what one is looking for, since "no matter how closely an analyst has understood,

However intricately the methodology is applied, pathography reduces the work of art to a projective phenomenon; thus it fails to deal with those aspects of the artist's intention that arise in response to the reality of the developing work itself, which has an existence in a medium, in a tradition, and in a reality external to the psyche of the artist. Perhaps this critique falls under the heading of adaptation and should be joined with the first and second points above. Certainly the artist's responses to the dictates of his medium and to the growing form of his piece constitute adaptive activity and must be counted as functions of the ego. I want to suggest further, however, that by dealing with the work of art as he does, the pathographer fails to treat it in its aspect as a part of external reality. He fails to see that the work represents not only an endopsychic (autoplastic) solution but an ectopsychic (alloplastic) one, that the work is not a fantasy but a real thing, out in the world for others to see, hear, read, and react to. The stone, the oboe, the wood grain, the sonnet form all dictate to the artist and determine aspects of his expression. Object-relations theorists such as Winnicott have addressed this problem, and I shall return to their views in Chapter 5.

Pathography involves highly complex theoretical schemata. The problem is compounded when the artist is no longer alive and has not in fact been analyzed by the pathographer. In studying an artist who inhabited a distant time and place, the pathographer is not entitled to treat him like a "sitting duck" for various standard psychoanalytic maneuvers. He is obliged to do the requisite homework, to make judicious use of all the knowledge that can be absorbed of the cultural, social, political, and economic history of the artist's lifetime as well as the stylistic and iconographic traditions of the period. How the pathographer goes about sifting and sorting such material is highly problematic; it constitutes the methodology of pathography, which varies from author to author. It can range from a fictive to an almost documentary to a thematic approach, and I shall explore these modes in the next chapter. In any case, the ultimate purpose of conducting such research is not merely to generate further data, the works of art themselves presumably constituting the primary data, but to provide a facsimile of *context*—that constant shared environment between analyst and analysand which is indispensable to psychoanalytic work. To attempt a psychoanalytic interpretation of the Maestà panels by Duccio, the engravings of Hogarth, the woodcuts of Dürer, the aquatints of Goya, without conducting such a major research project would quite possibly be to commit a series of embarrassing blunders.

This last point leads to the complex question of how truth enters into

formulated, and even predicted what a patient's hidden core neurosis might be—its final meaning, form and resolution are so uniquely personal as to be truly unpredictable—unvariably the details of those core factors *come as a surprise*. More often than not, the spontaneity of the surprise itself is a reliable indicator of their truth and validity" (1971, p. 237).

matters of interpretation.[23] How important is it, for example, to do voluminous research when, after all, we may feel that Freud's *Leonardo*, despite its inaccuracies, incompleteness, and distortions of data, leaves us with a certain sense of satisfaction and completeness, as both Farrell (1963) and Schapiro (1956) attest in spite of their severe criticisms? Freud's study compels us to look at several of Leonardo's paintings in new ways, forces us to raise questions about the artist and his works that had not arisen under more traditional approaches to the same material. Freud's interpretation, though patently false in some of its details and fuzzy in others, seems to address directly our quest, our hunger for the uniquely personal elements of this extraordinary artist's style and imagery. It provides us with a coherent, consistent narrative, a good story. But is this enough? Is coherent pattern-making all we demand from interpretation, psychoanalytic or otherwise? Are we after coherence or correspondence, narrative or historical truth (see Spence, 1982)? Can we have it both ways? Can we preserve the speculative, imaginative freedom of the one model while joining it to the careful, critical scrutiny of the other? This would seem to represent a pathographic ideal: a union of discovery and creation.

23. See Putnam, 1982, for a persuasive argument against the modern analytic philosophers who believe "that the problem of truth, if there ever was one, has been solved" (p.35).

3

Pathography in Practice

April is the cruellest month, breeding
Lilacs out of the dead land, mixing
Memory and desire
—T. S. Eliot, "The Waste Land"

The context for interpretation in pathography always consists of the artist's life (insofar as it can be known through whatever research is available to the author) plus the corpus of his works, but authors' needs or motives for interpretation may vary widely, resulting in quite different endproducts, ranging from what I shall call the *fictive* to the *documentary* to the *thematic*. The three examples of pathographic interpretation that follow illustrate these modes. The first, Freud's *Leonardo da Vinci and a Memory of His Childhood* (1910), remains the touchstone for all subsequent endeavors of this kind. Liebert's *Michelangelo: A Psychanalytic Study of the Man and His Images* (1983) is somewhat more ambitious in scope and hence raises additional and interesting methodological issues. Finally, Martha Wolfenstein's unfinished manuscript (forthcoming) on René Magritte organizes this artist's protean surrealist imagery around a single powerful theme, that of parental loss in childhood. Each example deals with the oeuvre of a visual artist as interpreted by a psychoanalyst/author who is a stranger to his or her subject, separated in the first two cases by centuries of history and culture and in the latter case by geography and again culture.

According to Laurent Stern (1980), we must recognize in discussing any interpretative mode the necessity for identifying a context, a need, and an audience. In pathography the context clearly consists of both the work(s) of art and what can be known of the artist's psyche; the audience, as I have argued, is, broadly speaking, modern in that psychoanalytic narratives of all types are generally accessible to a wide public today. But what about the need to interpret? This is the most perplexing aspect of pathography. Applied psychoanalysis lacks a presenting complaint that might serve as a starting

point or touchstone for intrapsychic interpretation. Likewise, if we compare biblical exegesis with the psychoanalytic interpretation of dreams, we note that interpretation seems to be prompted by absences or lacunae in the texts, missing words or sentences that create incongruous juxtapositions. How do such considerations relate to absent artists and finished works of art? How does the pathographer specifically identify his need to interpret?

I have suggested earlier that the pathographer *creates* his own version of a presenting complaint or *finds* gaps that call for psychoanalytic interpretation. Freud, for example, stipulated three presenting complaints: Leonardo's grad-ual turning away from artistic to scientific pursuits; his inability to work quickly, decisively, and to finish certain projects; and his manifest inability or refusal to have sexual relationships with women. One drawback of an approach such as this is that to make up "complaints" for the artist/patient is to impose an order on the given material, to prejudge it in a way that might reflect more of the interpreter's own biases, values, and needs than is valid and that must undoubtedly prejudice what he sees, experiences, and reports. Also, to formulate such complaints or problems is to approach the material aggressively, which contradicts Freud's own recommendation that analysts maintain an evenly hovering and free-floating attention (1912, p. 112); it is to predetermine the story that will be told rather than to hear fully the story that is being told. Furthermore, to find gaps and inconsistencies in finely crafted works of art is more difficult than to do so with dreams, random associations, or the remnants of ancient texts. This is partly by definition: we expect fully realized works of art not to exhibit such gaps, or, if they do, to exhibit them for a purpose consonant with the works seen sui generis, that is, aesthetically. Hence, if the pathographer cannot legitimately start from selected aspects of the artist's manifest behavior (for fear of countertransfer-ential contamination) or from the works of art themselves (without failing to see them as works of art), where is he to begin?

In presenting the work of three pathographers who have struggled with such problems, I have no hope of scrutinizing them in all their rich and varied detail. Rather, my purpose in each case is to characterize the approach in question and to indicate both its distinctive contribution to the interdis-ciplinary dialogue and the limitations peculiar to it.

FREUD'S LEONARDO AND THE FICTIVE APPROACH

Since its publication three-quarters of a century ago, Freud's *Leonardo da Vinci and a Memory of His Childhood* has provoked an inordinate amount of criticism and countercriticism. Even at the time of its appearance, Strachey remarks in his introduction to the English translation in the Standard Edition, "the book seems to have been greeted with more than the usual amount of disapproval, and Freud was evidently justified in defending himself in ad-

vance" (p. 60). This controversial book represents, however, Freud's only systematic effort to present a psychoanalytic study of a visual artist and his work and, hence, stands as paradigmatic for pathography. It is therefore important to reconsider *Leonardo* in spite of, as well as in light of, all that has been said about it.

Freud begins by asking why Leonardo's contemporaries failed to understand his personality (p. 164) even though by all accounts the artist was a charming and handsome man who cultivated his many talents according to the custom of the time. Freud tenders the answer that, as Leonardo began to spend more of his energies on scientific researches and less on his art, his contemporaries must have felt that he was "frittering away his time when he could have been industriously painting to order and becoming rich" (p. 65). Because the evidence Freud adduces for such remarks is scant at best, I suggest that we consider them in light of inconsistencies in Freud's own researches and the lack of positive reception to *his* work in the years preceding 1910 (see Jones, 1955). We see gradually that the point of view he offers regarding the relative merits of the ways in which Leonardo used his time is not only projected onto the artist's contemporaries but is in fact Freud's own opinion. Once assumed, this viewpoint, together with its implicit value judgments, supplies the raison d'être for much of the interpretation that follows.

Freud goes on to ask why Leonardo worked so slowly and had the habit of leaving his work unfinished (pp. 66–67); why he, master draftsman and painter that he was, abandoned his art at a certain point and turned ever more intensely to his scientific researches and to an interest in flight—concerns that strongly suggested to Freud a regressive symptomatology. Further questions include the genesis of Leonardo's alleged homosexuality and the idiosyncrasies of some of the master's paintings, in particular the enigmatic smile of the Mona Lisa and the choice of theme and composition of the *Madonna, Child and St. Anne.*

Momentarily setting these questions aside, I should like to call into question Freud's original choice of subject. One can assume on a fundamental level that Freud undertook his work because he was fascinated by, identified with, or admired Leonardo. In fact he says as much himself, though couching it in general terms and projecting it onto his critics: "biographers are fixated on their heroes in a quite special way. In many cases they have chosen their hero as the subject of their studies because—for reasons of their personal emotional life—they have felt a special affection for him from the very first" (p. 130). Freud goes on to object that such hero-worship causes idealization of the subject and a sacrifice of truth to illusion. What he fails to say here is that if such motives are present, if, as he claims, the biographer seeks to recapitulate with his subject the special relationship of awe and love he once felt for his own father, then surely the opposite motives may be present in

equal measure—namely, envy, aggression, and the impulse to destroy and replace. We are justified on Freud's own terms in asking whether such unconscious oedipal motives played a part in determining some of his judgments concerning Leonardo's maladaptive behaviors.

In fact, again operating from within Freud's own theoretical framework, the disclaimer that opens his *Leonardo* supports an interpretation of this sort. He writes:

> When psychiatric research, normally content to draw on frailer men for its material, approaches one who is among the greatest of the human race, it is not doing so for the reasons so frequently ascribed to it by laymen. "To blacken the radiant and drag the sublime into the dust" *is no part of its purpose.* (p. 63, emphasis added)

I submit that this need for denial in the first lines of the book, with the analysis that follows, may indicate the presence in Freud of motives, in this case, that perhaps both libidinized and aggressivized his own search for truth.

Further, near the end of the book, Freud demurs a moment about the validity of his conclusions while in the same breath revealing a resonance between himself and his subject—that is, he seems to defend against an identification with Leonardo by casting last-minute doubts on the whole enterprise:

> I shall reply that I am far from overestimating the certainty of these results. Like others I have succumbed to the attractions of this great and mysterious man, in whose nature one seems to detect powerful instinctual passions which can nevertheless only express themselves in so remarkably subdued a manner. (p. 134)

The juxtaposition translates into: I am not sure I can trust my results here because of the intensity of my own fascination with this man who in certain respects reminds me of myself. Freud does not, however, take this any further to explore both the negative and positive aspects of identification and empathy in interpretation.

What I suggest is that Freud based his work quite heavily on a methodology founded on unanalyzed countertransference plus the ad hoc application (and creation) of new theory. In lieu of the meticulous reconstruction that characterizes his clinical case presentations, he offers here what might be classified as an example of the "wild" analysis which, that same year (1910), he himself was to describe and deplore. Further, despite (and also because of) Freud's fascination with Leonardo, the major function of his book is not to make a contribution to our understanding of this particular artist and his works but rather to use both artist and works to illustrate aspects of psychoanalytic theory with which Freud was struggling at that time: the theories of narcissism and of a type of male homosexuality derived from an early identification with the mother that subsequently develops into narcissistic object choices.

The work therefore possesses a coherence, but one that stems from motives quite apart from aesthetic questions, from issues of Renaissance history, contemporary beliefs, customs, or artistic traditions. I am joined in this general assessment, though for other reasons, by Schapiro:

> Where Freud has misinterpreted Leonardo, and he admits more than once in his book how speculative his attempt is, it was in part because he ignored or misread certain facts. His false conclusions do not imply that psychoanalytic theory is wrong; the book on Leonardo, a brilliant *jeu d'esprit*, is no real test of this theory, which here has been faultily applied. (1956, p. 336)

Brian Farrell (1963) sees the book as exemplifying in simplified form the narrative explanations with which psychoanalysis is concerned. He is aware both of the serious problems of countertransference ("For the analyst will see in the material the sort of thing he is on the look-out for," p. 268, and "If we are ready to use these narratives, we have to use them with a care and detachment that is difficult for us to achieve and maintain," p. 273), and of the fact that "what Freud has difficulty in dealing with are Leonardo's intellectual and aesthetic interests, the range and the variety of his work" (p. 257). Wollheim too is of this general opinion, claiming that Freud's *Leonardo* is above all "a study in psychoanalytic biography" (1974, p. 205), and that "both in the original draft and in the final essay the feature most emphasized by Freud in Leonardo's works is certainly not an aesthetic feature" (p. 208). Peter Fuller concurs: "Psychoanalytically, the Leonardo text is of theoretical significance.... Nonetheless, it is pretty well useless from the point of view of aesthetics" (1980, pp. 39–40).

These authors generally feel that the problem stems from Freud's fundamental concern with the man, with life, rather than with art. Schapiro locates the difficulty principally in Freud's lack of knowledge of art, both its criticism and its history, in the "too little attention given to history and the social situation in dealing with individuals and even with the origin of customs, beliefs, and institutions" (1956, p. 335). My emphasis, by contrast, is on the problem of intentionality in the pathographer and on the complex ways in which his own motives and needs may become conflated with those attributed to the subject of interpretation (an issue that will be discussed further in Chapter 5 below).

The problem exists in clinical psychoanalysis as well, but its dimensions are quite different, a fact that is revealed by Farrell's four criteria to help clinicians evaluate their interpretations (1963, pp. 259–60): (1) the interpretation will appear repeatedly in the material brought up in the course of the analysis; (2) the interpretation will serve to tie material together and thus "ring true"; (3) it will be consistent with what is discovered about the patient during the analysis; and (4) it will help to develop the course of the analysis, proving in the long run to facilitate, not obstruct, the process. In the analysis

of a live patient producing new associations, the analyst can be "guided by a tentative, developing, and perhaps not even expressly formulated narrative" (p. 261), and he will rely on this fresh material as a guide for selecting among possible interpretations.

Farrell's argument is that the first three criteria are weak in that they might be satisfied by any number of alternatives and provide no way of judging among them. The crucial point in the fourth criterion is that, clearly, within a live human relationship, particularly in a clinical context which is highly suggestive, emotionally intense, and disorganizing to the patient, interpretation produces response—in fact, conditions response—and thereby profoundly alters subsequent data. If this were not the case, psychoanalysis could not "work" at all; but it is precisely this internal dynamic between analyst and analysand that constitutes the privileged arena of clinical psychoanalysis and its special claims on truth and value. By contrast, the applied psychoanalyst is dependent on relatively fixed data, is deprived of this opportunity to evaluate in transitu the results of alternative hypotheses; consequently, his interpretations are bound to be "wilder," more vulnerable to the vicissitudes of the countertransference, more rigid, and more open to attack by the skeptic.

The counterargument could be made that it is misguided to draw so heavy a line between clinical and applied psychoanalysis. This viewpoint would have it that one cannot legitimately differentiate among texts according to their interpretability, that, in other words, one can interpret equally a person's spoken words and a written record, a patient, a poem, and a painting. The assumption here is that because psychoanalytic theory postulates the unconscious as the ultimate source of all psychic productions, any and all of its representations are grist for the mill, equally capable of being mined for buried meanings. Dialogue is present in the relation between interpreter and text irrespective of the manifest nature of the text: There are, in other words, no privileged psychic texts.

This argument, however, does little to resolve the question of what in applied psychoanalysis constitutes a particular author's motive or "need" to interpret. According to Stern

> we will understand better the various senses of "interpretation" if we consider the interpreting activity always within the context of a *need to interpret*. It may be claimed that we interpret only if there is a need to interpret and that the interpreting activity is always dependent upon an overt or covert purpose, goal, or intention. (1980, p. 119, emphasis added)

The clinician, presented with human suffering of whatever magnitude, can define need intersubjectively in terms of the therapeutic and validate a given hypothesis on the basis of its therapeutic outcomes, even though this leaves open a range of interpretative possibilities. By contrast, for the pathographer confronted with a work of art, a personal moment of aesthetic pleasure, or

multiple accounts of the details of an artist's life history, the actual "need to interpret" is certainly more nebulous, perhaps even gratuitous. (Hampshire, 1952, argues that in ethics choices lead to action, whereas in aesthetics they do not; hence he considers aesthetic choices to be "gratuitous.")

Perhaps I have been able to do no more than question the authorial intentions imbedded in the text, but if it is possible that personal intentions or agendas have been conflated with those of the subject, then a measure of caution and skepticism is needed in considering the next issue: whether and how Freud has illuminated the relationship between the artist and his work. The questions Freud poses as he develops his narrative (why did Leonardo gradually abandon his art and turn ever more intensely to his scientific researches? why did he work so slowly and have the habit of leaving work unfinished? what was the genesis of his alleged homosexuality? and how can we explain certain characteristics of two particular paintings?) clearly place the artist in the position of a patient with certain maladaptive behaviors that call for psychoanalytic explanation. Freud does not question the bases of his judgments as to what might or might not have been maladaptive for Leonardo. He is not concerned with re-creating a framework into which Leonardo's life and work can be set, a framework which, as suggested in chapter 2 above, might serve as a counterpart for that privileged space that develops between analyst and analysand and as a corrective for misreadings. Rather, *Leonardo* assumes (1) the absolute reliability of the author, in the absence of dialogue with the (deceased) artist; (2) the power of the interpreter to move confidently from manifest to latent content in the absence of associations and live transference; and (3) the equations of works of art with ordinary symptoms or dreams as if they were transparencies through which primary process could be read rather than unusually complex compromise formations (see Bergler), in which specific unconscious meanings can be glimpsed only dimly and often only after they have been subject to a series of filters that minimally establish perimeters for interpretation.

There are many arguments against these assumptions in the specific form they take in Freud's narrative. Setting aside the methodological problems (e.g., the inexactitudes noted by many critics, particularly by Schapiro), the incompleteness of data (Freud considers only two of Leonardo's paintings in detail, dismissing major masterpieces with a phrase and ignoring others, as well as volumes of drawings, notebooks, etc.), misinterpretation of data (the misconstrual of "vulture" for "kite," with all the sequelae of differential symbolic meaning), and distortion of data (for example, Freud's construction from one screen memory and a few disputed legal documents of a full-blown affective picture of Leonardo's infancy that assumes pathogenic maternal tenderness as a compensation for paternal deprivation), it is not at all clear, for instance, that Leonardo's working habits need be attributed to "inhibitions in [his] sexual life" (Freud, 1910, p. 131). It is conceivable that a mind

of genius may generate ideas in such profusion that completion loses its ordinary value under the pressure of competing images. Even less gifted minds have experienced this phenomenon during periods of extraordinary creativity.

Likewise, as Freud himself acknowledges, though only as an "excuse" (p. 66), the question of when a painting is finished is surely one of the most delicate of artistic problems. Who shall decide when a painting is completed? Is the Mona Lisa any less complete visually than, say, a Pollock, a Whistler, a Turner, a Gilbert Stuart or any other Leonardo? To walk through any museum is to see paintings whose completion is debatable. This is perhaps one reason Schapiro has warned us that, if Freud is to claim that psychoanalysis can reveal factors which call forth genius and determine the subject matters it must choose, he is thereby compelled to "risk some judgments about the qualities of single works of art.... To construct his picture of Leonardo's spiritual fortunes, Freud, we have seen, must become a critic of art and commit himself to judgments about the better and worse in the painter's career" (1956, p. 335).

Again, a value judgment is implied when Freud explains Leonardo's turning from artistic creation to scientific researches by the statement that "his infantile past had gained control over him" (p. 133). Leaving aside as fairly obvious Farrell's argument about necessary and sufficient conditions (1963, pp. 238–39), Freud's statement seems presumptuous in that it implies that one sort of activity is somehow more exalted than another or would have been better for Leonardo. Would Freud have taken kindly to the thought of posthumous ex cathedra judgments about the order, scope, and form of his own creative activities? Such a statement also presupposes a split between the so-called scientific and the so-called artistic realms, which may have considerably more meaning in the twentieth century than it had in Leonardo's time. Surely Freud was aware of the tradition of painting and drawing as a way of knowing, as a mode of exploring, as a record of what has been learned; even a cursory acquaintance with Leonardo's notebooks indicates that for this artist the domains of art and science were intimately entwined. If Freud was not opaque to this possibility, why did he not develop it rather than choose to see only a pathogenic opposition between the trends?

Such questions point to serious flaws endemic to Freud's approach. Chief among these is the issue of undetected, unchecked transferences or "reading in" to the material on the part of the analyst who does not have any system of safeguards built into his methodology. As noted above, Schapiro is confident that greater knowledge of art history, his own discipline, could serve as a control for wild speculation. I am suggesting further that, along with such knowledge, which would provide a shared context between pathographer and subject, there must also be an active process of self-scrutiny, introspection, "observing ego," a measuring of distance on the part of the pathographer. Clearly empathy is an indispensable factor in any kind of

interpretative work. My intent is not to eliminate it but to recognize and regulate it or rather to ensure that the pathographer himself is sensitive to its far-reaching effects on his project. What changes in the course of a successful analysis is the awareness, the perceptions, and the insights of the analysand. In good pathography the interpreting process may change the sensitivities of the interpreter; this cannot happen if he finds only what he is looking for.

Farrell has noted that "the educational and professional background we bring with us" plus a host of other factors will determine whether or not we accept Freud's account of Leonardo's intrapsychic organization and development (1963, p. 272). Whatever our level of acceptance or doubt, however, we are bound to acknowledge the attraction, intrigue, and influence Freud's story has exerted on several generations of distinguished psychoanalysts, art historians, and philosophers.

By enumerating aspects of Leonardo's adult functioning that he considers aberrant at the outset, Freud gives us what I have called a dynamic/structural/economic picture, a picture of intrapsychic organization. Freud attributes Leonardo's slowness to inhibition and derives both his sexual abstinence ("Leonardo represented the cool repudiation of sexuality," [p. 69]) and his penchant for scientific investigation from the sublimation of libido into a passionate curiosity that, because of its unconscious dynamic roots, gradually overwhelmed other aspects of Leonardo's life, particularly his interest in painting ("he took up his brush with reluctance, painted less and less, left what he had begun for the most part unfinished and cared little for the ultimate fate of his works," [p. 66]). The economic aspect of the picture is the notion that, given a fixed quantum of sexual energy, Leonardo's was directed into investigation and not into more usual physical outlets. The dynamic part of the picture is harder to construct because, as Bergler (1945) points out in his critique, Freud focuses almost exclusively on the vicissitudes of instinctual drive and neglects to discuss the part played by the defenses. It is important to remember that Freud had not by 1910 developed either his structural model of the mind or his dual-instinct theory, so that the roles played by the ego and superego, as well as by aggression, are slighted in his picture. In fact, had the piece been reworked by Freud in light of later developments in psychoanalytic theory, it might have been more complex and possibly more satisfying to those critics who regard it as reductionistic.

Freud next offers a reconstruction of Leonardo's developmental history to illustrate his central conviction that the adult psychic structure can be largely derived from infantile sexuality and its fortunes. He begins with Leonardo's childhood memory, recorded in the scientific notebooks, of a bird who flew down to his cradle when he was an infant and " 'opened my mouth with its tail, and struck me many times with its tail against my lips' " (p. 82). Freud proposes that this story should be seen not as an actual memory but rather

as a fantasy or "screen memory," masking an earlier experience of the passive pleasures of being suckled at his mother's breast and transformed in the adult into a disguised homosexual wish. Much has been written about Freud's blunder in mistaking the species of the bird (see Schapiro, 1956, and Eissler, 1961, for claims and counterclaims); what is important is whether the intrapsychic interpretation holds up or crumbles when "vulture" is read as "kite" (*nibbio* in the Italian). Freud actually gets a lot of mileage out of his "vulture," linking this bird, who according to legend could be inseminated by the wind, with the absence of Leonardo's father in his infancy. Freud develops the narrative along the lines that the young artist was, in this state of paternal deprivation, "seduced" by his mother and remained erotically attached to her image as the preoedipal mother. It is to this "history" that Freud attributes the blissful smile not only of the Mona Lisa but also of several androgynous figures represented in Leonardo's other paintings, such as the *Bacchus* and *St. John the Baptist*, as well as Leonardo's tender representations of the mother and child theme (see, for example, *The Madonna of the Rocks*).

Another element in the narrative is introduced by the fact that Leonardo's father, after impregnating a local peasant girl, Caterina, and siring the illegitimate Leonardo, married a young woman who remained childless. From the most meager evidence—a single document that lists the five-year-old Leonardo as a member of his father's household—Freud speculates that the child experienced two mothers: "first, his true mother Caterina, from whom he was torn away when he was between three and five, and then a young and tender stepmother, his father's wife, Donna Albiera" (p. 113), which is a rather extraordinary conclusion considering our lack of evidence. For example, might we not, alternatively, assume that the stepmother was cold, jealous, and vindictive toward the child, thus further impeding normal oedipal development and intensifying his attachment to and longing for the all-good early mother of infancy? Or, as was proposed by James Beck in a recent study group on art history and psychoanalysis (APA, December 15, 1982, New York), that Leonardo did in fact experience two "mothers," but that these were not his real mother and stepmother but, rather, his stepmother and his paternal grandmother, who, as it is known, lived with the family? The possible variations are manifold (see Bergler, 1945). At any rate, from his version of the story, Freud interprets the choice of subject and composition of Leonardo's painting of the *Madonna, Child and St. Anne*. He claims that the two women represent Leonardo's two mothers and that they are shown condensed "into a composite unity" (p. 113), the biological mother being represented by St. Anne, who is portrayed as further away from the child, her blissful smile serving to mask her envy toward her rival. In fact, the strange quality of the Leonardesque smile is traced by Freud not only to Caterina's ambivalence between love and envy but also to Leonardo's, for, to him, his mother's passionate caresses served as a curse as well as a blessing, binding him to her

in a way that, according to Freud's interpretation, prevented him from ever attaining mature heterosexual genital development.

What Freud gives us in *Leonardo* is indisputably a narrative of extraordinary inner consistency. It is also beautifully written, a facet that I have not been able to capture in the above summary. Hence it possesses a quality that we experience as aesthetic and to which we can respond emotionally. Even Schapiro acknowledges its "beautiful simplicity and vigor" (1956, p. 303). Since it lacks a scrupulous cognizance of the facts, however, I have chosen to call this sort of interpretation "fictive," for although it is an important document of psychoanalytic theory, I believe that, with respect to Leonardo da Vinci, it must be viewed as essentially a work of fiction. It may tell us something about Leonardo's relationship to his work, but in most respects—his interest in flight and in science, for example, and their ultimate derivation from sexual wishes—it tells us something that is much less important than Freud seems to have thought; if the derivation is correct, it tells us very little about Leonardo in particular, and if it is false it of course tells us nothing.

Why, then, has this work been so influential? As Farrell indicates, the story Freud gives us is of a special kind, namely, that of a "simplified case study" (1963, p. 274), a narrative that is "very like the usual, full story that analysts and others produce about a patient. By examining it, therefore, we are able to come to grips with the complicated problem presented by the narratives used in the diagnosis and treatment of mental disorder . . . it exhibits their character" (p. 275). But what sort of narrative is this? Donald Spence (1982) helps here by defining psychoanalytic interpretation as the telling of a coherent, comprehensive story that, he argues, may possess a species of "narrative truth" that can be quite independent of historical reality. Drawing heavily on the pioneering work of Schafer (1980) in this area, he claims that psychoanalytic interpretations ought rightly to be seen as constructions rather than as reconstructions. He holds that Freud's image of the psychoanalyst as archaeologist, uncovering buried strata of the past, bringing to light "kernels of truth" (p. 27), is both misleading and false.

Spence argues that the more amorphous, incomplete, and discontinuous the material to be dealt with, the greater need the analyst will feel to interpret, to make sense of, to structure it. Thus, the more formless the patient's associations, the more inconsistent the historical records, the more enigmatic the works of art, the more active and constructive an effort is required on the part of an interpreter. This view, which emphasizes the intrinsic qualities of the interpretative narrative—its capacity, for example, to dramatize experience in such a way as to make it more accessible to a reader—and de-emphasizes its correspondence with any objective historical account, sheds light on the value and appeal of Freud's *Leonardo*. Spence unabashedly compares psychoanalytic interpreters to artists: "an interpretation can be seen as a kind of artistic product, and as such, it becomes possible to consider its effect on the patient as a kind

of aesthetic experience. What might be called its 'beauty' need have no necessary relation to its 'truth' " (p. 37). Such a model resonates with the need of some readers to know why and when and how an artist struggles, triumphs, and fails, and to expect an answer that will possess continuity and what Spence calls "an aesthetic finality" (p. 31). Whatever truth Freud's *Leonardo* possesses is expressed in the following passage by Spence:

> Narrative truth is what we have in mind when we say that such and such is a good story, that a given explanation carries conviction, that *one* solution to a mystery must be true. Once a given construction has acquired narrative truth, it becomes just as real as any other kind of truth; this new reality becomes a significant part of the psychoanalytic experience. (p. 31)

Thus, I have called Freud's approach "fictive," not in a derogatory sense, but to emphasize its special qualities as an imaginative piece of interpretative writing that serves to raise, if it does not fully answer, intimate and searching questions about Leonardo and his work. Whatever relationship it bears to Leonardo's real intentions, above all it offers us a design, a "seamless web of belief" (Spence, 1982; Quine and Ullian, 1970).

Because Freud saw art only as a psychic product, such authentic dimensions of Leonardo's works as their physical properties obviously held no interest for him; however, by carefully studying the works as bridges to the mind that created them, he reveals aspects of them that may enter into our aesthetic experience. After reading his book we are more sensitive, for instance, to the relationships expressed in the triadic *Madonna, Child and St. Anne*; we are sensitized to its latent drama, its ambivalence, which may resonate with our own unconscious fantasies. After reading Freud's study it is difficult to view this painting without thinking of the two mothers and rehearsing the story Freud has told. Somehow, as Spence suggests, it tends to take on the status of truth and to become an inseparable part of the experience of the painting. Stern (1980) offers a term for this phenomenon: he says that in such a case the interpretation becomes "unobtrusive," blending with all our other perceptions of the work of art. Likewise, I think, Freud enriches our reading of the Mona Lisa by tying her smile to smiles remembered and felt in the earliest months of life, smiles that beckon to us across the years and are never entirely forgotten or outgrown.

LIEBERT AND THE DOCUMENTARY APPROACH

Robert Liebert's recent work (1977–83),[1] a psychoanalytic study of Michelangelo and his imagery, presents us with an alternative to Freud's model

1. Although Liebert's work has been expanded into book form (Yale University Press, 1983), I have based my remarks also on his published papers and recent lectures, which are cited in the bibliography.

of pathography. Obviously, there are strong similarities between the two approaches, though my focus here is clearly on the disjunction they exhibit. In the seventy-odd years since the publication of Freud's *Leonardo* both psychoanalytic theory and the cultural milieu have undergone significant change, and such change is reflected in the differences between them in both methodology and goals.[2]

In Liebert's work, for example, there is a shift in focus from the presumed pathology of the artist to the corpus of his work, which is seen not as evidence to support a diagnosis but as the major datum for the interpretation of which all other relevant facts and hypotheses must be mustered. Liebert, therefore, represents a shift within pathography from the Romantic, expressive, artist-centered mode of interpretation still in vogue in Freud's day to the critical mode of our era, in which the primacy of the work of art is stressed and the artist's intentions, manifest and latent, become important only insofar as they illuminate particular works.

Liebert's study reflects meticulous scholarship. Whereas, as is now generally accepted even by Freud's staunchest apologists, the data in *Leonardo* were often selected arbitrarily, misinterpreted, and distorted, Liebert has heeded Meyer Schapiro's warning against the vanity of psychoanalytic endeavors to explain an artist's stylistic qualities, thematic content, and overall evolution by inferences about the nature of his character structure and early conflicts without due regard for history, contemporary beliefs, customs, and artistic traditions. Liebert has grounded the speculative aspects of his work on data amassed from a rich variety of sources, including contemporary biographies, the artist's letters and poems, other personal documents, and drawings; on a thorough acquaintance with Michelangelo's oeuvre and that of contemporary and earlier Florentine masters; and on aspects of the iconographic .tradition, especially the incorporation of mythological themes and their classical representations into the matrix of the Renaissance artistic repertoire. He has created something more substantial than a projective myth, and for want of a better term I have chosen to call it a "documentary" approach to pathography.

To avoid incompleteness, misinterpretation, and distortion (though obviously we are dealing in degrees because these cannot be altogether absent from any such work), Liebert has submitted his data to a number of relevant systems of interpretation before subjecting it to the psychoanalytic microscope. Further, he has made consistent efforts to integrate the historical, cultural, and iconographic contexts of Michelangelo's life with his psychoanalytic narrative. For him, the meticulous examination of massive data is a

2. In the discussion that follows it may not be apparent that Liebert makes use of more recent psychoanalytic theory, especially issues raised about art by both ego psychologists and object-relations theorists. My emphasis, however, will lie elsewhere.

prerequisite for the construction of hypotheses. He is thus concerned with "correspondence truth"; he seeks to tell a story that not only possesses internal consistency but tallies with the facts as they are known.

This more complex task raises a host of methodological questions. How, for example, does the psychoanalytic viewpoint serve to complement other systems of interpretation through which data must be filtered? In other words, how precisely can we integrate the psychoanalytic frame of reference with the historical, cultural, and so on if these systems of interpretation are not merely additive? Can conflicts of interpretation arise? If so, on what grounds do we assign weight to one system of interpretation over another? At what point do we feel satisfied with a rendition or a version?[3] Is fiction distinguishable from history only by degrees, or is the process of interpretation more like that of a mother teaching her child the meanings of words than like that of a scientist explaining to a student the cause of a phenomenon (Shapiro, 1970)? How is "making up" a story different from recounting a story, or are there multiple stories, all of which involve some recording and some inventing?

Psychoanalysis is concerned with psychic reality, with meaningful rather than causal relationships between past and present. Freud learned before the advent of this century that patients may have memories of events that could not possibly have occurred; thus, what is important for psychoanalytic interpretation is "reconstructing the psychical reality of the child rather than the material reality or the events that had transpired in the child's life" (Michels, 1983, p. 130). Yet, it is precisely these events that color and shape the internal unfolding of drives and wishes. In the case of applied psychoanalysis, which lacks the primary data of free association and live transference, it could be argued that an accurate and comprehensive knowledge of these external events provides the only reliable context obtainable. Surely there is no hope of capturing in interpretation the psychic reality of the child/artist without a thorough immersion in his milieu, an immersion that Liebert provides in his study of Michelangelo. To be immersed in the milieu is of course no guarantee of a true story, but it provides the interpreter with both opportunities and restraints.

There is a sense in which one could oppose Liebert's work to Freud's as an example of truth-seeking rather than pattern-making, correspondence not coherence, the historical not the narrative. I wish, however, to make a somewhat different point: that by doing careful research and approaching the historical milieu Liebert has possibly, in the absence of the usual psychoanalytic data, afforded us a more plausible and less contaminated picture of his

3. For example, one of the excellences of Freud's *Leonardo* is that, in spite of inaccuracies, it does stimulate new questions about the artist and his works by applying a new system of interpretation.

subject's psychic reality than Freud has of Leonardo. In other words, although "psychoanalysis discovered that the meanings that individuals create from events can be far more significant than the events that serve as stimuli for those meanings" (Michels, 1983, p. 142), the pathographer is dependent on knowledge of such external events and all that surrounds them in order to approach intrapsychic meaning. The alternatives are the "wild" application of theoretical constructs and the unmonitored emotional responses of the analyst to a subject's material.

Although it is impossible to convey here the power of Liebert's work, which depends for its effect on abundant evidence and the repetition of themes, his general method can be characterized by the fact that, above all the spotlight shines on the corpus of the artist's work. When questions are raised about Michelangelo's relationship with, say, Lorenzo de' Medici, Pope Julius II, or Tommaso de' Cavalieri, they are subordinate to a primary concern with the sculptures and paintings, because the major aim of the study is to make sense of the artist's imagery in terms of its distinctive and personal meaning to the artist and its effect on the viewer.

Liebert's most remarkable contribution consists of tracing the themes and motifs the artist chooses to borrow from the work of earlier artists. Although this tracing of figure-types, poses, and other stylistic idiosyncrasies to their sources in antiquity has been, at least since Panofsky, the staple of iconographic research in art history, Liebert examines Michelangelo's choices from a psychodynamic viewpoint, demonstrating that the artist's particular selections make sense not only culturally and intellectually but also in terms of his own intrapsychic themes. Liebert points out that Michelangelo, as part of a tradition that sponsored the adaptation and reworking of classical art, was able to put this convention to work for himself psychically by co-opting a series of acceptable symbolic forms for the expression of forbidden unconscious wishes.

In treating Michangelo's madonnas, sculptures for the tomb of Julius II, and pietàs, Liebert traces as many interrelationships as possible among formal, thematic, affective, and iconographic elements, and then both erects on and draws from this substructure of broad-based evidence his psychoanalytic hypotheses. An especially effective example is his interpretation of the *Doni tondo*.

I have had occasion to introduce students to the *Doni tondo* and have found that the painting, which has always haunted me as an anomaly among the great madonnas of the high Renaissance, also troubled my students. Discussions of the separate levels of space, the oddity of the pagan male nudes relaxing on the parapet, the muscular madonna of "humility" in her ambiguous relation to the Christ child, the coexistence of classical and Christian motifs, and so forth, did not suffice to unify the disparate elements of this painting under an interpretation that seemed adequate. Liebert, drawing on

Michelangelo's early life experience as well as on his daily life at the time he painted this madonna, offers an interpretative structure that unifies the perceptual, emotional, and intellectual dissonances of the painting. Moreover, the details of Liebert's analysis enable us to focus on areas that might previously have remained obscure or unnoticed.

Liebert's argument rests on the central assumption that, although we can draw only very limited conclusions from the fact that an artist treats a theme that was popular in his time, we can stand on much surer ground if we study his iconographic sources:

> by locating the earliest source from which he derived aspects of the form of his own later creations, we have a promising starting point for understanding the distinctive and innovative qualities of his art. This is particularly true when the narrative of the early source is entirely different from the theme of his later derivative work. It has been my assumption that when Michelangelo was drawn to a specific antique work as a source for his artistic solution, it was not simply because of the magnificence and suitability of the antique image. It was, in addition, because the narrative theme of the early work deeply touched dominant unconscious themes in Michelangelo which made it compelling as a model. Moreover, the conflict in the original work was sufficiently disturbing that he was impelled to master the anxiety inherent in the conflict by transposing it into a theme that was manifestly quite different. (Liebert, 1979, p. 522)

Thus Liebert assumes and seeks to demonstrate that the specific form of Michelangelo's work, form in the sense of representational choices, was determined not simply by visual or aesthetic needs but by compelling unconscious needs. This assumption and the test case of the *Doni tondo* focus on an issue raised earlier: namely, what is the relation in works of art between aesthetic needs and intrapsychic needs? Do they necessarily converge in works we take to be masterpieces? Perhaps to entertain this issue would take us into the labyrinth of normative aesthetics, value, and critical judgment, as Meyer Schapiro warned it eventually would. At any rate, I hope to bear this question in mind while reviewing Liebert's argument concerning the unconscious factors in Michelangelo's aesthetic choices.

Liebert begins with a visual description of the painting, focusing on perceived inconsistencies or gaps, not merely between one part of the work and another, but between this work and its contemporary counterparts. From these incongruities he derives his need to interpret. Clearly such a beginning presupposes both careful scrutiny of the painting as primary datum and detailed knowledge of its context in several dimensions. In an oscillatory manner, Liebert brings to bear upon the painting his understanding of the artist's psychic reality, and the painting, by yielding to his interpretations, corroborates this understanding.

What are these inconsistencies noted by the pathographer? The *Doni tondo*, Michelangelo's only painted madonna, includes: (1) a sharp division of the

picture space into three areas; (2) in the most distant of these areas, five androgynous male nudes who appear to be engaging in homoerotic play; (3) a muscular and also androgynous-appearing madonna whose arm for the first time in Renaissance history is completely bare, clearly displaying her biceps; (4) the ambiguous gesture with which she either receives or rejects the Christ child, who "mounts her shoulder like a trumphant Olympian" (p. 484); (5) the figure of Joseph, who is probably derived from ancient portraits of Euripides (p. 485); (6) the presence in the middle distance of the child St. John, who, separated from both the Holy Family and the background nudes, echoes in his tilted head and faraway expression the countenance of the madonna.

Like Freud, Liebert provides for his subject both a picture of intrapsychic organization and a developmental reconstruction. Central to the latter is the theme of early separation from the mother followed by actual loss. Michelangelo, the second of five sons, was boarded with a wet nurse, as was the custom with infants of his class in late fifteenth-century Florence, probably until the age of two and then returned to his family. His mother died when he was six years old (p. 469), and his father remarried when the artist was ten. Michelangelo's stepmother, who bore no children, died when he was twenty-two years of age (p. 469). Liebert recognizes that these facts are minimal, and he confronts the problem of ascertaining their psychic meaning by turning to the artist's works. He notes, however, that even by the standards of the day Michelangelo's childhood was marked by unusual trauma and by abrupt loss and inconstant care during the most vulnerable years, and that, consequently, there is reason to expect that derivatives of such early trauma will find expression later on.

Liebert traces the overall composition of the *Doni tondo* to a serenely composed Signorelli madonna painted ten years earlier in Florence, in which the pictorial space is likewise divided into sectors. The distal plane in the Signorelli is also inhabited by semi-nude young shepherds, whose presence, however, unlike that of Michelangelo's nudes, is justified by the iconography of the nativity. Thus, in Signorelli's rendering, the different spatial sectors are thematically unified. Michelangelo's nudes, on the other hand, have no obvious connection with the madonna. It has been suggested that they are sinners—homosexuals—awaiting redemption (p. 484). If so, they stand "in direct moral antithesis" to the madonna and hence contribute to our sense of incongruity in the painting. As Liebert remarks, "in a manner that is characteristic, Michelangelo draws directly from an earlier model and then repudiates the inspiration by radically transforming the meaning of the orig- inal form." (p. 484).

Similarly, the source of the "Doni" madonna herself is, curiously, a relief of the *Satyr with the Infant Dionysus*, a tondo in marble that stood in the Medici palace, where Michelangelo spent two years in his teens under the

protection and patronage of Lorenzo the Magnificent. Liebert points out striking similarities between the figures of satyr and madonna, infant Dionysus and infant Christ, particularly their poses, the body being Michelangelo's chosen expressive vehicle. He asks why Michelangelo co-opted as a model for this Christian theme of the relationship between mother and child a representation of the pagan myth of Dionysus, and seeks in rehearsing the details of that myth to explore its possible connections with Michelangelo's unconscious fantasy.

In retelling the myth, Liebert highlights its similarities to Michelangelo's own life history. Dionysus was, for example, abandoned by his mother, who died while was still in utero, and by his surrogate mother, Ino—both women victims of the vengeful wrath of the ever-jealous Hera. Michelangelo was also deprived of two mothering figures. Dionysus, born of the thigh of Zeus, into which the fetus had been implanted after being rescued from the womb of the dead mother, thus experienced an androgynous birth and a subsequent bisexual identification. This was accentuated by his upbringing under the tutelage of the debauched satyr Silenus and his band of followers. Likewise, "Michelangelo lived in his all-male immediate family and then moved for the rest of his life from one to another male, mentors at first, and patron-protectors later" (p. 492). Liebert speculates that Lorenzo may in Michelangelo's youthful fantasy have taken on the characteristics of unitary, bisexual parent (p. 493), as had Silenus in the myth of Dionysus.

I cannot here rehearse all the complexities of Liebert's discussion, but I want to follow some of the ways in which his line of argument helps illuminate the dissonances and ambiguities of the painting. For example, when we notice that the gesture of the madonna is unclear with respect to the child (is she handing him back to Joseph or taking him into her own lap?), we can understand it in terms of Michelangelo's conflicted feelings about mothering figures. Children who have experienced the death of a parent commonly feel intense rage over what seems to them in their infantile narcissism to be willful abandonment, a punishment for their own aggressive feelings. (In the later episodes from the myth of Dionysus, the god's generalized rage against all women is dramatized, as in Euripides's *The Bacchae*.) Hence the disturbing quality of the madonna's pose, as well as her hermaphroditic appearance, is illuminated by reference to the artist's troubled early developmental history and its proliferation in powerful unconscious fantasy which then dictated artistic choice.

Another anomaly in the painting is the figure of the child St. John, who is separated from the family group by what appears to be a wall. In contemporary renderings, for example the madonnas of Bellini and Raphael, the two children usually play together under the tender gaze of the madonna. Again, Liebert asks how the narrative of the life of St. John the Baptist may perhaps have resonated with Michelangelo's unconscious fantasy, causing him

to paint the child in this unusual manner, as a lonely, outcast figure. From the saint's legend, which Liebert takes from the apocryphal literature and which, like the myth of Dionysus, was surely well known to the literate Michelangelo, it becomes apparent that John, who abandoned his parents at the age of seven to live a solitary life of religious devotion in the desert, makes an appropriate (partial) self-representation for the artist. Responding to the universal fear of parental loss and abandonment, this child mastered his anxiety by turning passive into active and in fact exchanging his mortal parents for a life of devotion to the divine (p. 498). Liebert speculates that Michelangelo, not only in response to the realities of his earlier losses but in his later tendency to lead a life of lonely self-sufficiency and wandering, felt a particular kinship with this saint. Further, Liebert points out that just as Dionysus spent years of his later life fleeing Hera's murderous rage, so St. John met his fate at the command of the murderous Queen Herodias, through the offices of her daughter Salome. Thus, both stories develop the theme of maternal abandonment and destructive rage, unconscious motifs that powerfully determined aspects of Michelangelo's artistic and lived experience.

As for the division of the painting into three discrete segments, Liebert compares it to the structure of dreams, the divisions of which often enable the dreamer to play out several self-representations in the guise of different characters, settings, or events (pp. 495–96). In the foreground plane of the painting, Michelangelo has represented under the rubric of "holy family" both maternal ambivalence and gender conflation, and evoked the manifold resonances of the Dionysus story, through the reworking of figure poses from an earlier work and through the portrayal of Joseph in the image of Euripides (p. 495), chief dramatist of the later years of the life of Dionysus. The middle distance, as mentioned, represents Michelangelo's identification with St. John the Baptist in his youth as the excluded child, "the outsider, unnoticed by the parental figures, who are totally engrossed with the other baby" (p. 496). If, as the records show, Michelangelo's mother bore three more sons after him, then, that he felt usurped and upstaged is certainly plausible, especially when added to the wet nursing and reinforced so soon by his mother's untimely death.

In order to understand the meaning to Michelangelo of the distal plane, Liebert points out that "John's mission in the wilderness illustrates the dynamic in the young child and adolescent where the choice of seclusion and penitence effectively functions as a defense against impulses of destructive rage toward the parents" (p. 499). However, this "solution" to the problem did not work in the case of St. John, for, as we know, he ended up beheaded by command of a dreaded queen mother (p. 503). Therefore, an alternative solution is proposed, and this is what is represented in the distal plane of the *Doni tondo*: a world without females. The androgynous youths who inhabit this space have internalized and "become" in some sense the females

they need (p. 503). Hence this section of the painting represents a homosexual adaptation to the problems evoked in the other areas of the painting. The frightened and excluded child escapes into a homosexual environment—a masterful strode in Liebert's interpretation—yet even this solution is doomed. It is generally believed that Michelangelo abstained from acting out homosexual impulses in his daily life, and perhaps, Liebert suggests, the reason is adumbrated here. He points to the three youths on the right: two seem to be embracing as lovers, whereas the third, slightly separated from them, tugs jealously on the cloak of one of the pair. Liebert speculates that perhaps Michelangelo's sense of himself as the excluded and rejected child was so powerful throughout his life that even in homosexual relationships he feared he would succumb to this earlier and tragic fate.

Earlier I stated that in applied psychoanalysis we must approach inner meanings through knowledge of external circumstances. This is not to say that knowledge of the latter necessarily leads to that of the former: to know the territory is not necessarily to know the precise path the explorer took or why he took it, but *not* to know the territory or to know it only partially or to have false information of it would prejudice the task immensely. I have called Liebert's work "documentary" precisely because he has acquainted himself with the necessary documents; he has, if you will, traversed the territory.

Denis Dutton, in his recent paper on intentionalism (1982), makes the point à propos of authorial intentions that we should allow in court only those meanings that could have been intended by the particular artist in question, not the meanings that could have been intended by anybody (p. 13). I believe that Liebert establishes such parameters. If, for instance, it could be shown that the documents indicating that Michelangelo's mother died in his early childhood were false, that the relief of Dionysus had been placed in the Medici palace long after Michelangelo could possibly have seen it, and so on, Liebert's interpretation of the *Doni tondo* would lose considerable force. The psychoanalytic interpretation depends in this case upon the validity of the scholarship that underlies it. Arthur Danto (1981) makes a similar point when he speaks of "deep" and "surface" interpretation, claiming that the latter must have done its work before the former can be undertaken. If psychoanalytic interpretation is to point authentically back to its object rather than to itself, if it is to make contributions to our understanding of cultural phenomena and carry weight with respect to the objects it purports to interpret and not refer solipsistically to its own conceptual purview, it must be grounded in a marriage of sound scholarship with perceptual acuity and rich imaginative and empathic capacities on the part of the interpreter.

It is clear from Liebert's analysis of the *Doni tondo* that unconscious libidinal and aggressive needs, as well as the need to master conflict, may influence an artist's aesthetic choices. I say "influence" here and not "determine," for, just

as the *Doni tondo* is a magnificent painting, an unforgettable composition of images, so one could easily imagine a counterexample: a painting entirely determined by similar unconscious motives that did *not* work, that in fact appeared brutal or confused or redundant. Therefore, to grasp something of the intrapsychic fantasy informing the imagery of a painting such as the *Doni tondo* is to grasp that which is exquisitely relevant and which, in this case, affords a means of comprehending much that formerly seemed obscure, eccentric, even inexplicable. It is not, however, to unlock the key to the aesthetic impact of the work of art.

One need only point to this painting's *visual* qualities to grasp the power of purely formal aspects upon our experience. Quite apart from the *meaning* of the madonna's gesture, the presence of all those bended knees and elbows and fingers, gazes of eyes and torsion of bodies, imparts to the painting a wonderful strong circular motion that is accentuated by its frame. Likewise, the walls that divide the picture space and the friezelike background figures serve visually to arrest this circular movement, lending it a stability, a permanence. Similarly, one could speak of its intellectual dimensions, the congruence depicted here of classical with Christian motifs, for example. What becomes apparent is that we cannot attribute aesthetic impact to psychic forces or to formal qualities or to cultural content alone, but perhaps to some delicate balance among these variables that rivets our gaze and beckons us to look, to feel, and to interpret. What Liebert contributes through his documentary approach is, I feel, the special dimension that psychoanalysis has to offer, a dimension that is exquisitely relevant but by no means definitive.

Further, what emerges from Liebert's study is a less complete picture of the artist's psychopathology than we have in Freud's study. This is because Liebert's emphasis is on the works rather than on the artist as patient. Psychoanalytic theory, with its postulates about universal human experience, informs the interpretation without overwhelming it; in other words, the goal of Liebert's interpretation is not, as one feels in *Leonardo*, a clinical diagnosis of the deceased artist or a contribution to psychoanalytic theory per se but, rather, an illumination of the artist's imagery. Liebert's work is therefore more like a genuine critical enterprise. We are made to look carefully at the *Doni tondo* to see in detail the similarities between it and the Dionysus relief, to notice the precise relationships among the figures in the distal plane, to mark that there are five such figures and that Michelangelo was one of five brothers, to experience the look of yearning in the face of the child St. John, who, in his unhappy and reluctant way, serves to unite foreground with background—the past, present, and future.

Isenberg (1973), discussing critical communication, describes the exemplary critic as one who "gives us directions for perceiving and does this by means of the idea he imparts to us, which narrows down the field of possible visual orientations and guides us in the discrimination of details, the orga-

nization of parts, the grouping of discrete objects into patterns" (p. 162). Although Isenberg is speaking of visual qualities in particular, I think what he says is equally applicable to the elements with which Liebert is concerned—with semantic issues and fantasy and symbol—and that Liebert, functioning vis-à-vis these elements, fits Isenberg's description of the good critic. He "shifts the focus of our attention and brings certain qualities which had been blurred and marginal into distinct consciousness" (p. 167). By focusing on the works of art rather than on Michelangelo as patient, he offers a psychoanalytic interpretation that returns us to the artist's work with a heightened sensitivity. He thus educates our aesthetic functioning by enabling us to see more fully what is present and by teaching us pari passu about the meaning of our own affective responses.

The limitations inherent in this approach to pathography can perhaps be put most succinctly by saying that interpretation is largely an art, and the best interpreter is not necessarily the one who knows the most. Along these lines I am reminded of a favorite children's story by James Thurber (1943), which, like many well-loved children's stories, contains at core a philosophical nugget. *Many Moons* tells of a small princess, remotely derived from Poe's elusive Lenore, who, after eating a surfeit of raspberry tarts, falls ill and announces to her father, the king, that she will be well again only if he procures for her the moon. The king in desperation consults one wise man after another, and as the story proceeds we learn precisely what the moon means to every character we meet, as well as, at last, to the Princess Lenore. In so learning, we taste the pleasures of infinitely elastic interpretation and realize ultimately that the right interpretation turns out to be pragmatic—that is to say, the one that works for the individual in question. What the implications of this might be for clinical practice must be left to the clinicians, particularly to Spence (1982), who tends toward a Thurberian viewpoint anyhow.[4] In applied psychoanalysis, however, this story brings us full circle to a point near Freud's *Leonardo*, reminding us that as we obsessively dash about testing reality we must prize the imaginative, the fantastic, the impossible; that we must refuse, when consorting with the arts, to put absolute faith in either fact or theory, but must instead treasure our intuition.

WOLFENSTEIN AND THEMATIC APPROACH[5]

A third model of pathography is found in the work of Martha Wolfenstein, who, unique among psychoanalysts who have written on the arts, has taken

4. See the review of Spence by Malcolm (*The New Yorker*, Jan. 24, 1983, pp. 96–106).

5. Parts of this section are adapted from my article "Toward the Separation of Memory and Hope: Applications of Psychoanalysis to Art in the Writings of Martha Wolfenstein," *The Hillside Journal of Clinical Psychiatry*, vol. 6, no. 1, 1984. Permission granted by Human Sciences Press is here gratefully acknowledged.

her own special area of clinical practice and research and applied it to the aesthetic domain. Her work on René Magritte[6] demonstrates how sharply focused clinical acumen can be brought to bear on the aesthetic, revealing at its best depths of meaning, both formal and substantial, that have eluded other modes of interpretation.

Wolfenstein published contributions to the fields of psychoanalysis and psychology over a thirty-year period, beginning in the late 1940s and continuing into the present with the forthcoming posthumous publication of her book-length pathography of Magritte. It would be out of place to review here all the articles and books she authored and coauthored, including several with her colleague and friend Margaret Mead. What is relevant is that she concentrated her energies for many years on a single theme that specifically informs her work in applied psychoanalysis. This theme is the reaction of a child to the death of a parent, and Wolfenstein treats it in clinical and theoretical papers, as well as in applied psychoanalysis.

I have already noted (in chapter 2) that the theme of childhood loss has often been central to psychoanalytic discussions of art, and it will not have escaped notice that both Leonardo and Michelangelo suffered the loss of their mothers by death or physical separation. As I have indicated, the concept of loss in psychoanalytic discussions may refer not only to actual death (specifically, the death of a parent) but to loss in multiple senses of the term. Freud (1926) has shown that psychic life requires from the moment of birth the experience of a progressive, interconnected series of loss and fears of loss. It can easily be inferred from this that, in the case of an artist who endured in childhood the actual death of a parent, complex reverberations might be set in motion at many levels of the psyche, which could ultimately find expression (though possibly disguised, distorted, and displaced) in that artist's created works. Such is Wolfenstein's major claim and thesis.

Wolfenstein's theoretical contributions to our understanding of parental loss in childhood were developed during the 1960s from extensive clinical work with bereaved children at the Albert Einstein College of Medicine. Her aesthetic insights grow organically out of this clinical-theoretical matrix. In her work on the twentieth-century surrealist painter René Magritte, whom she studied for many years and whose pathography she was still writing when she succumbed to cancer in 1976, Wolfenstein's major effort is to trace the thread stemming from one central event in the artist's life through its multiple representations and transformations throughout his later life and his repertoire of painted images. The event was his childhood experience of his mother's death, a trauma that Wolfenstein had come to regard through her own immediate clinical experience as formative and focal.

6. The following discussion is drawn from three sources: one published paper (1973), one unpublished paper (1974)—both in the bibliography—and Wolfenstein's book-length work, *The Man in the Bowler-Hat*, Yale University Press, forthcoming.

Unlike the fictive and documentary approaches, the thematic model sets somewhat more circumscribed goals. Wolfenstein, having chosen her subject in part because he suffered the loss of a parent in childhood, aims to trace this theme and does not presume to explain or account for all aspects of the artist's work. Nor does she extend her findings to artistic creativity in general. Although she is interested in applying untapped resources of psychoanalytic theory to her subject and in speculating on the displacement of oral, sadistic, and genital drives to the visual mode, she avoids vague inferences, preferring to stay close to her material. Like Liebert in the documentary approach, she starts with the paintings and conscientiously attempts to deal with a sizable portion of the artist's oeuvre. (In the case of Magritte this is no mean feat, considering that he managed, during just one particularly fertile period in his life, the 1920s, to produce nearly one painting a day [Gablik, 1976, p. 43].) As was pointed out earlier with respect to Liebert's work, the persuasiveness of psychoanalytic interpretations derives largely from the wealth of examples, the repetitiveness of certain themes, and the available data. Obviously, for reasons of space, this important aspect of Wolfenstein's work, as of Liebert's, cannot be fully presented here but only indicated.

An added dimension to the thematic approach as Wolfenstein develops it is that it provides us with an interpretative framework so apt and suggestive that one is compelled to take it beyond the works she specifically discusses. This is in sharp contrast, for example, to Freud's pathography of Leonardo, where, as I have claimed, the pathographer is so removed from his actual data that he offers us very little that we can fruitfully employ when faced with works not specifically discussed in his text.

In the first of two theoretical papers on the death of a parent, Wolfenstein (1966) describes differences between the ways in which adults and children respond to death. Drawing on Freud's seminal paper "Mourning and Melancholia" (1917), and comparing his description of the mourning process in adults with her own clinical observations of bereaved children, she concludes that, even through adolescence, it is impossible for a young person to mourn in the sense in which we understand that process to occur in an adult: namely, the gradual acceptance of the finality of death on both a cognitive and an emotional level. She quotes Freud's account of adult mourning as a protracted process by which the bereaved prolongs intrapsychically the existence of the lost object and then, by means of both a painful remembering and reality-testing, by "separating memory from hope" (p. 93), as she puts it, eventually frees psychic energy for reinvestment in the world of the living. The slowness and piecemeal quality of this process serve to protect the mourner from being overwhelmed, flooded, by objectless libido. Eventually, by tolerating a hiatus between object relationships during the period of mourning, the survivor can release major quantities of libido formerly bound to the lost object, thus making it available anew for various adaptive purposes. It is the ability to endure this important process of decathexis, the painful missing and reliving

of past moments with the lost object, the feeling and expression of sorrow—a process which is, of course, never fully completed—that characterizes the adult mourner.

Wolfenstein notes that children, on the other hand, commonly do not express grief or sadness in response to death; often they do not cry. Rather, these painful emotions are warded off. Children before the completion of adolescence experience the death of a parent as a massive trauma against which they must summon all the defenses at their disposal. Foremost among these is denial. Unlike the adult, for whom the lost object is preserved intrapsychically but gradually decathected, the child resorts to what Freud (1927) has called the "splitting of the ego." He can verbally, superficially, acknowledge that the parent is dead, but he does not accept this terrible truth on a deeper level and denies it in manifestations of his fantasy life and behavior.

Wolfenstein, both in her previously cited paper and in "Loss, Rage and Repetition" (1969), provides striking clinical illustrations of the results of such splitting in the lives of children. Fantasies of the parent's return may, for example, precipitate bargains with fate in which the child's behavior (either by being exemplary in "goodness" or achievement or by being impulsive, destructive, and regressive) implies a covert attempt to coerce—for purposes of reward or punishment—the lost parent's return. Rather than decathect the lost object, the child invests it with intensified cathexis. Thus, by holding tightly to the image of the lost parent, the child protects himself from what is unbearable. This hypercathexis is related by Wolfenstein to a similar response, noted by Freud (1926), toward a diseased or missing body part. It links up also with Niederland's thesis (1967) that artistic creativity may arise in part as response to a permanent, severe, and unresolved narcissistic injury. What makes this notion relevant is that for the very young child the lost parent is, in these cases, analogous to a body part in that the parent is experienced as essential to the self (Wolfenstein, 1966, p. 110).

This hypercathexis of the lost parent is maintained at great cost to the child. Anna Freud (1936) describes the way in which the ego, when engaged in defense, is precluded from developing other (adaptive) functions, and this point is underscored by Hartmann (1964). To maintain his inner fiction, the child cannot permit himself to develop fully in the area of reality-testing. He fails to develop particularly in the conflicted sphere of object relations, so that, as a result, he may be condemned to a series of repetitions of the original painful loss. Or else he may feel compelled to restrict whole areas of functioning in order to feel protected from the possibility of a repetition of loss. In addition, to maintain this fantasy, a sense of infantile omnipotence must be preserved along with its obverse, helplessness. Because of the need to idealize and protect the lost parent, normal ambivalence can have no place; hence further splitting occurs. Rage and all manner of hostile feelings originally directed toward the parent who has abandoned him are now projected

outward. Anger is often diverted toward the surviving parent and the world at large. The child, as Wolfenstein says, may turn himself into "a living and dying reproach" (1969, p. 433).

Wolfenstein's work poses two important questions: (1) What are the developmental preconditions for the work of mourning? (2) Since mourning is unavailable to the child, what sorts of nonpathological adaptive responses are available to him in the face of death? To the first of these she offers the hypothesis that adolescence, representing a "trial mourning" period during which the child must gradually give up his parents, the first love objects, and face the irrevocability of childhood as past, constitutes the necessary precondition for the ability to mourn (1966, p. 116).

Adolescence is frequently characterized by many of the affects and behaviors associated with mourning, such as depressed moods, nostalgia, and withdrawal into the self. Wolfenstein explains how adolescence demands a fundamental change in the child's love for the parents:

> In adolescence developmental exigencies require a radical decathexis of the parents. With sexual maturity, the adolescent is powerfully impelled to seek a sexual object. The images of the parents become relibidinized, but there the incest barrier stands in the way. The adolescent is confronted with the dilemma: to withdraw libidinal cathexis from the parents or to renounce sexual fulfillment. This may be likened to the dilemma of the mourner as Freud described it. The mourner is bound to the beloved object, no longer available; at the same time he is attached to life and all it may still have to offer. Eventually the decision is in favor of ongoing life and the renunciation of the past which this requires. The adolescent, impelled forward by his sexual urges, is similarly constrained to detach himself from his beloved parents and his childhood past. (1966, p. 113)

Thus, for Wolfenstein, it is only after a person has passed through this developmental stage that he can, having once endured the renunciation of beloved objects, effect the painful work of mourning, thereby recapitulating this aspect of his adolescence.

To the second question Wolfenstein offers two answers based on clinical and nonclinical observations. One constructive, adaptive mode for the bereaved child is to transfer love to a surrogate parent who, under the most favorable conditions, was known to the child before the bereavement and to whom feelings can then be immediately transferred without the hiatus of adult mourning, which would be intolerable. Another adaptive strategy involves the child's effecting a positive identification with the lost parent in such a way that he in essence replaces the parent, develops constructively along lines associated with her, and attempts to fulfill her expectations or achieve goals derived from her. Difficulties with the first of these solutions are often practical and, with the second, psychological, in that, to identify adaptively with the lost parent, the child must have passed beyond the stage of perceiving that parent primarily as a need-gratifying object and must also

go beyond the most proximate memory of the parent in illness and death to identify with her healthy and positive aspects.

Thus Wolfenstein concludes that even under the most benign conditions the loss of a parent in childhood presents a serious threat to development and may produce disturbances that persist throughout the life of the individual so bereaved. In many of the case studies presented in her papers, young patients, after establishing a transference, abandon treatment, thereby effecting a repetition of the original loss with the reversal of turning what was passively endured into what is now actively controlled—that is, by forsaking the therapist as the patient was once forsaken by a dying parent (1969, pp. 450–52).

As long as the ego is split in defense, as long as the finality of loss must be denied, and until memory can be severed from hope, the tendency to loss, rage, and repetition remains.

For Wolfenstein, then, the central concept in understanding traumatic childhood loss is that of psychic splitting, the maintenance of division between wish and knowledge. In an artist's later life this fundamental splitting may give rise, she suggests, to a kind of mental dualism that is intensely experienced as "that dual aspect of near and far, present and absent, lost and inalienable, living and dead" (1973, p. 434). Thus an artist's inability in childhood to accept the finality of loss may cause him to modify a vast range of later mental representations and functions; it may foster in him a mode of consciousness in which opposites coexist, in which the past is ever-living, in which there is endless alternation, counterpoint, and ambiguity.

Wolfenstein's general interpretative schema involves two major operating principles: (1) the coexistence of multiple opposites, the dualisms arising and displaced from original defensive splitting at the time of traumatic loss; and (2) the persistence and hypercathexis of primitive infantile fantasies, reinforced at first by external events and later preserved by defensive maneuvers that coerce an impairment of reality-testing. It is interesting to speculate whether the deficit in psychic integration these two principles represent should best be seen as a precondition for or as a hindrance to artistic creativity. Although such a question leads beyond the scope of the present inquiry, it is my sense that Wolfenstein, though she does not address this issue directly, would have inclined toward the first alternative, thus sharing the views of many of her colleagues (such as Niederland).

The Belgian surrealist René Magritte (1898–1967) was a first-born son who lost his mother in his early adolescence: she committed suicide by drowning when he was thirteen years old. In two articles (1973, 1974) and in a book-length manuscript Wolfenstein analyzes the visual imagery of this artist, tracing much of its uncanny and enigmatic quality to the experience of maternal loss and to the operation of the two principles formulated above. In addition, she enriches her interpretative schema by the introduction of ma-

terial drawn from research into the earliest stages of human development, ideas found in the writings of Isakower (1938) and Lewin (1946). Since she is dealing with a visual artist, one who has chosen a nonverbal medium as his principal mode of expression, the effort to include material derived from preverbal developmental theory seems appropriate and auspicious.

Magritte's distinctive style is characterized by a minute rendering of the most precise details of his (and our) visually perceived reality (one notes, for example, the linear idiosyncrasies of finely grained wood, the downy masses of cloud, the cold, unshatterable surfaces of rock). It is the startling contrast between, on the one hand, this hypercathexis of the material objects that constitute his and our shared external reality with, on the other, his suspension of all expected conventions governing these objects (for example, the relations of distance, dimensionality, scale, and inner and outer boundaries) that creates the dual response of the viewer—the attraction and repulsion, the fascination plus fear—so intensely aroused by these paintings.

Wolfenstein approaches the problem of accounting for Magritte's style as well as his content by offering a narrative, a reconstruction, in which both the artist's mother, Regina, and his wife, Georgette, play a central role.[7] I say "a role" and not "roles" because it is important to see the object relationship with the latter as deriving intimately from that with the former. The narrative begins with a childhood characterized by loss, absence, and disappearance. Magritte's birth was followed a year and a half later by the advent of a sibling, his brother Raymond, and then of another brother, Paul, before he was four years old. Remarking on how these external events served to reinforce primitive fantasy, Wolfenstein notes: "We may suppose that he was not unaffected by being so soon supplanted in his mother's arms" (Ms., pp. 1–2). This comment illustrates an important aspect of Wolfenstein's interpretative work: she takes as her theme not merely the bald factor of maternal death in isolation but, rather, the layers of loss, the antecedent disappointments and also later events, which reverberated with both earlier and later losses, shaping and coloring their intrapsychic meanings for the artist.

In addition to these changes in the family composition, young René was exposed to continuous moves from town to town and from house to house, so that he experienced multiple losses of a stable, holding environment even before his mother's death in his early adolescence. According to Wolfenstein, the cumulative effect of these experiences and their consequences for his psychic reality determined many aspects of the artist's later everyday behavior and painted imagery. For example, he manifested in adulthood a strong aversion to change in his daily routine: he moved only once during the last thirty-seven years of his life, and he followed more or less unvarying habits—

7. Wolfenstein traveled to France and conducted interviews with others who knew him, as well as with Georgette.

walking his dog, playing chess in the local café, wearing his conservative garb, including the emblematic bowler hat, rarely traveling abroad (1973, pp. 444–45). Furthermore, upon marrying his wife, Georgette, he determined never to be parted from her and actually managed, except for one brief period during the war, to keep his vow. In Magritte's painted imagery Wolfenstein traces concrete references to the two younger brothers who "stole" his mother's breast from him, as well as to the changing, soon-vacated houses of his childhood. Striking and unmistakable allusions to the latter theme overlaid by the experience of maternal loss are to be found in such works as *L'empire des lumières* (1948, 1954), *La voix du silence* (1928), *The Bosom* (1960), and many others. It is interesting to note the disparate dates of these paintings and to connect this observation with Liebert's view that, for an artist, externalization does not signify working through, that the same intrapsychic themes persist and are continuously reworked throughout an artist's career. In the instance of Magritte, this is remarkably the case, so much so that many of his critics and chroniclers have elected to present his work taxonomically rather than historically (for example, Torczyner, 1979, and Gablik, 1976, p. 15).

Central to Wolfenstein's narrative is a description of the mother's suicide as remembered by Magritte and communicated many years later to his close friend Scutenaire:

> The mother shared the room of the youngest son, who, in the middle of the night, realizing that he was alone, aroused the family. They searched throughout the house in vain, then noticing footsteps on the threshold and on the path, they followed them to a bridge over the Sambre, the local river. The mother of the painter had thrown herself in the water, and when they recovered her corpse, her face was concealed by her nightgown. They never knew if she had covered her eyes not to see the death she had chosen or if the movement of the water had veiled her in this way. (Scutenaire, quoted by Wolfenstein, 1973, p. 445)

Thus, this loss, so untimely and tragic in and of itself, was intensely complicated by the added experience of the boy's seeing in early adolescence the naked body of his mother. Wolfenstein focuses prominently on this point and on its special significance for a child who, in addition to experiencing the normal upsurge of sexual feelings typical of his age, would develop the hypercathexis of visual images typical of a painter. She speculates that such a hypercathexis of visual images, which, by an artist, can be conjured up from within or created on canvas, may serve as a means of defending against the fickleness and frustrations of reality (Ms., p. 71). The artist, in liberating his image from the object it represents, by in fact turning object into image, seeks to evade the oedipal conflict implicit in forbidden looking. Yet, as Magritte shows us in so many of his paintings, this conflict is not evaded, for, by pointing up discrepancies between images and objects while at the same

time producing porous symbols (Sarnoff, 1976) that discharge and evoke powerful affects appropriate to both, as well as to the tension between them, he intensifies and preserves it. The repressed returns, as Freud said; having proliferated in the dark, as it were, it clamors for expression and etches new channels. In fact, as Thomas Mann knew (and explored in *Death in Venice*) there is a sense in which the artist's intense attachment to looking actually precipitates moral conflict, for in looking and painting (exhibiting), he defies the taboo. In Magritte's case, the enigmatic titles of his paintings serve to plunge his viewers even more deeply into such conflict, for, rather than naming or explaining each image, they plumb still further the discontinuous, un-satisfying, and asymmetrical correspondences among images, objects, and words (Ms., pp. 161, 182ff).

Thus, as Wolfenstein shows us, for the young Magritte, the sight of his mother's body in death proliferated into a vast array of images that express through the primary-process mechanisms of denial, reversal, condensation, and displacement various aspects of this experience and its intrapsychic mean-ings to him. For example, he often painted images in which women are partly dead and partly alive, absent and present simultaneously, inanimate and an-imate. In *L'inondation* (1931), for example, we see only the naked lower half of a woman's body while her upper parts fade into the blue sky; in *L'histoire centrale* (1928) a woman's head is shrouded in a white cloth, recalling the nightgown that covered the face of Magritte's mother when she was recovered from the river; *The Enchanted Domain* (1952) shows a seated woman, her lower parts naked, her body from the waist up transformed into that of a fish; in *La philosophie dans la boudoir* (1947) and *Le modele rouge* (1935), parts of a woman's body, the breasts, the toes, are painted as flesh, while the rest fuses with inanimate matter, the leather of boots or the cloth of a nightgown (see Wolfenstein, 1973, p. 446). Such images, Wolfenstein claims, express the child's inability to mourn, for their function is to preserve the painful memory "like a never-healing wound" (p. 447).

As Wolfenstein observed in her clinical experience with bereaved children, Magritte employs denial also to ward off guilt, associated with both his aggressive and libidinal wishes toward his mother and with his acting them out at the time of her death by looking at her naked corpse. Wolfenstein shows how this denial is laced in his paintings with wit and absurdity, creating images that move us to what has been called "panic laughter" (1973, p. 447). She interprets in this context a painting called *The Rape* (1945), a work whose title is surely no accident, expressing as it does the aggressive sexuality that can attend the act of image-making. In this painting the torso of a naked woman is presented as if it were her head (the breasts are her eyes; the navel, her nose; the vulva, her mouth). Wolfenstein views this as a "pretended mistake," an "overscrupulous covering up," a "grimly humorous alibi" (p. 447). Instead of seeing his mother's face, which was covered by her nightgown,

the young Magritte saw her body, which he should not have seen; hence he created an image in which he seems to protest that face and body are conflated, that what was body looked like face, thereby denying his guilt. In this painting he indirectly substantiates a point Sandor Ferenczi makes in his paper, "Eye Symbolism" (1913):

> Since the face (apart from the hands) is the only uncovered part of the body, children have to satisfy all their curiosity relating to other parts of the body on the head and face of their adult friends, especially the parents. Each part of the face thus becomes the representative of one or more genital areas. (1980, p. 273)

Also, as is so often the case with Magritte, it is crucial to remark the title. *Le viol* in French is a word that not only denotes rape but intimates a range of nuances from distinctions between that which is veiled and unveiled to the image of a violin with its myriad sexual innuendoes. (For a fine supplementary discussion of the word, see Spector, 1973, pp. 172–77.)

Likewise, in *L'invention collective* (1935) we see the use of another mechanism of defense, this time, multiple reversals. A creature lies on a sandy shore; her upper part is a fish, but from the waist down she is a naked woman. In this image Magritte expresses, as in the paintings mentioned above, his bitter hostility toward his mother, his rage against her for dying and thus abandoning him. By portraying her as a reversed mermaid, he exhibits her as sexually available, unlike a traditional mermaid, and so humiliates and ridicules her. He also repeats the reversal of clothed face and naked body that he experienced at her death. Reversal thus serves as another chosen means of warding off his guilt at having, through the act of looking, violated the incest taboo. Earlier I mentioned the displacement of various instinctual drives (oral, sadistic, genital) to the visual mode; it is clear that Wolfenstein, in her analysis of Magritte, relies heavily on this concept. Eroticized looking is then, of course, subject to all the mechanisms of disguise, through which the repressed manages, however, to emerge. Wolfenstein points out that in this particular painting Magritte again pretends to make a mistake. It is as if he were saying about the mother who threw herself into the river: " 'What did she think she was—a fish?' " (Ms., p. 205). And he mocks her by giving her the brains of a fish and the legs of a woman, thus depriving her image of its erotic appeal, and in so doing denying his own erotic feelings in adolescence at the sight of her exposed corpse. Wolfenstein summarizes her interpretation of this painting as follows:

> The number of reversals involved in the formation of the image is striking: the mermaid is inverted, a tragic scene is turned into an absurd one, erotic feelings are turned into aversion, and intimacy into strangeness. In transforming his mother's fatal melancholy into a comic mistake, Magritte turns his own grief into vindictive mockery. As in his profound absurdities, generally, he struggles to maintain a jocose defense against depression. . . . However, Magritte's mock-

ery, here and elsewhere, does not reduce the impact of his underlying tragic and furious feelings but rather adds a distinctive quality to his complex images. (Ms., p. 206)

Wolfenstein addresses the issue of the artist's style as opposed to his content by taking up the narrative at the point when, shortly after his mother's death, Magritte met his future wife, Georgette—at that time a young girl. It is important to note the psychological as well as temporal propinquity of these events. He became separated from—"lost"—Georgette and then, some years later, met her again by chance, whereupon he married her and determined never to part from her side again. Clearly this avowed intention was dictated by powerful defensive needs to ward off any possible reexposure to the loss of another beloved woman so profoundly connected intrapsychically with his lost mother. In Magritte's promise never to brook separation from his wife is the bereaved child's attempt to coerce fate by adopting, in this case, a renunciatory course of action.

However, within a year or so of their marriage, Magritte underwent a severe disturbance that he described as his loss of the sense of reality. He spoke of seeing a familiar landscape as though it were "a curtain placed before my eyes" (collapsing, in other words, its third dimension), and of being "in the same state of innocence as the infant who believes that from his cradle he can seize the bird flying in the sky" (quoted in Wolfenstein, 1974, p. 7). It was at this time that Magritte's style of painting changed dramatically, emerging after this disturbance in the form we recognize today as characteristic of his work.

Wolfenstein, at first deeply puzzled by this episode and its dramatic sequelae, sought assistance via a personal interview with the widowed Mme. Magritte (see n. 7). From her, Wolfenstein learned that just at that time in the marriage she had experienced pregnancy, miscarriage, and a lingering postpartum illness that were deeply disturbing to Magritte. From these facts Wolfenstein constructs the following hypotheses: Magritte's attack of anxiety was in fact brought on by these events. Having faced death (of the fetus) a second time, dreading the loss of his ailing wife, and flooded by panic as the long-guarded grief of his mother's unmourned death threatened to return, Magritte assumed at this time an even more drastic defensive posture: he again chose a renunciatory course, this time the extreme of abdicating fatherhood forever. In thus denying a fundamental aspect of his own sexuality and masculine identity, he, in Wolfenstein's words, "turned away from a reality which had proved so unbearably disappointing" (1974, p. 9).

The cataclysmic narcissistic withdrawal produced by this decision was responsible, she postulates, for his sense of loss of reality and caused an intrapsychic struggle that resulted eventually in his restitutive artistic creation of an altered world, a world in which, "in his effort to undo the loss of

reality, Magritte reversed the tendency toward abstraction in his work" (1974, p. 10) and, instead, hypercathected the details of material objects, as if to cling fiercely, desperately, to their visible and tangible reality. Simultaneously with this trend, and especially as time went on, Magritte would also deny the reality of his images in his titles (for example, *Ceci n'est pas une pomme* of 1964) as if to betray his sense of the ultimate futility of his own restitutive enterprise, his skepticism and shaken confidence in the "omnipotence of pictures."

As to the distortion in the relations among these painstakingly delineated objects, their reversals of inner and outer, of near and far, and their deviations in scale and dimension, Magritte himself explained these stylistic elements by the statement (quoted by Wolfenstein, 1974, p. 11) that he wished " 'to make the most familiar objects howl' and that to do so these had to be disposed in a new order and to acquire an upsetting meaning." Here the defensive mechanisms of projection and displacement come into play: Magritte, rather than cry out his own grief, seeks to make objects do it for him and in so doing to terrify his viewers. We may interpret these altered relations further as visual counterparts of the dualisms that arose from the original defensive splitting at the time of loss, and as expressing the need to keep opposing views in simultaneous sight.

Take, for example, Magritte's painting *La condition humaine* in its 1933 version. One can find no imagery in it whose manifest content can be traced to the death of the mother. It presents a picture of a room in which a canvas is placed before a window in such a way that the painting on the canvas and the view through the window are coextensive, thus creating a visual paradox and play on the counterpoint between illusion and reality (1973, p. 454): we see the painting of the painting, the painting in the room—nothing is lost or given up. As in dreams, we need not choose between alternatives. Thus, the child preserves the lost mother who, internalized, pursues him and remains a part of all his imaginings; reality-testing is impaired. Style and content are derived from the common theme.

Wolfenstein also, as I have noted, picks up on the aggression both of Magritte's explanatory statement about his choice of stylistic elements and of the paintings themselves, many of which seem at first an assault on the viewer. She attributes this to the rage so frequently observed in clinical practice with children who have felt abandoned, an overdetermined rage emanating from the child's own aggressive impulses toward his mother, his anger at her for giving of herself early on to other babies and then for withdrawing altogether in death. The last is, of course, an outcome that the child has wished for in secret and believes he has caused by his own narcissistic omnipotent destructiveness.

Wolfenstein interprets Magritte's statements about his sense of unreality and the form it took in terms of Bertram Lewin's concept of the "dream

screen" (1946), which was derived in turn from Otto Isakower's reconstruction (1938) of the infant's experience falling asleep at the mother's breast. Even a superficial acquaintance with Magritte's oeuvre conveys the centrality to this artist of these images of curtain and bird, both of which Wolfenstein links to the breast. Thus, according to Wolfenstein, that sense of unreality Magritte experienced at the point in his life just after his wife's miscarriage, and before his major stylistic evolution, evoked in him primitive memories of infantile states of oral satisfaction and bliss alternating with emptiness. Wolfenstein describes the way in which

> fantasies of return to the womb develop when an older child, looking up at his mother's pregnant belly, has re-evoked in him earlier feelings of being taken into the breast, which now become directed toward the belly by displacement downward on the mother's body. Later dreams of being drawn into the mother's body may give rise to ecstatic feelings of being merged with the beloved or to the terror of being annihilated. (Ms., pp. 54–55)

It is interesting to speculate whether the artist's adult access to such states (including screen memories involving such explicit images as "the envelope of the balloon,") is dependent on the factor of the unmourned loss of the mother, since, as we have seen, the need in such cases to preserve the past is primitive, powerful, and, especially in the case of artists, cast in a sensuous mode (see Greenacre, 1971). Wolfenstein implies this connection but does not explore it dynamically or generalize it beyond the context of Magritte's specific life and work. Normally, however, except under unusual circumstances or within the context of an analysis, such primitive, preverbal experiences remain unconscious and unavailable.

There are numerous paintings by Magritte in which a large bird may be seen as representing the mother. These birds may appear graceful or threatening (protective or persecutory), they may be made of stone or leaves, they may be black or transparent, static or in flight. Among such paintings is *Le printemps* (1965). Although Wolfenstein has not commented on this particular painting in any of her extant writings on Magritte, my understanding of the work is very much informed by her insights. *Le printemps* shows us the graceful outline of a bird filled in with green leaves. The bird flies over an abandoned nest precariously set upon a stone wall. The nest of dry twigs is occupied by three lovingly painted, warm-toned eggs. Using Wolfenstein's schemata, one would discern an unconscious reference in the leaf-bird image to the insubstantial mother who has taken flight, who has, as it were, become one with nature, leaving three little boys, Magritte and his younger brothers, unhatched eggs in their lonely and prickly nest, which rests uneasily on the cold stone of, perhaps, a coffin.

Another painting, *The World Awakened* (1958), recalls Magritte's illusion of the curtain and Wolfenstein's interpretation of this as a dream-screen

derivative. It depicts two tiny figures standing before an enormous pale blue sphere with three vast, rather solid pink curtains to their right. The scene, as so often in Magritte's paintings, is an otherwise deserted beach with gentle waves and a benign sky. The painting recalls a statement Wolfenstein quotes from the artist's autobiography: " 'From his cradle, René Magritte saw helmeted men who carried away the envelope of a balloon. . . .' " (1974, p. 20). In keeping with what has been presented thus far, one would tend to see this as a screen memory condensing feelings about the two younger brothers who stole his mother's breast from him and about the actual death of the mother—the collapse of the balloon, the pallbearers, and so forth. In this painting, the two tiny figures are black and appear to be helmeted as they stand fondly contemplating an enormous balloonlike, breastlike orb which is, though pleasingly round, blue and hence inorganic, dead. The beach and water refer to the mother's suicide by drowning, and the pink curtains may represent in a somewhat disguised form the enveloping and receding screen of the breast as experienced in infancy (Lewin, 1946), which, however now no longer bounds nor covers but simply remains as an image for contemplation, a testimony or monument to the eternal presence of the past.

At this point, I should like to step back from the psychoanalytic approach of Wolfenstein and consider briefly the views of other Magritte scholars who have approached his paintings from a purely intellectual perspective (see Gablik, 1976, Foucault, 1983, von Morstein, 1983). Magritte's paintings have been viewed as metaphysical speculations. ("We are thrust into a conflict between reality and illusion—a problem which fascinated Magritte. Perhaps he is asking whether or not the external world really exists," suggests Gablik, p. 42). They have also been seen as statements concerning "those relations of uncertainty which at present reflect the philosophical mentality of modern physics" (Gablik, p. 156). It is certainly possible to see Magritte's images in this way, as expressing changes in our view of reality because of the shift from classical, fixed, Newtonian mechanics to relativity theory and quantum theory. Gablik contends that a proper study of Magritte's work should therefore disclose the "searching mind of a philosopher rather than the aesthetic and painterly concerns of an artist" (p. 11).

The obvious problem with such an approach is that it casts no light whatever on Magritte's specific choice of images, nor does it deal with the specific and potent affects aroused by them. A philosophical interpretation can perhaps point out that "for Magritte, reality denies the impossible to which, within the bounds of the possible, his paintings aspire" (Gablik, p. 15), but it cannot tell us why an artist would feel driven to rearrange the known and to re-create in his images moments of panic caused not only by vague existential terror but by other, more specific terrors as well.

As regards *Le modele rouge* or *La philosophie dans la boudoir*, for example, Gablik points out that the image starts by being a foot and ends up as a boot

by a process of hybridization (*condensation* in psychoanalytic terminology). She quotes Magritte to the effect that the union of human foot and leather shoe arises from a "monstrous custom" (p. 124) and notes that a new object is thus produced by the merging of container and thing contained. However, Gablik's discussion leaves out the emotional origins of this image—its monstrousness, its horror, its connection of life with death and of sexuality with violence.

Michel Foucault (1983) speaks of Magritte's fascination with visual non sequiturs. He speaks of Magritte as creating visual "heteropias," disturbing arrangements of objects drawn from sites so different from one another that it is impossible to find their common ground. Foucault claims that in this way Magritte destroys the syntax that causes words and things to hang together, and thus he welcomes Magritte as a fellow in his critique of language. Foucault invokes Saussure's assertion of the arbitrariness of the sign, which Magritte illustrates, and claims that Magritte's paintings vigorously assault the mystical platonic identification of words with the essences of things. For Foucault, Magritte's enterprise is subversive: it strives for the effacement of bonds and the celebration of difference, and it is committed to breaking down the hierarchical relations between words and images, to the cruel and careful separation of graphic and plastic elements. When words occur superimposed within a painting like a legend and its image (as in *La clef des songes*, 1930), it is only on condition that they contest the obvious identity of the figure and the name we were prepared to give it.

Such philosophical interpretations may have considerable interest, and they can go further and catalog the ways in which Magritte actually transforms objects. Gablik attempts this, listing such devices as isolation, modification, and hybridization. But such discussions miss the personal, idiosyncratic meanings of these operations for the artist and, hence, fail in a crucial way to help us account for our own responses to the images.

Earlier (see chapter 1), I claimed that philosophers seeking to understand the art of our era must sooner or later deal with aesthetic qualities that can be seen as isomorphic with primary-process modes (for example, distortion = modification, condensation = hybridization, projection = interpenetrating images). Albert Rothenberg (1979) contends that when such processes are used by artists, they are *consciously* manipulated and hence must be seen as "the mirror image of dreaming" (p. 130) rather than as manifestations of primary-process mentation. He argues, in other words, against "the popular belief in the importance of the Unconscious in creativity" (p. 130) and on behalf of what he calls "an act of will" (p. 130), which necessarily involves *janusian thinking*, a term he has coined to encompass the sort of simultaneously conceived antithetical images or ideas employed routinely by Magritte. Central to Rothenberg's thesis is the question of the relative force of conscious versus unconscious factors in artistic creation, or, in slightly dif-

ferent terms, the relation between primary and secondary process. I find Rothenberg's argument unconvincing. In Magritte's case, for example, it is clear that unconscious factors dictated formal choices fully as powerfully as did conscious will. An artist may manipulate forms via *janusian thinking*, toward which, in fact, he may be predisposed by virtue of his unconscious conflicts and native endowment; but, like Glendower in *Henry IV, Part I*, he would be fooling himself if he thought he could "call spirits from the vasty deep" (act III, sc. i).[8] What emerges in the creative process must remain, as philosophers since Plato—not only psychoanalysts—have acknowledged, largely unknown to the conscious mind of its creator.

Affect is the surest indicator that this is so. We can, for example, imagine a picture built on the philosophical conundrums Gablik appeals to: intellectual antitheses and logical inconsistencies represented by various types of inter-penetrating images (impossible occlusions, etc.). Such a picture might be viewed with mild or even fascinated bewilderment, or neutral curiosity, and possibly boredom (see the visual riddles of M. C. Escher). By contrast, Magritte creates images that possess the power to make us *want not to look*; he actually forces us at times to turn away, but then immediately to turn back again in horrified fascination (as he once did). No purely intellectual, cognitive explanation can satisfactorily explain such a phenomenon. The psychoanalytic mode, on the other hand, is a means of understanding something about how such evocative images come about, though it too must ultimately fail to provide the total explanation.

Wolfenstein's brilliant work in reconstructing the psychic reality of Magritte around the theme of maternal loss in childhood has added a new dimension to our perception of these paintings and in so doing has contributed substantially to the interdisciplinary dialogue. Her method is, like Freud's and Liebert's, subject to the complications of countertransference, but because of her involvement in relevant clinical casework, these factors are perhaps more in check. Further, in her model there is an inherent danger of overstating the case and thus ultimately oversimplifying. However, in my view, Wolfenstein avoids this pitfall by carefully respecting the parameters of her quest. There is also the danger of ahistoricity, of failing to consider, for example, the surrealist movement, the world wars, existential philosophy, and modern science. A propos of this, it seems clear that even though the pathographer who employs the thematic mode consciously delimits her scope, she should nevertheless have a substantial tacit grasp of such background issues, which will necessarily impinge, often in unexpected ways, on her theme. Such tacit knowledge is of course easier to achieve when pathographer and subject are contemporaries.

8. I am indebted to Dalton (1979, p. 15) for first associating this wonderful boast with the surrealists' enterprise.

One question implied by Wolfenstein's work is the centrality of the experience of early parental loss to artistic creative experience. Closely related to this is that of the artist's relative unawareness of conflict—the question of splitting. It is hard, after reading Wolfenstein's cogent and persusive argument, to believe that Magritte, a man of intelligence, sensitivity, and introspection, was totally unaware of the psychological dimensions of what he was doing, of what he was so blatantly expressing. And yet, his very lack of awareness, the heavy blanket of repression indicated by the obsessive behavior patterns Wolfenstein describes, as well as by his total refusal to talk about his mother, even with his wife (" 'René never spoke of his mother; he never confided anything about his relatives to me,' " Georgette Magritte reports, Passeron, 1970, p. 12), his denigration of psychoanalysis (Torczyner, 1979, pp. 58–62) his obstinate disclaimers of any symbolic meaning in his paintings (" 'To equate my painting with symbolism, conscious or unconscious, is to ignore its true nature,' " as quoted in Gablik, p. 11), and such remarks as " 'I detest my past' " (Gablik, p. 16) and " 'for me the world is a defiance of common sense' " (Gablik, p. 14) actually made possible the outbreak in his imagery of primitive fantasy and almost overwhelming excitation. To have been unaware was a necessary precondition, and such unawareness is in fact the definition of psychoanalytic symbolization. Psychoanalytic symbols are formed when there has been repression of the connection between a representation and that which has been represented, between, that is, the signifier and the signified (Sarnoff, 1976, pp. 97, 121, 159).

It is natural to speculate about how things might have turned out for Magritte the painter if he had at any point become aware, had perhaps been analyzed, had worked through his grief and guilt and pain, had mourned. How central to art is unanalyzed loss and repressed conflict? The loss and conflict are in Leonardo and in Michelangelo as well, and artists have on occasion intuitively refused analysis because of their fear of losing inspiration. One answer is, of course, that art encompasses more than psychoanalytic symbols, that the return of the repressed can be seen as only a feature, a substrate, of its form and content. There are also nonpsychoanalytic symbols, such as metaphor, in which the connections between signifier and signified are consciously manipulated by artist and audience. Another answer lies in the fact that intrapsychic conflict is always a factor, that by definition the unconscious consists of that of which the subject is unaware, so that, even with a high degree of insight and psychic integration, that which is dynamically unconscious will continue throughout life to exert influence and determine aspects of self and object representations. In other words, in the case of Magritte, we might imagine that, given his cathexis of the visual mode—reinforced by the events Wolfenstein has described—and his endowment of artistic talent, a degree of self-awareness and insight in a psychoanalytic sense

would have resulted not in his ceasing to paint but rather in his painting quite differently in terms of both form and content.

PATHOGRAPHY IN REVIEW

The three models of pathography presented in the foregoing pages suggest that this mode is by no means obsolete; nor is it, as some have claimed (Ricoeur, 1970, pp. 170ff.; Wollheim, 1974, pp. 205ff.), without critical relevance. While I could not capture these models in all their intricacy, I have sought to present them in sufficient detail to examine some of the questions they raise and to explore their contributions to the interdisciplinary dialogue that is the focus of this project.

Each of the pathographic models has grappled with the issues of the relation between an artist's life and work, the nature of artistic creativity, and the problems of intention and expression. Although psychoanalysis is concerned with inner realities rather than with external events, and though the purpose of reconstruction is to gain a clearer picture of the artist's psyche, not to find out what "really happened," the paradox in applied psychoanalysis is that, in the absence of clinical data, the pathographer must use the external as a pathway to the internal. Such a method is fraught with dangers, the most common of which are incomplete or inaccurate external data and the contamination of the countertransference run amok. By countertransference in this context, I mean, of course, the unconscious affects and fantasies that the subject evokes in the interpreter. However, even in cases where the interpreter has succumbed to these dangers, the resulting interpretation may possess critical relevance and value. I have attributed this partly to the appeal of "narrative truth" in interpretation (Spence, 1982) and to the unconscious resonances of the text in question with its readers as well as with its interpreter. One might further invoke the readers' needs to find patterns, to ascribe meaning, to provide reasons so as to gain and retain control over experience, as well as complex and often unconscious identifications with the artist (Kris, 1952). Granted the existence of universal primitive fantasy, even an interpretation of this type may in places ring true, although strong unconscious resistance may make it inaccessible to some readers.

A fascinating treatment of this issue by Reed (1982) develops the theory that the writings of nonpsychoanalytic critics will mirror unconscious fantasies evoked by the text, as analysts in supervision frequently reflect the unconscious themes of their analysands. This theory corroborates my view of the importance of the (conflicted) father-son relationship in Freud's *Leonardo*, as does new research reported by Beck (1982). Beck reports that Leonardo's father was apparently deeply involved in the artist's education and subsequent career, both encouraging and financing him, even to the point of arranging early commissions. He speculates that Leonardo's

deeply conflicted love for his father may have been at least as crucial a factor in his development as the disappearance of Caterina. If this is true, and if we apply Reed's theory, then my remarks about Freud's countertransference gain added support.

Psychoanalysis has contributed to the problem of intention the notion of unconscious intention, and the pathographic studies presented here show that unconscious intention may be not only an important determinant of final artistic form and content but, possibly, if we consider the affective qualities of works of art as paramount, their most crucial determinant. We have seen that, in order for an image to function as a psychoanalytic symbol it must involve repression of the connection between signifier and signified (had Michelangelo understood the dynamic significance of the *Doni tondo* in terms of his own intrapsychic themes, he could not have painted it as he did). Thus, psychoanalysis complicates the problem of intention by assuming that its crucial features cannot (by definition) be known to the artist, while at the same time demonstrating that such intention largely determines which intrapsychic themes are externalized in the resulting works of art and how.

I have suggested that in the absence of that shared therapeutic context peculiar to clinical psychoanalysis the pathographer must substitute sound scholarship and self-scrutiny in the hope of creating between himself and his subject a semblance of the privileged space that comes into being between analyst and analysand, and in which the dramas of transference neurosis and countertransference are enacted. Again, I have pointed out the difficulties of such an enterprise and indicated that Freud steers the course by relying on his own developing theoretical constructs, inductive and deductive reasoning, and empathic insights. Liebert trusts largely in his prodigious grasp of the external data; and Wolfenstein depends on the acuity of her clinically honed skill, restricting the scope of her interpretations accordingly. In each case, the interpretations that result reflect how context is conceived and constructed, just as in a clinical analysis the force and reverberation of an interpretation will depend upon the fit and depth and quality of the transference.

Likewise, in each model the need to interpret is conceived somewhat differently. In Freud's model, taking the artist as patient, the motive was to probe Leonardo's psychopathology, and his works were discussed as incidental to this overarching theme. Liebert's model takes Michelangelo's images as a starting point and notes puzzling inconsistencies in their manner of representing certain iconographic themes, both with respect to the internal structures of the works themselves and in comparison with other contemporary works. These incongruities are then taken as points of departure for the interpretative effort. Wolfenstein begins with a particular clinical interest, the child's reaction to the death of a parent, and then traces the symbolization of this theme in the works of her subject. As I have suggested, the danger in each case is that the interpreter will find only what he or she is looking

for, that too fixed or rigid a program will prejudice the outcome and preclude the possibility of discovery. If what is to change in applied psychoanalytic interpretation is the sensitivity, the awareness of the interpreter (and his audience), then it is essential that the interpreter remain open to learn from his subject, to be changed in some way by experiencing the works of art.

This issue, the motive for interpretation, creates an interesting difference between clinical and applied psychoanalysis. In the former, the analyst is clearly in control of the analysis, however intermittently or precariously. Even if he is profoundly moved by his patient, even if he learns a great deal from him and shares responsibility with him, it is nevertheless primarily the patient whose role it is to change. Likewise, in the educational milieu, even when teachers permit themselves to be influenced or informed by their students, their own function is principally to teach. In the domain of art, however, these functions are less clearly defined and distinguished. An interpreter goes to works of art both to learn and to teach. He must, as Kant says (1790, 1952, pp. 58, 71, 89), permit himself the "free play" of the cognitive powers, of the imagination, while also constructing his interpretative narrative. (The alternation between these modes of perceiving is discussed further in chapter 5.) This "free play" is fundamental to our experience with art; we must be able to give ourselves up to the painting, the sculpture, the music, the drama, and allow *it* to control *us*.

By contrast, the clinical enterprise, however much it is conceived as a joint endeavor, is still an endeavor in which the analyst's main goal is to help the *patient* to change, and in which the relationship is fundamentally asymmetrical. To state my point in another way, in aesthetic experience and in applying psychoanalysis to art, the analyst/interpreter must assume (at least intermittently) the role of patient himself, in the sense that he must permit himself the luxury of free association within the presence of the works he seeks to interpret in order to learn from them and to experience his own inner change in their presence. (Perhaps this is merely analogous to the free-floating hovering attention Freud recommends as optimal analytic technique.) Earlier I stated that responsible scholarship must dictate parameters for any interpretations resulting from such aesthetic moments by establishing appropriate contexts. But ultimately the pathographer is freer to risk, to play, to transgress, than is the clinician. And, depending on the motive for his interpretation, I think it is essential that he use and enjoy this freedom as an antidote to mechanical applications of theory or routine adherence to clinical standards. Of course, the dangers of "wild" interpretations are ever present, but perhaps such dangers are inherent in all genuine aesthetic encounters.

We have seen that pathography in practice poses a question as to how the aesthetic needs of the artist relate to his intrapsychic needs. We have only to go to the drawings of children or the products of psychotic patients to find examples of art that may externalize some aspect of intrapsychic need but

frequently do not work aesthetically. Within the enormous oeuvre of Magritte, for example, there are more and less successful paintings. This issue may indicate a clear boundary between the disciplines of aesthetics and psychoanalysis. To treat this issue from the outside, to ask how it is that we are satisfied or pleased through experiences with great works of art, is, as Schapiro pointed out in his critique of Freud's *Leonardo*, to step squarely into the realm of normative aesthetics. There is another way of asking this question, however, that bypasses the normative and falls rather into the province of psychoanalysis. This is the question of the relation between the satisfactions obtained by the artist in managing to master inner conflict, at least temporarily, by painting, sculpting, or composing, and the satisfactions he obtains in solving the technical, formal problems in order to create a piece that is aesthetically "right" or pleasing. In psychoanalytic terms, we might speak here of instinctual versus ego satisfactions. In any case, by asking the question from the inside we enter into the territory of "sublimation," with its multiple layers, and are firmly within the domain of psychoanalysis. Thus, the question of the relation between aesthetic and intrapsychic needs, if it is asked from the outside, becomes a matter for debate in the philosophy of art. If it is asked from within, it falls into the territory of psychoanalysis. What seems intuitively clear is that because the work of art is always more than a psychic product there can be no simple predictable relation between the two.

Each model of pathography examined yields an *expanded awareness* (in Isenberg's terms) of both perception and meaning. In none of these models is such awareness the primary focus of the interpretation; rather, it is a secondary gain arising from the close and intense looking necessary to do the job. Whether the pathographer emphasizes narrative or historical truth, intuition or documentation, the test of aesthetic relevance is always the strength of the pull back to the work of art itself.

A further issue raised is the relation between early loss and artistic creativity. We have seen that each psychoanalyst/interpreter places emphasis on a particular type of response to such loss—namely, splitting. This is avowedly the focus of Wolfenstein's work on Magritte, but it figures prominently as well in Freud's reading of Leonardo and in Liebert's study of Michelangelo. How central to art is such defensive splitting?

Freud first introduced this term in his work on conversion hysteria, where he spoke of "the splitting of the content of consciousness" (1894, p. 46). Eventually this more general use of the term was refined, after the development of the structural hypothesis, to mean the splitting of the ego, which Freud had by that time conceived as a set of functions with a coherent organization (see Freud, 1927, 1940). What I want to stress here (without presenting a history of the development of this concept in Freud's thinking) is the notion suggested by Jeanne Lampl-de Groot, that we "view the neurotic defense mechanisms as pathologically exaggerated or distorted regulation and

adaptation mechanisms, which in themselves belong to normal development" (1957, p. 117). This is important because, as we have seen, in certain artists defensive splitting may lead to highly adaptive symbolic functioning, which is often prized by society, whereas in nonartists (and in many artists as well), the same mechanism may result in debilitating neurotic illness. Therefore, rather than ask how central a particular defense mechanism is to the creative process, a more appropriate line of inquiry might emphasize the progressive or protective uses of such a mechanism as opposed to its regressive or destructive uses (see Hoffer, 1954; Eissler, 1953). Lampl-de Groot suggests a possible solution to this problem by reminding us that the ego's defensive activity is but one of its many functions, including the regulative-adaptive and constructive functions. When these other functions are well established (and accompanied by native endowment, such as artistic talent), they may serve to tip the balance away from "pathological, rigid employment of the mechanisms in the neurotic conflicts" (1957, pp. 125–26). However, this suggestion by no means answers the question. The nature, genesis, and nurturance of the coping strategies of both artists and nonartists constitute an area that bears further study by psychoanalysts (see recent work by Anthony, 1983).

Loss of one kind or another is intrinsic to the human condition, as is defense against such loss. One might wish also to generalize loss to the more encompassing category of psychic trauma, the sequelae of which often include the distortion, impairment, or arrest of a variety of ego functions, including the sense of time (see Terr, 1979, 1983). The issue here is the use to which loss and defense are put. To quote Ricoeur:

> Sublimation is as much a problem as a solution. In any case, it may be said that the object of psychoanalysis is not simply to *accept* the difference between the sterility of dreams and the creativity of art but rather to treat it as a difference that *poses a problem* within a single problematic of desire. (1970, p. 175)

Thus, pathography raises a host of interesting and open questions for the dialogue between psychoanalysis and aesthetics. Its most marked contribution lies in helping to discover the distinct and personal meanings to the artist of his imagery and in exploring the genesis and quality of affect evoked by this imagery.

All too often the pathographic model ignores the viewer of the work of art. This dimension of the aesthetic, peripheral to pathography, is central to recent phenomenological thinkers and has been addressed in the psychoanalytic sphere by certain object-relations theorists, whose contribution is taken up in chapter 5.

Pathography also, however, restricts its inquiry by tying works to their makers in a way that has been uncongenial to many modern critics and philosophers of art since the 1940s. The so-called New Critics, for example,

chose to see art works as "constructed," "invented," or "possible" worlds—as "heterocosms" (Abrams, 1953, p.27) occupying time and space and coextensive with other objects and persons. From this point of view, art works are fundamentally misconstrued when cast in the shadow of their maker and considered as belonging to the set of objects made by him, as in the pathographic model. What can psychoanalysis contribute to a study of works of art severed from their original context and viewed as autonomous? The answer lies beyond pathography and the philosophical idealism that underlies it.

4

The Psychoanalysis
of Autonomous Texts
and Artistic Style

All this time the Guard was looking at her, first through a telescope, then
through a microscope, and then through an opera glass. At last he said,
"You're traveling the wrong way," and shut up the window and went away.
—Lewis Carroll, *Through the Looking Glass*

Beyond pathography, psychoanalysis has made and continues to make
contributions to the study of the arts in areas where the intertwining of an
artist's biography, intrapsychic world, and oeuvre is not considered to be
paramount. Psychoanalysts have, for example, interested themselves in the
possibility of the interpretation of autonomous texts and objects. Likewise,
they have considered using psychoanalytic concepts to view artistic periods
or more global phenomena in the history of art and culture (see Gombrich,
1963).

HETEROCOSMS: PSYCHOANALYSIS AND
THE NEW CRITICISM

In this chapter I shall consider several such approaches, beginning with the
critical viewpoint that chooses to take each work of art "as a self-sufficient
entity constituted by its parts in their internal relations" (Abrams, 1953, p.
26). Such a perspective removes us at once from the world of Romantic
criticism, where the highest premium is placed not on what is seen in a
painting, read in a poem, or heard in a musical composition but, rather, on
what can be inferred from these works about the psyche of their makers. In
the "heterocosmic" model, emphasis shifts from the expressive needs, aims,
and desires of the artist to a view of art objects as having their own existence
in the real world, in historic time, and as subject to various forms of change

and deterioration. From this perspective, works of art are seen as surviving their makers and continuing to exert influence on and be influenced by their surroundings. Art objects are viewed as having the capacity to take on aesthetic qualities beyond anything that could have been consciously or unconsciously intended by the artists. As Erwin Panofsky points out:

> When abandoning ourselves to the impression of the weathered sculptures of Chartres, we cannot help enjoying their lovely mellowness and patina as an aesthetic value; but this value, which implies both the pleasure in a particular play of light and color and the more sentimental delight in "age" and "genuineness," has nothing to do with the objective, or artistic, value with which the sculptures were invested by their makers (1955, p. 15).

The distinction Panofsky draws between the aesthetic and the artistic has been underlined also by Wolfgang Iser (1978) with respect to literary texts. Iser, however, describes these as two poles, the artistic pole being the actual text or object created by the artist and the aesthetic, the "realization" or experience of that object by a reader, viewer, or listener. Iser concludes that the work of art cannot be considered as identical with either of the two poles but must be situated somewhere in between; he speaks of the work of art as being "virtual in character" (p. 21), and thus adopts a phenomenological position (see also, chapter 5, below). Those espousing the heterocosmic viewpoint would bridle at this conclusion. Their reverence for what they take to be the legitimate boundaries of each work of art would cause them to object to ceding so much power and responsibility to any (mere) viewer. Their goal in distinguishing artistic and aesthetic poles is to free the work of art from its attachment to the artist, but not in so doing to reattach it to its audience. From their point of view, works of art are seen as independent and autonomous, constituted by their own materials or language, structures, and internal relations—severed as fully from the expressive needs of their makers as from the responsive activities of their beholders. The context for interpretation shrinks in this model to the boundaries of the individual work of art.

Although Abrams traces the origins of this point of view to late eighteenth and early nineteenth-century criticism (1953, p. 27), it is particularly associated today with a number of mid-twentieth-century English and American literary critics, among them I. A. Richards, Archibald MacLeish, Cleanth Brooks, and William Empson, who began to regard poems as artifacts in and of themselves, with lawlike structural attributes: tensions, paradoxes, lines of development, and specific types of ambiguity. What came to fascinate these critics was an analysis of the given, the palpable, the available datum. They directed their efforts at "close reading" rather than "reading in." Their concerns can be compared with those of the somewhat earlier formalist critics in the visual arts—Roger Fry and Clive Bell, for instance—and to some extent

with the philosophic concerns of Langer (1953),who stressed the "presentational immediacy" of works of art rather than their representational aspects.

It is curious to note that as the twentieth century progressed both art criticism and psychoanalysis shifted focus from the "what," or content, to the "how," or form, of art and psyche respectively. Psychoanalysis shifted from an exclusive interest in repressed instinctual impulses, wishes, fears, and affects to a concern for strategies of defense, resistance, and adaptation. As criticism was rejecting the Romantic view of works of art as containers for the "overflow" (as Wordsworth put it) of powerful feelings, so psychoanalysis began to grow restive under its model of the mind as a fogged transparency through which the trained observer could read out a determined narrative of drive and conflict. As Kris (1952) noted, psychoanalytic attention began to turn to the particular ways in which predetermined intrapsychic themes come to be represented in given individuals and to the specific strategies thus called repeatedly into play. In the realms of both art and psyche attention came to be focused on style: what had become compelling was the edifice discernible to eye and ear, the structural nuances and mechanisms of the given text.

It would be well beyond the scope of this study to document the parallel changes that have occurred in twentieth-century literature, music, and visual arts, and in the critical theories pertaining to each of these domains. I do wish to point out, however, that by the time publications by the so-called New Critics appeared, in the 1930s and 1940s, the same decades in which the major ego psychologists began to publish their contributions to psychoanalytic theory, it had become impossible, in the realm of the visual arts, for example, to ignore the formalist challenges offered earlier in the century by the many European varieties of post-impressionism, by cubism, futurism, and then abstract expressionism. The challenge of all these approaches to painting was to engage the active attention of the *eye* of the viewer, to force the viewer to look *at* rather than *through*, to see form rather than to read narrative or symbol. These paintings as a whole were intended to *be present* rather than to *represent*. The temporal propinquity of these parallel developments in the history of ideas and culture strikes with particular force when one notes that the conscious and unconscious ego functions explored in detail by ego psychologists such as Anna Freud (1936), Hartmann (1939), Rapaport (1951), and Kris (1952), including the mechanisms of defense, adaptation, and psychic integration, are precisely those that can be seen as giving rise to the formal qualities in art.

The painter who discriminates color, shape, and texture, who manipulates materials, makes aesthetic and practical judgments, exercises skill, intention, memory, and reality testing (as well as the poet who employs language as an organizer for these other functions), is engaged in high-level ego functioning, whatever else his behavior may involve, psychoanalytically speaking.

Hence, it could be argued that to analyze works from the vantage point of formalist criticism is to consider them first as products of the complex conscious and unconscious processes of the ego. Just as pathography has been able to refine the intuitive perceptions of the Romantic critics by naming and tracing the origins of specific unconscious fantasies, so ego psychology may help to refine our understanding of the formal qualities of art by bringing to bear its theories of adaptation, defense, and psychic integration. Yet can this be done if the artists whose works are in question are excluded from the interpretative context?

Is there a viable psychoanalytic approach to works of art that have been bracketed in this way? Is it feasible to use language designed to describe mental functioning when speaking about works of literature, music, and the visual arts without referring to the particular mental functioning of either the artists who created these works, the audiences who perceive them, or the critics who discuss them? The art form with which this approach has been tried most frequently is literature, particularly the novel and the drama, which, because they project a possible world of human characters in the medium of verbal language, seem to be the forms most likely to provide a sufficiently rich context for generating and/or applying psychoanalytic hypotheses. Prototypic of this approach is Freud's *Delusions and Dreams in Jensen's "Gradiva"* (1907), the first attempt to psychoanalyze a written text. Later, Freud also employed this general mode in his analysis of the Moses of Michelangelo (1914), as well as of myths, fairy tales, and tragic drama. He treated *Oedipus Rex, Hamlet, Lear,* and *Macbeth,* for example, but eschewed significant references to either Sophocles or Shakespeare.

The underlying assumption in these and other similar efforts at the psychoanalysis of autonomous texts is well put by Elizabeth Dalton (1979):

> whatever personal conflicts the work has come out of, if it succeeds as art it objectifies those conflicts. And therefore it should, by and large, explain itself; its most important references are internal. . . . although the configuration of unconscious meaning in the text is derived from the unconscious psychic life of the author, it is not necessarily coextensive or identical with it. (p. 28)

The two can therefore be separately discussed. Richard Kuhns (1983) puts it as follows: "Art is not simply a working through of the artist's problems and conflicts; it is a representation of universal communal conflicts in which everyone is entangled" (p. 103).

I take these statements as justifications for the attempt to apply psychoanalysis to autonomous texts. Kuhns claims that applied psychoanalysis must move away from the artist to the work of art; this is, according to him, its proper goal (p. 92). He deems it a mistake to look outside the work to the artist's life and declares that "the object itself and its own establishment of reality must be the focus of attention" (p. 115).

Accordingly, in this approach the manifest content of the work of art is scrutinized and "mined" for its own unconscious structure, its own latent themes. A clear danger here, as in pathography, is that venturing to interpret psychoanalytically, with only the manifest text as evidence, may lead even more precipitously to wild analysis and to its own insidious brand of reductionism.

Further, a number of serious problems are raised by this approach to works of art, particularly ontological problems. To use constructs that apply to the human psyche in discussing works of art, one must assume that such works *are* principally psychic products, a position that objective criticism, however, seems to abjure, or at any rate to minimize, since it chooses to see objects sui generis, divorced from their makers. If one provisionally allows, however, that works of art, taken autonomously, *may* be approached in psychoanalytic terms, one is left with dangling questions as to referents. If art works are removed from their makers, what sort of psychic products are they? What precisely *is* the context for interpretation: is it the work of art as a mental structure? To take such a position would be to deny the very input of materials, craft, and culture with which the objective critics are most concerned. Does one analyze invented characters as if they possessed minds of their own and life histories extending beyond what is given in the text? To do this would be to violate the boundaries of the text, so sacred to objective critics. Does one engage in self-analysis in the presence of works of art and therefore end up probing one's own unconscious mental life? This, again, is to exceed the boundaries of the given text. Does one simply extract a determined narrative of universal conflict, or read out a symbolic subtext in the manner of tour guides at Chartres who translate for the uninitiated the religious meaning of the magnificent twelfth-century windows? Possibly, in the best examples of this approach to psychoanalytic criticism, something of each of these modes enters in, but the methodology is highly complex and poorly accounted for by existing theory. Elizabeth Dalton's study of Dostoevsky's *The Idiot*, for instance, though a sensitive and persuasive example of the psychoanalysis of autonomous texts, fails to come to grips with these ontological issues.

If, as interpreters who employ this approach are wont to do, one casts aside these difficulties, there is yet another dilemma to confront. Even assuming that works of art possess unconscious structures that can be analyzed in psychoanalytic terms, one would do well to ask how such structures can be related to those formal or aesthetic structures usually attributed to works of art and, in fact, taken as fundamental to their definition as art. In other words, what is the relation between so-called unconscious structure and formal or aesthetic properties? Would it make sense to speak of a layering of "deep" and more superficial structures, to map a topography of interpretative levels ranging from instinctual wish to perceptual quality? This issue

bears on the question raised at the end of chapter 3, on how or whether the level of sublimation or neutralization could be tied in any predictable way to aesthetic value. Here too the normative question enters in, and unless one applies stock criteria, such as complexity, ambiguity, and multiple function, which philosophers of art have shown to be misguided (that is, there exist no critical criteria that have universal validity with respect to works of art, see Weitz, 1956), any clear correlation between the psychoanalytically derived structure and aesthetic value cannot be shown. In this respect, all versions of psychoanalytic criticism are on a par with other critical approaches to art.

Earlier I alluded to Rose's attempt (1980b) to equate certain aspects of aesthetic form with psychic processes. He calls attention to intriguing parallels involving such notions as separation and fusion, tension and release, control, and ambiguity. The ontological question, however, is evaded in that he never clarifies whether he is attempting to offer causal explanations for phenomena that exist (somewhere), or is merely noting linguistic similarities between constructs used to describe psychic phenomena, on the one hand, and aesthetic phenomena, on the other, or attempting to reduce the latter to the former.[1]

In spite of such difficulties, the effort to psychoanalyze autonomous texts has led to some noteworthy interpretative results.

Dalton and the Unconscious Structure of Literature

In her preface to *Unconscious Structure in "The Idiot": A Study in Literature and Psychoanalysis* (1979), Dalton explains why she has avoided using biographical material:

> Psychoanalytic critics frequently seem to compromise the autonomy of the work of literature as well as its meaning by interpreting it in terms of the author's life, rather than according to the unconscious patterns it can be shown to contain in itself. Because I wanted to demonstrate that unconscious meaning can be derived from analysis of the text alone, information about the author has been kept to a minimum. (p. ix)

Dalton argues that Freud always intended psychoanalysis to be a general psychology applicable to all products of mental life and quotes him as having told Jones at one point that he would like to give up the practice of medicine to occupy himself with unraveling the great cultural and historical conundrums. Taking this as a warrant, Dalton equates psychoanalysis with the interpretation of texts (p. 7) and claims that the principal task of the psychoanalytic critic is to discover "the unconscious structure" of works of art (p. 24).

1. It is interesting to note that in a recent paper, Perri (1984) has attempted to solve this dilemma by suggesting that we view literary texts as "possible minds" (p. 121).

The novel she has chosen, she points out, has often been attacked for its apparent lack of structure. She cites Henry James's descriptions of great Russian novels as "baggy monsters" and "fluid puddings" (p. 24), but claims that by the use of psychoanalytic hypotheses she will reveal the unconscious structure of *The Idiot* and thus discover its underlying organic unity. To do this Dalton must confront the question I raised earlier about the relations between psychological and aesthetic necessity. Although she seems to sense a problem here, she neither identifies it nor attempts to solve it. Maintaining that the conscious efforts of artists to create and control structure in their works cannot be accepted by psychoanalytic critics as sufficient explanations for the sense of unity in any given work, she presumes the existence of a "psychic configuration that governs the work" (p. 25), a psychic configuration that, by inference, is largely unknown to the artist. If by this Dalton means a psychic configuration reflecting unconscious fantasies of the artist, as is the object of inquiry in pathographic interpretation, her work would pose only the problems already brought to light in chapters 2 and 3. As it is, however, she means to locate a psychic configuration in the work itself—that is, *Unconscious Structure in "The Idiot"*—and this is a notion that requires careful scrutiny.

For Dalton's claim seems to rest on a number of doubtful and irreconcilable premises: (1) conscious structure (the artist's planned design) is insufficient to explain the coherence of works of art (pp. 24–25); (2) structure unconscious to the artist exists in works of art and governs them according to an "internal necessity" (p. 25); (3) we need not refer to external data about the artist or know the artist's associations (in any form) in order to infer and interpret such structure (p. 28); (4) this unconscious structure, presumably because it is present in all works, does not guarantee that the overall effect of any work will indeed be unified and aesthetically satisfying (p. 29); and (5) works formerly similar to "soggy puddings" can coalesce if we apply psychoanalysis and reveal unconscious structure (p. 24).

Her first premise appears unassailable. Although art historian Leo Steinberg, in his review of Liebert's *Michelangelo*, objects that "artists, if they are any good, preside over their work with eyes open" (1984, p. 45), it has long been obvious to philosophers, artists, and critics that all aspects of creative processes are by no means under the conscious control of the artist. This point seems indisputable, even trivial, except that, judging from Steinberg's recent protestation to the contrary, it clearly bears repeating. What is problematic about Dalton's formulation, however, is the implication that unconscious factors confer organized structure upon works rather than that the artist's conscious manipulation of formal elements confers order on the chaos of deep and primitive material. Her position, taken seriously, wrests control of their works out of the hands of artists in a radical way, opening her to precisely the sort of attack that Steinberg levies.

Dalton's second premise is intimately connected to her first. Internal ne-

cessity in works of art, she claims, derives from their unconscious structure, which is by definition unknown to the artists who create them. Thus, one need not go beyond the works to discern this structure. If, however, unconscious structure is defined as that which is outside the artist's awareness, how can it be identified as such without in fact having recourse to the artist? How can decisions be made as to which elements of any work are primarily consciously or unconsciously determined without having a larger context to draw upon than the specific work at hand? To go a step further, granted that any given work not only possesses aspects not planned by the artist but even those not consciously available to him, and granted that one can somehow divine those elements without appeal beyond the boundaries of the work, on what basis can the dynamic roles played by such elements be identified? On what basis can they be considered wishful or defensive, autonomous or conflicted, alien or syntonic, progressive or regressive? Dalton claims that such interpretations can be made on the sole basis of the givens in the work itself. Yet she herself defines unconscious elements with respect to the artist. *Unconscious*, after all, either means "not conscious to someone" (in which case we are obliged to deal with that someone) or refers to a predetermined, superordinate realm such as that of Jung's archetypes (specifically rejected by Dalton as critically unhelpful and reductionistic [p. 17]).

On what grounds, then, does she locate within literary works an unconscious structure, a psychoanalytic subtext that exists independent of the artist? Here is her definition:

> The unconscious configuration in the work is the form of the work as it is *experienced emotionally*—a complex internal system of correspondences, oppositions, and tensions that operate dynamically through the *manipulation of the reader's attention and feeling*. (pp. 28–29, emphases added)

This description of the unconscious structure of a literary work so vigorously implies both an artist and an audience, and in fact assigns such starring roles to each of them, that we are left groping for the very text she asserts "has priority" over them. By the terms of her own definition Dalton contradicts her earlier statement that unconscious meaning can be derived from the analysis of text alone and acknowledges that works of art possess their psychoanalytic subtexts not apart from artists and audiences but with respect to them. More serious than inconsistency in her formulations is her failure to emphasize that it is precisely the complex interactions among author, text, and reader that constitute the psychoanalytic subtexts of works of literature (and the other arts).

Dalton's other premises, as I read her, contradict each other as well by claiming that unconscious structure (the psychoanalytic subtext) does not guarantee aesthetic quality while maintaining that seemingly amorphous works cohere into structural unity when their psychoanalytic subtexts are revealed.

Such inconsistencies are characteristic not only of Dalton's views but of similar attempts to psychoanalyze autonomous texts. The difference is that few other authors writing in this mode have made a comparable effort to articulate the theoretical underpinnings of their interpretative maneuvers.

Freud's experience with the Dora case is paradigmatic for what is missing in this model. Freud's interpretations in this case were indisputably brilliant and accurate; yet he failed in his treatment of this adolescent girl. The reason for his failure was his inability at that early moment in the history of psychoanalysis to value fully and to understand technically the workings of the transference. It is the recognition and use of transference that, in my view, distinguishes psychoanalysis from all other interpretative theories, and it is precisely the absence of this crucial dimension that impoverishes most theorizing about psychoanalysis and art, including the theory of autonomous texts.

Psychoanalysis is not simply an interpretative exercise. Here are Freud's words from his postscript to the Dora case:

> [Transference] happens, however, to be the hardest part of the whole task. *It is easy to learn how to interpret dreams, to extract from the patient's associations his unconscious thoughts and memories, and to practise similar explanatory arts*: for these the patient will always provide the text. Transference is the one thing the presence of which has to be detected almost without assistance and with only the slightest clues to go upon, while at the same time the risk of making arbitrary inferences has to be avoided. Nevertheless, *transference cannot be evaded*, since use is made of it in setting up all the obstacles that make the material inaccessible to treatment, and since it is only after the transference has been resolved that a patient arrives at a *sense of conviction of the validity of the connections which have been constructed during the analysis.* (1905, pp. 116–117, emphases added)

Freud is saying in this passage that psychoanalysis does not offer only a sacred text or concordance that we can master and with which we can then go forth to interpret hidden symbols in human behavior and cultural objects. Rather, it involves a monitored and applied awareness of our own deeply personal, tortuous involvement with, and vulnerability to, the texts we are endeavoring to interpret. Dalton seems to understand this when she deplores what she calls the "mechanical translation of symbols, without sufficient attention to context" (p. 34), but I think she misjudges the boundaries of the context she herself uses.

The issue is raised by pathography, but it is especially compelling here in that critics who claim to look at works of art "objectively," to "find in [them] the objective psychological order that evokes fantasy and emotion in all readers" (Dalton, p. x), run perhaps a greater risk of presenting their findings as revealed truth. Paradoxically, Dalton acknowledges the critic's need to make use of his subjective responses, but she excludes these responses from her definition of interpretative context. She suggests that such subjective

responses must lead one into "the unconscious life of the text itself." As I see it, however, what is manifest in the text provides an opportunity, a script as it were, for certain depths of subjective experience and leaps of insight on the part of a reader, some of which is made possible by a prior, corresponding, but by no means equivalent experience on the part of the artist (see Kris, 1952, pp.54–62). Again, the question revolves around how we choose to define boundaries.

However, if we agree that one major contribution of psychoanalysis to our understanding of the arts is its illumination of emotional factors (note Dalton's definition, quoted above), then central to such understanding must be the circuitous displacements of feelings and attachments from one object to another and from past to present—the transference reactions—which occur not just between an author and his work during the process of creation, but in critics during their private reading, before, during, and after the writing of public critiques, and in the subsequent readings of critiques by others. Sensitivity to the rippling effects of these transferences, though they lead beyond the boundaries of strictly internal textual reference, provides that richness of context and authenticity necessary to the "sense of conviction" of which Freud speaks. The finest examples of psychoanalytic interpretation among the models I present resonate with such transferences, though often these transferences remain uninterpreted, overlooked, or disavowed.

Dalton opines (as does Liebert, with respect to the fine arts) that "the application of psychoanalytic ideas to literature now arouses a great deal of resistance" (p. 12). While she attributes this resistance to "a general reaction against the rigor and complexity of Freud's thought" (p. 12), I submit that it proceeds from precisely the same failures we have observed in Freud's handling of the Dora case—from a lack of sensitivity to transference reactions and from insufficient respect for defensive stratagems. Keen and accurate psychoanalytic interpretations are destined to be resisted. Indeed, they inevitably must be resisted, though they can lead to insight within the context of a primed relationship. Therefore, the psychoanalytic critic who overlooks the relevance of his own unconscious agendas, ignores those of his chosen author, and denies those of his readers may risk losing his case. Like the notorious surgeon, he may perform with consummate skill a perfect operation and yet witness the demise of his patient. I think Dalton's worry about the hostile reception of psychoanalytic criticism has less to do with her colleagues' awe in the face of Freud's genius than with the distortion and misuse of psychoanalysis by certain psychoanalytic critics, who behave as though they were (as one of Greenson's patients once put it) "cold-blooded [un]paid interpreter[s] of unconscious goings-on" (Greenson, 1974, p. 517).

The theoretical position (typified by but certainly not limited to Dalton) that identifies unconscious structure as inhering in works of art viewed as autonomous, entails a number of problems: (1) it confuses categories by

applying to works of art terms appropriate to mental function, after defining works of art as more than the psychic products of their makers; (2) it fails to clarify how such terms are to be understood in their transposed context; (3) it distorts psychoanalysis by reducing it to an explanatory discipline, thus slighting the crucial and complex determining factors of transference and countertransference; (4) it avoids the discrepancy between finding an objective order that touches all readers and the possibility of multiple divergent meanings not accessible to all readers; (5) it commits the "heresy of paraphrase" so vehemently attacked by Brooks (1947, p. 201) and other critics of this school by extracting statements of unconscious meaning analogous to statements of "rational meaning," which tend to splinter works of art, severing form from content; (6) it bypasses the difficult question of what actually constitutes a sufficiently rich context for applied psychoanalysis, a context that yields interpretations difficult to dismiss as "wild" or trivial, interpretations that (for at least some readers) ring true without appeals to shibboleths of psychic determinism and overdetermination.[2]

To proceed strictly in accordance with the theory of autonomous texts, an interpreter must be seen as an anonymous authority, an expounder and abstracter, endowed with special knowledge and sanction. His task is to reveal, as Kuhns avers, the "universal communal conflicts" with which art deals. Freud points out, however, that this is the easy part. At least as important (and more exciting and difficult from a psychoanalytic as well as a critical perspective) is confrontation with the impossibility of interpretative closure: for example, it is quite reasonable for Shakespeare scholars to expect new and "definitive" works on Shakespeare to be published every few decades—not because the texts change but because we change (see L. Stern, 1980, p. 126).

Dalton demonstrates her awareness of this problem when at the end of her book she asks rhetorically whether she has plumbed the deepest layer of meaning and replies: "This deepest meaning may be only a sort of false bottom, beneath which lie still further meanings; at the heart of the maze there may be still another maze" (p. 183). The reasons for this potential infinity of meaning lie, I believe, in the particularity of the critical (as well as the analytic) enterprise, in the relentlessness of history, the paradoxical uniqueness yet ubiquitousness of transference, the tenaciousness of resistance, and the indeterminacy of works of art, all of which require that both the psychoanalysis of the human psyche and the interpretation of art be ongoing, or, as Freud puts it, interminable.

If I have persuasively shown defects in the objective theory of psychoanalytic criticism, I am now at pains to explain the odd circumstance that,

2. This is a question that is being seriously raised today in the clinical sphere as well, where increasingly smaller units are being mined for their diagnostic, prognostic, and interpretative possibilities.

despite these flaws, we do occasionally find, among the chaff of absurdly simplistic readings of literary texts, some fine and persuasive examples of this model in practice. A prime case in point is Dalton's own interpretative work on Dostoevsky's novel *The Idiot*. How is it that so fragile a theory occasionally spawns such beautiful examples? Partial reasons for this discrepancy have been implied, and others, closely related, are to be found in the work of Meredith Skura (1981). I am convinced that those comparatively rare psychoanalytic critics who have worked well with individual texts simply do and must go beyond the texts at hand. Their tacit knowledge of author, period, literary tradition, and medium (language); their fine tuning to intimate emotional resonances with works at hand; and their grasp of recurrent patterns in their own intrapsychic life and personal history, as well as their clinical skill (when that is present), nourish such interpretations and infuse them with authenticity.

Dalton, prime example of this phenomenon, claims that she will abjure extra-textual reference, but then, just before embarking on her interpretation of *The Idiot*, prepares her reader for this journey with a compelling chapter on Dostoevsky's feelings about the novel. She includes extensive quotations from a letter to his niece on the principal ideals he felt he was attempting to instantiate in it (through Prince Myshkin) and previous models by other writers that he hoped to surpass, his despair over projected failure, and the intensely conflicted feelings—hopes, fears, and ambivalences—entangled with his artistic themes. Two prominent Dostoevsky critics are quoted. Dalton recounts the hysteria and frenzy surrounding the composing of the work and refers to Dostoevsky's gambling mania, which apparently resurfaced during his writing of *The Idiot*. She informs us that the novel was composed at a furious pace, that Dostoevsky spoke of flinging himself at it headfirst, that he saw it as his only salvation and as a desperate risk, thus inducing a self-state of terrible apprehension, which, Dalton speculates, "forced out" material from the deepest reaches of his psyche.

This forceful chapter belongs more to the pathographic model than to the one Dalton is nominally espousing. It functions in the critical enterprise to set up a frame for what is to follow, to expand the context for psychoanalytic interpretation. Dalton primes our relationship with her, with Dostoevsky, and with the novel in such a way as to create a "working alliance." We are, after reading it, better equipped to receive her interpretations, to accept her as our guide. A similar expansion of the context also occurs in the Appendix of her book, where Dalton analyzes the notebooks Dostoevsky kept during his writing of *The Idiot*. Though none of this material belongs to the text of the novel per se, I submit that its inclusion in Dalton's book serves not merely to round out her interpretative efforts but to confer upon them a fair measure of their genuineness, their accessibility, and their sense of rootedness.

Skura and the Use of Process

Meredith Skura (1981), another recent theorist who chooses to limit her interpretative context to the individual work of art, describes her approach in more expansive and dynamic terms. Therefore she offers certain correctives for the theoretical limitations of Dalton's model. She begins by drawing attention to psychoanalytic *process*, to

> *psychoanalysis as a method* rather than a body of knowledge, *as a way of interpreting* rather than as a specific product or interpretation. I am interested in psychoanalysis not so much for what it reveals about human nature . . . but for the *way in which it reveals anything at all*. A sensitivity to the delicate changes in consciousness taking place moment by moment in the actual process of an analytic hour can lead to a renewed awareness of the possibilities of language and narrative—an awareness that will increase our range of discriminations rather than reduce them to a fixed pattern, as the theory tends to do. (p. 5, emphases added)

Thus, Skura does not consider the application of psychoanalysis to literature to be the probing of texts according to well-defined theories of mental function that incorporate interpretative rules. She sees it, rather, as the use of subtle processes analogous to those that occur in the clinical setting, where "mutual reorganizations rather than divine revelations" (p. 270) constitute both the experience and the goal. Her interest is in exploiting the method of psychoanalysis for application to literature rather than in affirming its preserve of information and its claims to truth. The latter, she asserts, lead only to reductionist results, such as the familiar unmasking model, in which the surfaces of works of art are "stripped away" in order to expose what lies beneath. One danger of such an exercise, as L. Stern (1980, p. 127) points out, is that the text, instead of being illuminated by the interpretation, becomes hidden behind it.

Skura proposes, instead, to keep the work of art intact and to regard the analyst as "a connoisseur of strange relations, not between conscious and unconscious, but between different modes of consciousness which work both together and against each other in shaping each aspect of the material" (p.11). Skura, therefore, unlike Dalton, is not in search of the "unconscious structure" of literary works. She seeks rather to probe the capacity of psychoanalysis to increase our awareness of the complex patterns of "kaleidoscopic recycling" through which we experience and represent our worlds to ourselves and to others. But where in all of this is the literary text?

Skura, holding that "psychoanalysis is a dynamic discipline, not a formulaic one" (p. 13), proposes that the literary text may be conceived of in various ways. She identifies five models which are derived from the clinical process: these range from case history to fantasy, dream, transference, and, finally, the entire psychoanalytic process. She documents the historical significance of each model in terms of Freud's developing theory and practice. Rather

than examine her various approaches with the thoroughness they merit, I shall touch on just two topics that bear on our earlier discussion: the ontological problems attendant upon the psychoanalysis of literary characters and the question of the relations between aesthetic and psychological structure.

On the Psychoanalysis of Fictional Characters Skura argues against the psychoanalysis of literary characters, and in so doing she takes a heterodox step that bears scrutiny. After all, this practice has been the stock in trade of most of her predecessors, including, of course, Freud. Freud, as is known, had no compunctions about psychoanalyzing literary characters and indeed based a central tenet of his theory on the dilemma of one of Sophocles' characters. In fact, his intrepidity in this endeavor has served as license for a raft of analyst-critics who, since the earliest days of the psychoanalytic movement, have embarked boldly on quixotic journeys into the intrapsychic lives of fictional characters unmindful of the ontological questions prompted by their adventures.

Among the examples that abound is the Barchilon and Kovel study (1966) of *Huckleberry Finn* (not mentioned by Skura). The authors, taking a familiar tack, announce that they have refrained from consulting any biographical material concerning Mark Twain. They are concerned with the novel in its own right, shunning external reference. Their general method is to treat "novels as if they were life histories of real people" (p. 776). Nevertheless, though eschewing a pathography of the author, they proceed immediately to contruct a pathography of the novel's principal character. They "reconstruct" his putative past life and freely diagnose him as a patient:

> In this analysis, we believe to have uncovered the exquisite psychological consistency of the character of Huckleberry Finn. In fact, the interplay between his unconscious (reconstructed) nuclear conflict and its derivatives is so unbelievably congruent, that one could indeed make a fairly precise metapsychological formulation of Huck's psychic equilibrium. (p. 808)

Skura argues persuasively against just this sort of practice and its concomitant pinning of grandiose "psychoanalytic tags." She points out that to treat characters as if they were people is to fail to recognize that works of art serve as limiting contexts for all their component parts, including the characters who inhabit them. In emphasizing the error of confusing characters with human beings, Skura calls attention to the dual qualities, aesthetic and psychological, of every literary text, as well as to problems of reference. Her premise that a literary character is only one aspect of a complex work that invites multiple readings gives rise to a view of characters as, for example, foils for, or extensions of, the general feeling-states that pervade an entire work. A character may represent a fragment of some larger conception whose other pieces are scattered throughout the landscape and in other images (a formulation that calls to mind Bion's construct of pathological "bizarre ob-

jects" that arise as a result of secondary splitting). A literary character may seem wooden and static because whatever has been subtracted from his manifest psychology has been introduced elsewhere in a complementary image that, for its part, appears similarly impoverished or exaggerated. As plots unfold, characters may assume varying roles and functions in accordance with overall requirements and demands. Thus, for Skura, a character is hardly equatable with a human personality, but is, rather, a facet of the overall design of a work of art. In this regard she agrees with the New Critics, as well as with anti-intentionalist aestheticians like Beardsley, whose primary concern is always to perceive and preserve "total pattern," "essential structure," the unity of form and content.

Moreover, Skura distinguishes between the unconscious and the irrational, arguing that literary texts provide examples of the latter rather than the former; that is, literary characters exhibit irrational behavior rather than unconscious conflict. Citing Hamlet as a prime example, she illustrates the difference between fantasizer and fantasy. According to Skura, it is *Hamlet* the play that re-creates an (oedipal) fantasy, not Hamlet the character. Fantasy exists not in the "mind" of Hamlet (wherever that might be)[3] but in the totality of the play. Madness, rottenness, and conflict are instantiated in the unfolding of the drama. Its many levels of tension are evoked, moreover, not only internally (by plot, setting, sound) but also externally, through ironies in the skewed experiences of characters on stage and spectators in their seats. For Skura, it is the interplay of all these elements drawn from different aspects of a work—contradictions, gaps, and missed nuances—that constitutes its intrigue and attracts interpretation. Likewise, while nominally limiting her context, Skura expands its boundaries as well to include elements missing from stricter versions of the theory.

She sees in *Hamlet* not an elementary psychoanalytic equation between Hamlet's plight or pathology and the oedipal plot but, rather, a "branching tree" of fantasy (p. 83), with its roots in primitive undifferentiated infantile experience and its derivatives continually shooting forth in all directions, all the way up the tree trunk, existing simultaneously, and, as she puts it, "kaleidoscopically recycling" in the text (p. 96). She reminds us how unsettling the play is on every level, how impossible it becomes to tell who is doing what to whom, as

> Claudius poisons both sword and cup; he pours poison into the King's ear and drops poison into the Queen's cup.... And this crime spreads to "poison the

3. To compound the confusion entailed by any attempt to locate oedipal fantasy in Hamlet's "mind," one might consider the somewhat more plausible but equally unsatisfactory possibility of locating oedpial fantasy in the mind of whatever actor happens to be playing Hamlet in a given performance.

ear of Denmark" and taint all human communication, as people "take," "beg," or "assault" each other's ears throughout the dialogue. (p. 97)

Exploring the bewildering possibilities of the text, rather than attempting to read out a psychoanalytic equivalent of mathematical identities, she speculates:

> Is Hamlet taking Hamlet senior's place and repeating Claudius' crime, or is he punishing Claudius and undoing Claudius' crime? Is brother (Claudius) pouring poison into his brother's (the older Hamlet's) ear, as in the play-within-a-play? Or is nephew (Hamlet) pouring poison into his uncle's (Claudius's) ear as in the dumb show? Or is the son pouring poison in his father's ear, if we short-circuit the two actions? (p. 97)

Skura's questions proliferate as she demonstrates how psychoanalytic process can pursue the multitude of meanings branching outward from a given text.

On Relations between Aesthetic and Psychological Fitness In this branching-tree image, Skura suggests a tentative solution to the question of the relation between psychological and aesthetic fitness. Although the literary text, the work of art, does not, according to Skura, possess an unconscious structure of its own, it both presents and evokes a web of possibilities with roots in primitive fantasy. Yet the task of the psychoanalytic critic goes far beyond labeling each fantasy or even identifying primitive levels of organization. His role is to experiment (through openness, a controlled naiveté, a species of "evenly hovering attention") with different ways of reading and attending, ways that bring alternative patterns to light and display the proliferating network of even more elaborated fantasy that characterizes the enterprise of art.

How relevant are these alternative patterns to the aesthetic effect of the work of art? Skura on this issue is again close to the views of the New Critics, particularly Empson, who, in trying to sort out—after expounding his seven types of ambiguity—which meanings of a phrase or line are relevant or effective, describes the dilemma as follows: if one takes an excessively hedonistic view, admitting all associations, one destroys the text by dissipating it; whereas if one takes an ascetic view, stripping the text of all associations, one also destroys it (1947, p. 234). Not surprisingly, Empson, like Skura, comes down squarely on the side of multiple meanings and associations, thus holding with Graves that a poem means anything it can mean. I can well imagine Skura smiling at Empson's ingenuous conclusion, in the midst of his own thoughtful deliberations on this problem, that "most of the ambiguities I have considered here seem to me beautiful" (p. 235).

Thus, for both Skura and Empson, the psychological and the aesthetic are felt to be contiguous. But even if one agrees with them that texts are unstable enough (Skura, p. 242) to compel readings for ambiguity, one might ask

how far such a process can go. Interpretation may be open-ended and works of art indeterminate, but unless one resembles Borges's mentally omnivorous character, Funes the Memorious, there comes a point where new readings exclude the old, where to perceive means to disregard. Skura tries to solve this problem by reminding us, as does L. Stern (1980), that interpretations are undertaken for a variety of agendas. She implies that knowledge of such agendas (conscious and unconscious, I should add) might help the analyst in explaining interpretative choices, in deciding how far to go and how, in individual cases, his awareness of psychological complexity affects his sense of aesthetic fitness and pleasure. (It would be interesting to consider, in this context, how and in what measure such choices differ when psychoanalysis moves from the critical into the clinical arena.)

On the matter of the aesthetic relevance of ambiguity and of how far we can go with it, Empson tries to help by simply affirming aesthetic pleasure. He points out that, after all, "unless you are enjoying the poetry you cannot create it, as poetry, in your own mind" (p. 248). Therefore, it might prove helpful to include the maximizing of pleasure on the interpretative agenda. But, like Kant in his analysis of the antinomy of taste, Empson soon realizes that this turns out to be futile because, at one end of the spectrum, as he puts it, there are readers for whom "the object of life, after all, is not to understand things, but to maintain one's defenses and equilibrium and live as well as one can; it is not only maiden aunts who are placed like this" (p. 247). At the other end of the spectrum are those like Empson, whose sympathies lie with readers "who want to understand as many things as possible, and to hang those consequences which cannot be foreseen" (p. 248). For Empson the relations between aesthetic and psychological fitness in works of art finally come down to the pluck of the beholder. In this respect, his position reminds one of the ordinary criteria for analyzability, for to pursue the implications of both art and psyche requires fortitude and flexibility, or perhaps an ego that functions like a dancer's body—supple, muscular, capable of strength, stretch, and endurance.

Whether this is true because art possesses an unconscious structure of its own or because it serves as a spur to fresh areas of conscious awareness is more a matter of theoretical than practical disagreement in the model of autonomous texts. The finest examples of psychoanalytic interpretation from various theoretical perspectives all exhibit that fascination with ambiguity which Freud first began to explore in *The Interpretation of Dreams*.

Before leaving this model, I should like to point to one example that highlights the theoretical differences I have been exploring. Empson notices that opposites defined by their context can be suggested to the reader by a unique characteristic of the negative. He cites the first line of Keats's *Ode to Melancholy* (p. 205), in which the presence of four negatives in eight words

compels the reader to recognize the enormous strength of some regressive pull, whose tide is stemmed only with equally great energy:

No, no; go not to Lethe; neither twist. . . .

Empson points out that the four consecutive negatives evoke an immediate experience of tension, not between the opposites given in the words on the page but between all those no's and the *unspoken* yes.

But where is the unspoken yes that in this case forms the other pole to which aesthetic tension is stretched? Dalton would locate this yes in the "unconscious structure" of the poem. Empson, however, moves freely outside the text and tentatively locates it in "the poet's mind," in "somebody's" mind, and mentions "you" and "the reader." Empson even says at one point that those who enjoy poems must in part be "biographers" (p. 242) and, I would add, autobiographers. Wherever one chooses to locate the unspoken yes, the recognition of its influence on the experience of the line is what makes good psychoanalytic criticism. For Iser, Keats's poetic line itself would constitute the artistic pole; whereas, the agony experienced over one's desire to drift back into passivity, sensation, and/or death would constitute the aesthetic pole. Here, too, psychological and aesthetic structure come together. The essential point, however, is that to understand the *nature of the regressive pull*—to realize *what* the unspoken yes is an assent to, to empathize with whatever it is that "going to Lethe" can mean and evoke—it is indispensable to expand the boundaries of the given text. To recall Cioffi's argument against Wimsatt and Beardsley: the distinction between internal and external evidence doesn't hold up. One always throws a field of force around a work and responds to it according to what one knows—about Keats, about one's self, and about poetry.[4]

My major criticism of Skura is that she does not go far enough with her emphasis on process. Because psychoanalytic process entails an "I" and a "thou," however, I have chosen to develop further ideas on this topic in chapter 5, under the general heading of aesthetic experience. I have already suggested that a more comprehensive consideration of the role of transference is indicated, and I would add to that the need to study the central role of empathy. Skura, although paying homage to psychoanalytic process, falls short of treating these phenomena adequately.

Further, Skura does not explore the (admittedly murky) relations between psychoanalytic theory and practice in her own work. She never ventures beyond deploring the sort of reductionism to which we have frequently alluded. Yet she uses theory in her own approach; in fact, she is remarkably

4. It seems inconceivable that without knowledge of Magritte's mother's suicide Wolfenstein's incisive psychoanalytic interpretations could have arisen.

eclectic in her choice of theory, drawing upon a range of authors including Schafer, Erikson, Lacan, Winnicott, Kris, Loewald, and Masud Khan, as well as Freud. She does not explain how she makes choices among this array of disparate psychoanalytic theoreticians—how she justifies, for example, her omission of object relations theorists such as Klein, Jacobson, and Mahler, or includes scattered references to, say, Pontalis and Lacan. If she intimated that psychoanalytic process and theory are not in fact quite so easy to disentangle and offered a rationale for her own theoretical choices, her work might serve as a more useful guide for others and bear a less idiosyncratic cast.

Naturally I make this point in full awareness that the relations between theory and practice are nowhere fuzzier than in present-day clinical psychoanalysis, where many public theories compete, but where what goes on in the private consulting room remains obscure and dubiously linked with theory. One might see similar discrepancies between the public criticism of literature and the private act of reading—something that Empson explores (see chapter 5, below).

Clearly Skura's forte, like that of most psychoanalytic interpreters, is to demonstrate her method rather than to ground or justify it. We are indebted to her contribution to this interdisciplinary dialogue because, through a brilliant choice of examples, ranging from Chaucer and Shakespeare to Dickens, she opens doors to a view of psychoanalytic interpretation as an expansion of consciousness; because she passionately insists on preserving the integrity of the whole fabric of the text; and above all because she insists that this can all be done by looking *at* the text and not *through* it.

EARLY EGO DEVELOPMENT AND THE ROOTS OF ARTISTIC STYLE

I have suggested that psychoanalysis has been applied not only to particular works of art but to larger phenomena in the history of art, such as artistic styles and periods. An excellent recent example of the latter is to be found in Steinberg's (1984) work on the sexuality of Christ. Notable work on more general topics has also been done by Erikson (1963), Gombrich (1963), Gay (1976), and Kuhns (1983). In keeping with these efforts to apply psychoanalytic ideas to more universal issues in the arts, I propose to speculate on the puzzle of the origins of artistic style. I shall be concerned not with style as it is manifested in the iconography of a particular historic period and geographic locale (see Panofsky, 1953), nor as it develops formally from one era to another (see Wölfflin, 1932), but, rather, as it characterizes the oeuvre of the single artist who works in a medium and a genre in a given place and time. Unlike Gay's (1976), my aim is not to trace the causal input of culture, craft, and private sphere on the solitary artist but to apply to this riddle of

style insights gleaned from psychoanalytic developmental theory and research.

Peter Gay, in his tripartite monograph on style in Manet, Gropius, and Mondrian, beguiles us with several paradoxes. He attempts, for example, to show that Manet, generally regarded as one of the most aggressively personal, highly individual, and original of artists, was, in fact, deeply dependent on cultural context for his art; that, indeed, his originality can be understood only in terms of this cultural context; whereas Mondrian who, Gay implies, is often thought of as epitomizing the zeitgeist of early twentieth-century abstract art, cannot be properly understood without careful attention to certain highly idiosyncratic and marked characteristics of his obsessive personality. Gay's thesis is that the dimensions of cause in any event in human history (among "events" here he includes both particular works of art and "historical actors," p. 11) fall into three categories: culture, craft, and the private sphere. He implies that although one might assign the preponderance of influence (or, one might say, causal priority) on a given event to any one of these three spheres, historians (and art historians) have tended to favor the first and to slight the latter two. Gay's response is to demonstrate the relevance of the neglected spheres of influence to an artist's life and works.

Somewhat closer to my own concerns is a recent article by Emilie Kutash (1982), who seeks to derive an understanding of modern abstract expressionist and minimalist painting style from psychoanalytic theories concerning self psychology and early ego development. Kutash tries to demonstrate a connection between the physical sensations and spatial experiences evoked by certain post-World War II American abstract painters (for example, Rothko, Noland, Still, Newman, and Stella) and archaic experiences in the development of the body ego. Her paper does not clearly differentiate the perspective of the painter from that of the viewer of the painting; rather, it is a general attempt to utilize selected aspects of psychoanalytic theory to account for the emotional impact and significance of what she has called "contentless modern art" (pp. 171–75).

Kutash claims that the human figure in art, a major classical subject, has gradually become fragmented (she cites Duchamp's *Nude Descending* . . . , p. 172), and she speculates on the defensive function possibly served by such fragmentation at a time of worldwide anxiety and tension (p. 168). The intact human figure, she contends, has virtually disappeared as a subject of contemporary art, leaving nonhuman forms which correlate with our most primitive awareness of the body-self in space. She quotes Piaget as designating proximity, separation, order, enclosure, and continuity as the child's most elementary spatial relations (p. 169). Subsequently, she traces these very elements in the works of the American abstract painters mentioned above, claiming that their general preference for such two-dimensional spatial schemata relates to the very earliest perceptual experience of the infant, before spatial depth has been explored by reaching arms, vertical body, and toddling

legs. She associates the "zips" in Barnett Newman's paintings (vertical lines that bisect the monochromatic fields of his canvases), for example, with the upright posture a child finally attains, man being, as she reminds us, the one creature who walks upright. Color field paintings are related to Lewin's (1946) dream screen and to Isakower's (1938) theory of the nursing infant's experience of a flattened, expanded breast. It is interesting to note in this connection that Peter Fuller (1980), in discussing color-field paintings from a British object-relations perspective, has emphasized their capacity to draw viewers into an experience of merging, of both ecstatic and terrifying boundary loss. Kutash also points out that many of the artists she discusses (for example, Pollock and Newman) use oversize canvases that force upon their viewers the physical sensation of being dwarfed by looming size, again a typical experience from earliest childhood.

Kutash offers other similar suggestions, and she is persuasive in that the paintings she has chosen do invite interpretation along the lines she explores. One must be careful, however, not to claim too much. I am convinced that, although the regressive, somatic attractions, almost seductions, to which she alludes significantly contribute to the aesthetic pleasures of a Clyfford Still, an Ad Reinhardt, or even a Kenneth Noland, one must also come to terms with skill, subtlety, the quality of each painting taken individually, as well as the direction of each artist's growth and achievement over time. None of this can be addressed by the eclectic theoretical framework offered by Kutash. Indeed, her interpretations may relate more directly to the experience of viewers than to that of the painters (though only careful research could prove this point). What Kutash's work demonstrates, in my view, is the possibility of relating the theory of early ego development to a theory of aesthetic experience.

But important questions remain. Clearly she has shown that knowledge of primitive spatial and bodily experience can contribute to an understanding that includes other sorts of explanatory hypotheses, but how is it that any one theoretical orientation is more appropriate than another for a particular stylistic period? Why are the same psychoanalytic hypotheses not equally applicable to seventeenth-century Dutch landscape paintings and Egyptian reliefs of the Amarna period? How does one define limits for the applicability of any one aspect of the theory? Although this is a thorny matter that many psychoanalytic theorists have preferred to dodge, my sense of it is that the relative strength of any of the various psychic components of style will differ according to cultural context, individual input, and the possibilities and limitations of the medium. Thus, my categories resemble those of Gay. Furthermore, I do believe that the art of a given period (such as that targeted by Kutash) might lend itelf more legitimately to one interpretative emphasis than another. Missing from Kutash's construction, however, are many pieces, including (as is generally the case) knowledge about the psyche of the in-

terpreter, whose own agendas, needs and desires, perceptual acuity, biases, history, and aesthetic preferences will always codetermine the direction of any interpretative focus. Her contribution, however controversial, is noteworthy as an attempt to apply psychoanalytic theory to a period style.

Ego Function and Style

Cennino Cennini begins his celebrated handbook of painting, *Il Libro dell'Arte*, by defining his profession as:

> an occupation known as painting, which calls for imagination, and skill of hand, in order to discover things not seen, hiding themselves under the shadow of natural objects, and to give them shape with the hand, presenting to plain sight what does not actually exist. (1960, p. 1).

John Dewey has said:

> What most of us lack in order to be artists is not the inceptive emotion, nor yet merely technical skill in execution. It is the capacity to work a vague idea and emotion over into terms of some definite medium. (1979, p. 75)

These remarks by a fifteenth-century Italian painter and a twentieth-century American philosopher suggest a picture of art, artist, and art-making that cannot be encompassed by understanding drawn from psychoanalytic drive theory alone. The quotations, if taken seriously, demand a broadened range of inquiry that includes such notions as "skill," "capacity," and "working over" something vague into that which takes "shape with the hand" in a "definite medium." I have suggested that ego psychology, by including the perceptual, motoric, cognitive, and other realms of experience, makes possible an extended psychoanalytic discussion of art not feasible when the investigation is limited to unearthing the contents of the dynamic unconscious of the artist.

An approach based on drive theory and a topographic model of the mind imposes limitations on the understanding of psychic apparatus as well as on the capacity to encompass aspects of the aesthetic. Fundamental areas of concern in the arts are left untouched by that model because relevant mental functions, such as perception, judgment, adaptation, and symbolic process are not its major focus. Even more decisive is the point that psychoanalytic drive theory simply offers no language in which to discuss basic features of the arts, such as skill, technique, the sense of design or color, style, and form.

What interdisciplinary contribution can we expect, then, from ego psychology, a body of theory with outstanding potential for addressing aspects of art central to Cennini and to Dewey? My major interest is in exploring the implications of ego psychology for the development of style, particularly the relevance of early body ego experience and the genesis of individual difference as it has been studied in recent infant research.

Rather than recapitulate Freud's development of the concept of the ego and its subsequent refinement, I refer the reader to three perspicuous reviews of this topic in the literature: Hartmann (1964, pp. 268–96), Rapaport (1959, pp. 5–17), and Blanck and Blanck (1974, pp. 19–25). Ego psychology refers to those aspects of psychoanalytic theory that detail the multiple functions (Hartmann writes: "The ego is defined as a system of functions," 1964, p. 290) of that structure of the mind whose role it is to mediate between the id and the superego (wish and conscience), to test reality and thus adapt to the outside world, to regulate and defend against drives from within and stimuli from without, to engage in and internalize object relations, to perceive, to think, to judge, and above all to synthesize and integrate all psychic experience—to establish, that is, a style, a character, a personality that is consistent through time.

Thus, if one thinks about art and artists as Cennini does from his perspective and Dewey does from his, it is clearly useful to refer to the theory of the ego. Although we cannot be satisfied to view art-making merely as a vicissitude of drive discharge, nevertheless, drive derivatives (which Dewey would call "vague ideas and emotions") may constitute starting points in the art-making process. In many cases, however, artists are so immersed in their respective media that such "vague ideas and emotions" (unconscious wishes, fears, and guilt) do not serve as starting points but enter in, if at all causally, at a later stage of work already under way. Thus, what motivates an artist to paint or to compose may, on occasion, be traceable not to "vague ideas or emotions" but to a pleasurable and challenging mode of semi-autonomous function that occurs under the auspices of the ego and that is neither fueled by libidinal or aggressive energies nor driven by conflict. (In such cases one might invoke Hartmann's notion of "change of function," 1939, p. 25, or Kris's notion of neutralized energy, 1955). To take this view is to go beyond Dewey's statement but not to make any claim that would shock psychoanalytically sophisticated lovers of Bach's fugues, seventeenth-century Dutch flower pieces, monogram pages from the *Book of Kells*, or the color studies of Josef Albers.

How might one go about constructing a methodology for studying each aspect of ego function in terms of its possible impact on the processes and products of art? Following Hartmann's "powerful triad of functions" (1964, pp. 290–291), one might begin by dividing the ego functions into three main groups: the adaptive functions (turned outward toward reality); the defensive mechanisms (turned inward toward the drives and superego); and the integrative functions (which continually organize psychic life and establish characteristic patterns of coping and constructing). One would also have to bear in mind the psychoanalytic principle of multiple function (Waelder, 1936)—that is, the fluidity of the psychic apparatus—which makes it possible

for each psychic function to be co-opted to serve numerous purposes, defensive, adaptive, and so on. Further, any ego function may be drawn into conflict; for example, that which has become autonomous may with stress undergo regression to an instinctualized state. Even so-called character armor is not entirely immune but, rather, as studies of psychic trauma have shown (see Terr, 1979, 1983), is temporarily permeable and context-dependent. (Note, for example, Magritte's and other artists' dramatic changes of style in the aftermath of psychic trauma.) With the theoretical tools of ego psychology it may be possible to trace at least some of these various conscious and unconscious contributions to the art-making processes and to observe their vicissitudes as they pass into and out of both inter- and intrasystemic conflict. But because the model is so complex, it is difficult to imagine a methodology that could accomplish the task. Nonetheless, the possibility lies open, and whether the relations discovered come to be regarded as causal or analogic, at least ego psychology offers a language with which to speak psychoanalytically about certain previously neglected but crucial elements of art.

On Style

Meyer Schapiro, in a celebrated essay, has defined style as "the constant form . . . the constant elements, qualities and expression—in the art of an individual" (1953, p. 137). From a psychoanalytic point of view, taking up this definition, one would certainly want to ask what possible relations may obtain between artistic style and character. Further, one might pose a philosophic question: how are style and originality connected? Is it an artist's style that constitutes his originality, or does originality occur when an artist transcends his style—that is, at points of stylistic discontinuity? Whether style is seen as the sine qua non of art or as its antithesis, its importance must be acknowledged.

Clearly, there is continuity in an artist's oeuvre over time. To the connoisseur, as Wölfflin says, each master reveals himself in even the smallest fragment or detail—in a finger or a fold of drapery: "In the drawing of a mere nostril, we have to recognize the essential character of a style" (1932, p. 2). How to account for the fact that, when one walks into the Albertina and catches one's breath before Dürer's exquisitely delicate self-portrait at age thirteen and, again, before the Rasenstück painted at age twenty-two, one instantly recognizes the hand that designed the great woodcut portrait of the Emperor Maximilian sixteen years later in 1519? How can this continuity be explained in spite of changes in subject matter, technique, and media? When Degas moves from drawing dancers in oil pastels to modeling them in wax; when Winslow Homer shifts his focus in the last years of his life to totally nonhuman subjects: the rocks and sea beyond his studio at Prout's Neck on the Main coast; when Matisse turns in his last years to the stark white ground, crude black drawing on tile, and reflections of blue, green, and yellow light that comprise the unfor-

gettable interior of La Chapelle du Rosaire in Vence—how is it that in each case the artist's self persists, that one *knows* him and connects his later with his earlier work? What are the bridges between style and character? What provides continuity of self over time? How do artistic changes and repetitions mirror, complement, or contradict other aspects of an artist's psychic function and behavior? How does one connect these stylistic changes with Nietzsche's observation that "if one has character, one has also one's typical experience that recurs again and again" (Aphorism #70, *Beyond Good and Evil*, 1886).

Style comes down to individual difference, an issue with which psychoanalytic drive theory has had minimal concern. As Kris puts it, "Whereas the common elements relate to the id, we might say that the differences are determined by the ego" (1952, pp. 105–6). Yet, as pathographic studies have shown, style is profoundly influenced by all aspects of the psyche, and in the zeal to demonstrate the value of any one psychoanalytic approach, one must not lose sight of complementarity among the various approaches, all of which are, in my view, historically, theoretically, and experientially entwined. Ideally, of course, one would want to be able to analyze the impact of all aspects of mental structure and function on the final product.

To grasp the complexity of such an endeavor, consider, for a moment, the trajectories of different artists' stylistic developments and try to imagine assigning relative weight to various intrapsychic (not to mention cultural) factors. Artistic self-development may entail a continuous search for technical excellence and innovation (as in Dürer), combined with, in some cases, a deepening of psychological insight (as in Rembrandt and Goya), a quest to discover the truth about the visible world in some quasi-scientific sense (Leonardo), the progressive representation of powerful social themes (Daumier), the translation into pictorial form of intensely felt dramatic and narrative themes (Delacroix), the unconscious working over of motifs both defensively, in terms of displacement, projection, identification, reversal, and undoing, and in a simultaneous effort at mastery (Magritte). The task is formidable, especially if one adds the further differences between an artist like El Greco, for example, who, after having originated a vivid idiosyncratic painting style, pursued its implications inexorably, often overtly copying himself, and Picasso, whose equally inexorable stylistic discontinuities (possibly unique in the history of art) may have sprung from a capacity for multiple identifications, a more fluid sense of self, as well as from self-alienation and a conflicted, less integrated relationship with his past (see M. Gedo, 1980).

Clearly every artist experiences twin needs: to maintain continuity of self in terms of the traditions of his art (as Sir Joshua Reynolds advised repeatedly in his *Discourses*, where he speaks of "invention" as if it were "little more than a new combination of those images which have been previously gathered and deposited in the memory," *Second Discourse*, 1769), and, at times equally

or more urgently, to risk rupture, to break utterly with such continuities. When united in rare individuals, these contradictory needs can produce works of genius.[5]

Yet style is more than individual difference. Schapiro (1953) and Panofsky (1955) have explored the intricate relationships between cultural (art-historical) context and individual style. The psychoanalytic critic is bound to remember that no matter how detailed an understanding he may manage to obtain of the intrapsychic life of an artist, that artist's work will always remain inexplicable in terms of such an understanding alone. As Wölfflin has declared and Gombrich has seconded: not everything is possible in every period. The range of choices available to individuals is limited not only by intrapsychic factors but by powerful cultural determinants. Furthermore, the artist's style is both alloplastic (affecting and altering the world around it) and autoplastic (producing inner psychic changes). Art is born into and out of tradition. As Erikson (1963) and others have shown, ego psychology can help explain how cultural elements are internalized and occasionally transcended by individual artists. Object-relations theory (to be discussed in chapter 5) has a major contribution to make to this dialogue as well.

Art and the Body Ego

Freud's statement that "the ego is first and foremost a bodily ego" (1923, p. 26) serves as the point of departure for considering contributions of early ego development. Art-making might, in its most primitive, physical sense, be viewed as a quintessentially psychosomatic adaptive act involving mind and body in the shaping of material to a purpose with both conscious and unconscious dimensions.

For complex reasons (see Kristeller, 1951) we tend to forget that an artist's work is, first of all, physical work. This is true not only for the visual and plastic arts of painting and sculpture and for music, dance, and theater, where perceptual and motor capacities are obviously fundamental, but also for literature, where often an author's acute sense of self-as-body enters into specific works in terms of content and form. One remembers, for example, Proust's evocation of a range of intense physical sensations including the gustatory, tactile, and auditory; Kafka's "Metamorphosis," "A Hunger Artist," and other works deriving from and conjuring up profoundly disturbing distortions in body image; the writings of Swift (*Gulliver's Travels*) and Carroll (*Alice in Wonderland*), who, as Greenacre (1971) has persuasively argued, project into their magical worlds imagery betraying a preoccupation with distonic irregularities in early body-ego development.

5. See Kant, *Critique of Judgement*, "Analytic of the Sublime, #49": genius is the capacity to so put the sense of freedom from the constraint of rules into one's work that "for art itself a new rule is won."

Previously, I discussed the more general papers of Greenacre, especially "The Childhood of the Artist" (1957), where she traces aspects of artistic giftedness to unusual bodily sensitivity in infancy. I have also referred to Niederland (1967), who demonstrates on the pathogenic side how early injury to the body image can serve to motivate artistic work, which then in both content and process may serve reparative intrapsychic purposes. Recently, Mary Gedo (1985) has studied, from the interpretative side, how Goya's altered physical sensations after recurrent illness, particularly in balance, poise, and equilibrium, produced idiosyncratic factors in his painted imagery. Pinchas Noy (1968), discussing the genesis of artistic talent, has put forward the plausible thesis that musical ability may stem in some individuals from an infantile hypersensitivity to sound stimuli against which they defensively develop the capacity to regulate and produce, that which had once threatened to become overwhelming.[6] Such examples can be multiplied; they serve to indicate the central relevance of the notion of original body ego to art in many dimensions.

A vast psychoanalytic literature exists on the topic of early ego development, and the infant's first awareness of his body is approached from a variety of standpoints. Some of these studies are frankly speculative and theoretical (Isakower, 1938; Lewin, 1946; Hoffer, 1949, 1950); others have an empirical base. In general, the cherished psychoanalytic premise underlying nearly all experimental and speculative studies until quite recently has been that the infant's subjective sense of body-as-self develops gradually out of an undifferentiated phase in which archaic experience of and wishes to merge with mother gradually yield to a more realistic awareness of body boundaries and a clearer distinction between inside and outside, between the "me" and the "not-me." The gradual clarification of body boundaries is thus intimately bound up with reality testing, and, in fact, the search for boundaries or the wish to negate boundaries may often motivate aspects of the art-making process.[7] It is striking to note, too, how relevant such boundary issues are to questions of interpretation, for the rigidity or flexibility with which one defines one's outer limits may determine the course of the resulting interpretation.

It is important to mention the current debate among psychoanalytic theorists centering on these issues. Certain authors (Bowlby, Fairbairn, Win-

6. Although such an etiology of musical ability is by no means universal, it is corroborated by the biographies of Mozart and Rossini and congruent with my own experience as parent of a young musician and composer who, in infancy, would cry out in pain at loud noises and developed a mannerism of putting both hands over his ears to protect himself from strident stimuli.

7. Milner, 1957, has explored these issues with great sensitivity from the perspective of object relations, and her work is discussed in chapter 5 (below).

nicott) dismiss any research that attempts to separate babies from their primary maternal environments because, in their view, infants are imbedded from the start in an infant-mother dyadic matrix. This theory of a so-called undifferentiated phase has recently come under attack by several infant researchers (see D. Stern, 1983) within the psychoanalytic establishment who claim that, since young infants can make extraordinarily fine cross-modal sensory distinctions and exhibit rudimentary forms of intentional behavior (make choices), there is no good reason to postulate an undifferentiated phase and a symbiotic tie with mother (see also Lichtenberg, 1983; Emde, 1983). Notwithstanding these views, it seems intuitively valid to see the development of body ego in human experience as fundamental, gradual, and vulnerable to the vicissitudes of both genetic endowment and environmental input. The incipient ego would thus represent a unique interaction of these factors in the psyche of a child seen not merely as passive recipient but as active constructor as well.

Ways in which the developing child takes his own body directly as a model for constructing the world have been elaborated by several psychoanalytic authors beginning, after Freud, with Ferenczi (1913), who pointed out how upper parts of the body (visible) can come to represent lower parts (invisible, covered) and how the young child projects bodily sensations into the world around him. Rose (1980) has written on the centrality of such experience to art, citing various manifestations of primitive art in which body decorations and coverings figure prominently. Various styles of primitive art come to mind, particularly that of the Northwest-Coast American Indian, where formal design elements are derived from the eye, the ear, the hand (see Holm, 1965). While enjoying such art, one is reminded that all human learning begins with the body, as infants mouth objects, push, grasp, kick, and that all symbolic connections have at root a bodily component.

Earlier, in chapter 1, I referred to the connections between muscular tensions, heart rhythms, and the experience of musical tempi. Special attention, however, is due the *hand* of the artist. Citing Willie Hoffer's noted papers on early ego development and infantile links between hand and mouth, Rose speculates that the painter's hand may recapitulate in its movement back and forth to the canvas, the stimulations of bodily care once given to the infant by the mother and the "tensions of love and hate . . . as in infancy the hand spread stimulation from the mouth to the skin" (1980, pp. 101–2).

Matisse apparently responded to a question about his art by saying, "Well, one feels it in the hand," and Dickens begins *The Old Curiosity Shop* by confessing, "I am conscious that my pen winces a little even while I write these words." The celebrated art historian Bernard Berenson writes, agreeing with Cennini, that "the great painter . . . is above all an artist with a great sense of *tactile* values . . ." (1957, p. 85, emphasis added).

This intimate relation between art and the human body extends to Chinese painting, where one finds these identifications and projections in a technique manual:

> Rocks without *ch'i* are dead rocks.... [Old trees] are like hermits, the Immortals of legends, whose purity shows in their appearance, lean and gnarled with age, bones and tendons protruding.... [Two trees] should stand together gazing at each other.... Each movement of turning, bending, drooping or rising ... must be observed and felt through the heart for full understanding of the expressiveness of bamboo. (Sze Mai-Mai, 1959, pp. 158ff.)

Here the aspiring artist is advised to project body image and bodily sensations into each natural object in order to render it optimally with brush and ink.

Those who work with children in the arts will understand the psychoanalytic principle that the reality of one's body is the fundamental reality. Many children draw and sculpt not by studying their models visually but by identifying physically with them. An art teacher working with children who have difficulty in capturing a model's pose or in representing a particular movement may find that some children can benefit from advice to study more carefully with the eye but that many others must be told: "Take the pose yourself. Get into it! Do it and see how it feels." The projection of a child's own bodily sensations into the art-making process often results in images of striking power and expressive distortion. Viktor Lowenfeld (1957) has written widely in this area and claims that children can be divided into two groups, those who see and draw with their eyes and those who see, as it were, with their bodies, who possess, as he calls it, "haptical" sensibility. In his fascination with such nonvisual sources of painting and the plastic arts, Lowenfeld also conducted research into the art work of the blind.

Among the many media within the general province of visual arts it is the art of sculpture that brings experiences of the body ego most strikingly to the fore. One thinks immediately of cases in which subject matter and form converge—the works of Michelangelo, for example, where the human body is itself the principal object of representation. One thinks also of the Norwegian artist Gustav Vigeland, who created hundreds of sculptures of men, women, and children, including a massive pillar of stone consisting of over a hundred interlacing, thrashing human bodies. The following lines from a poem by this master express the physical intimacy he felt with his work:

> From this came figures, linear, spare,
> gaunt, so like the self I was, so bony,
> sinewy, a tautness which I fashioned in
> ecstasy ... (quoted in Stang, 1965, p. 186)

Or one might cite the straining sculptures of Ernst Barlach, with their power to wrench visceral and kinesthetic responses from their viewers.

Yet it is not only the subject matter of sculpture into which identifications

with the human body are projected but the very medium of sculpture itself. Sculpture is the art form which, by creating volumes in space, seems to possess an organic quality very like that of the human body. Sculptural volumes organize the space around themselves in the same way that we, with our breathing space and reach of limbs, create a space of which we are the center, a "kinetic" space" (see Langer, 1953, pp. 88–92). Thus, sculpture is above all others the art form in which body image and the sense of self-as-body play central roles. Psychoanalysts studying early ego development, the growth of our awareness of space, complex connections between psyche and soma, and cross-modal connections such as those between visual and tactile experience have much to contribute to our understanding of the art of sculpture.

On the other hand, what about those psychoanalysts who would prefer to invoke drive theory in this context, placing their emphasis, for example, on sculptural activity as displacement from the wish to smear and handle feces (see Brenner, 1955, pp. 104–5)? Doubtless, anal components are factors in the development of many sculptors, especially those who choose to model their initial studies in clay and wax. But the explanatory power here is insufficient, for the normal anal drive derivatives of children do not usually ripen into the desire and skill to create volumes in space that reflect a sense of organic life itself. Whatever role anal wishes play in the origins and choice of sculptural activity, they seem a relatively remote contributor to the aesthetic experience (on the part of both artist and amateur) of plastic art, which embodies an illusion of kinetic form and incorporates not only passion and aggression but also the offices of hand (technique) and eye (design) and judgment in the service of art—the very attributes that Cennini and Dewey describe.

Primary Endowment, Temperament, and Individual Difference

Another way in which early ego development has relevance to the arts is in the area of primary endowment. Clearly, constitutional givens, temperamental traits, are indispensable to any discussion of artistic style. Although Freud despaired of either broaching or resolving it in his famous 1928 dictum ("Before the problem of the creative artist analysis must alas lay down its arms"), primary endowment is a topic that is apparently less intimidating to ego psychology and that has been addressed indirectly by psychoanalytic infant research.

Although Freud (1937) noted the importance of individual differences (especially with regard to prognosis of treatment), and though this issue has been underscored, especially by Hartmann (1964), who links it with subsequent choice of defenses (much as Noy sees musical giftedness as a defensive derivation of constitutional hypersensitivity to sound), the psychoanalysts who have made the most significant contributions to our knowledge of individual differences are those who have been involved with infant research.

By no means have all aspects of the theory of the ego been derived from data taken from the free associations of analysands; many aspects have been inferred from data gathered in child therapy and through child and infant observation. In fact, this empirical approach was central to the work of such noted early ego psychologists as Anna Freud, René Spitz, and Margaret Mahler. Indeed, it was Anna Freud's close contact with the coping strategies of young children that inspired her volume on defense mechanisms (1936) and her delineation of the developmental sequences ("lines") for various functions of the ego. Freud himself was always open to the consideration of data gathered outside the classic psychoanalytic situation (witness his ventures into literature, anthropology, and the visual arts, and the observations of his eighteen-month-old grandchild reported in *Beyond the Pleasure Principle*), so that there are ample precedents for such extraclinical psychoanalytic research. I emphasize this point because its critics are many.

Among those who have studied individual differences in their research are Margaret Fries and Paul J. Wolff (1953), Sibylle Escalona (1963, 1965), and Alexander Thomas and Stella Chess (1977, 1984), who are persuaded that certain temperamental characteristics present in infancy persist throughout childhood and into adulthood. Fries has provided longitudinal studies of character; Escalona (1963) has attempted to relate the subjective experience of the infant to individual variations in thresholds and observed variable patterns of reaction tendencies, which she sees as reflecting and determining the subsequent course of development; Wolff (1959) has noted that within the first week of life infants vary with respect to the length and frequency of alert activity states, a putative precondition for later capacities to concentrate, and Anneliese F. Korner (1964) and Thomas and Chess (1984) have each developed nine categories of observation with which to assess the relative weight of primary-endowment factors in young infants.

Such literature represents a search for continuities in human experience and behavior comparable to the art historian's search for style—for ways of accounting for the continuities perceived in the works of individual artists. Meyer Schapiro (1953) has spoken of the need to consider both psychological and historical dimensions of artistic style (p. 137). It seems possible that research on early ego development may help us discover attributes that contribute to individual style, baseline attributes that may or may not subsequently be drawn into conflict, altered, reversed, or temporarily overshadowed by environmental circumstances. Relevant to this last point is ongoing work by E. James Anthony (1983) on the coping strategies of children.

Thomas and Chess (1984) define temperament as "a categorical term without any implications as to etiology" (p. 4). They suggest a possible genetic role, but indicate that sex difference and parental attitudes are not decisive. They offer an operational definition of temperament that includes such stylistic qualities as *quickness of movement* (as in a painting style featuring rapid,

bravura brushstrokes); *ease of approach* to new physical or social situations or tasks (as in a large, varied artistic repertoire of subject matter and media); and *distractibility* (as in choice of media and method of working). Their research has shown that "continuity over time of one or another temperamental characteristic from infancy to early adult life has been strikingly evident" (p. 4). In their view, such continuity of temperamental characteristics is relative to "stability in the dynamics of interplay between the individual and the environment" (p. 4). They have introduced the notion of "goodness of fit" (p. 8) to denote a consonance between the properties, expectations, and demands of the environment and the organism's own capacities (p. 8). Thus, their model implies mutual adaptation between the "I" and the "social fields of force in which that 'I' moves" (p. 6), but with temperamental characteristics and developmental potentials a constant.

Korner (1964), in seeking to discriminate the constitutionally given from the conflictually determined in individual development, fixes on the notion of style. She points out the methodological difficulties of making connections between neonatal and later behavioral patterns, because the increasing complexity of content tends to obscure continuities:

> To overcome this difficulty the variables to be studied should reflect the *formal* characteristics of behavior rather than the continuously changing content. Thus, it is the study of the *style* of development ... which may provide the continuities in behavior for which we are searching. (p. 196, emphases added)

Similarly, as noted above, art historian Schapiro has identified artistic style as "constant form" and expressed the view that we need a deeper knowledge of the psychological problems of style, form, construction, and expression (1953, p. 171). By tracing ego attributes in early infancy, charting their contribution to symbolic process in the second year of life, and developing specifically targeted longitudinal studies, we may eventually be able to refine our knowledge of core factors that influence the creation of individual style.

Among the variables Korner describes with respect to the newborn is "singular or global versus multiple response to external stimuli" (1964, p. 197). This category establishes distinctions along a continuum among infants who acknowledge an (auditory) stimulus with a single response, or globally with their whole bodies, and those who manifest a large and varied repertoire of responses. Such variations may correlate with later preferences for a more or less constricted range of expressive modes. To speculate on the connection between such findings and the aesthetic, one might imagine a continuum comprising the stylistic differences between such roughly contemporary and dissimilar British poets as A. E. Housman and Dylan Thomas, the one possessed of a more restricted repertoire of imagery and the other bursting with a flood of sensuous sounds, smells, sights, and turbulent emotions. With respect to music (possibly more relevant in that the research involved an

auditory stimulus), one might construct a spectrum extending from the simple melodic line of a score by Copeland to the complex relations of sequence and sound, rhythm and intensity, in a composition by George Crumb.

Another variable Korner mentions is "distinctness of state" (p. 198). Some infants manifest more clearly than others hunger, fatigue, and other internal states. In such cases, caretakers learn to respond appropriately over time and thereby reinforce the infants' sense of their own capacity to discriminate, anticipate, and communicate. In this example the intimate reciprocity between primary ego endowment and the quality of primary object relations is clear; in fact they are mutually interdependent. With babies whose internal states are less distinct, caretakers often experience frustration and annoyance at what they judge to be their own inability to understand and attune emotionally (Brazelton, 1984). Indeed, deeply empathic responsiveness on the part of a mother or other caretaker may enable an infant to better differentiate his inner states. In any case, children whose affective and physical states are poorly differentiated, whether for physiological, temperamental, or environmental reasons, may throughout life experience their likes and dislikes with less clarity, as well as suffer from corresponding deficits and failures of empathy in the area of object relations.

The possible implications of this for style might include such variables as choice of medium (for example, that which preserves and maximizes the accidental versus that which minimizes it and therefore allows the artist more control). Artists who prefer sharply defined shapes and linear contours might be distinguished from those who are more comfortable with vague forms and more painterly qualities.[8] As an example of differences in the painting styles of two contemporary masters, with possible correlations to early response patterns bearing on distinctness of state, one might cite the lucid, placid, geometric canvases of Vermeer versus the mobile, elusive images of Frans Hals.

Obviously such correlations are highly speculative. In such analogies we must consider the possible roles of other ego attributes, such as the defense mechanisms. Reaction formation, for example, might come into play in some instances, temporarily reversing the original predispositions of the artist. The examples offered above merely indicate possible ways in which one might over time begin to form a more detailed picture of the relations between temperament and style. Thomas and Chess suggest such additional categories as the infant's activity level, intensity of reaction, and threshold of responsiveness. From the perspective of libido theory, one might consider the variable sensitivity of erogenous zones from individual to individual, as well as variations in emphasis placed on each zone by a particular culture (for ex-

8. Wölfflin, of course, has made such distinctions and interpreted them on historical grounds, but psychoanalytically oriented researchers may provide psychological grounds as well.

ample, the special role of oral experience, food, language, and the mouth as an erotic orifice in French culture).

My purpose here has been to point out the need for balance in attributing causal factors to any aspect of an artist's work. Although it would be naive to overemphasize the part primary-endowment factors and temperamental attributes play in the style of the mature artist, it would be equally naive to omit these factors. A psychoanalytic study of art, artists, and particularly of those obscure constants we call "style" must take into account whatever researchers can tell us about the earliest manifestations of individual difference.

As a postscript to this discussion, however, it should be mentioned that there are prominent theorists within the psychoanalytic community today who would completely exclude the data of infant observation from their purview and declare its findings to have no bearing, confirmatory or otherwise, on psychoanalysis. Their position is that psychoanalysis is concerned with psychic reality alone and that its data must be restricted to the associations of adult patients in the throes of the transference induced by standard psychoanalytic situations. This viewpoint deserves mention because it is shared by analysts from widely divergent backgrounds, such as Schafer, Brenner, and Lacan, but it would be tangential to present or debate it. Such an argument would, I suspect, boil down to a host of definitional issues.

At this point I shall say only this: to cast one's net so narrowly as to exclude the topics discussed in this section is to constrict the field of psychoanalysis and make it less than the general psychology Freud intended it to be. One might offer over to cognitive, developmental, and experimental psychology these vast realms of psychic experience, but, as Shapiro and Perry (1976) persuasively argue, it behooves the analyst to *know about* baselines even if he does not discover them himself. Likewise, it is crucial for applied psychoanalysts to know about cultural and other contexts relevant to the interpretation of their subjects even if they do not consider themselves the principal investigators of such contexts. Furthermore, these baselines and contexts enter into and prescribe limits for psychoanalytic interpretation. The meta-question of how extensively or narrowly the range of any discipline is to be marked out must be one of constant debate within that discipline. My own view is patent: the scope of psychoanalytic inquiry has been enlarged and enhanced by the theory and research of ego psychologists, many of whom have been directly involved in empirical work with very young, preverbal children. In my view, their past, present, and potential contribution to our understanding of the arts should not be overlooked. It has the possibility of shedding light not only on the problem of artistic style but also on patterns of response and aesthetic preference, a subject neglected by psychoanalysts, but a well-funded research topic for psychologists of perception and cognition (for example, Project Zero at Harvard; Irvin Child's studies at Yale).

There are grounds for serious objections to infant research because of its

inherent philosophical and methodological problems. Most often cited is the dubiety of moving from the "objective" viewpoint of the psychoanalytically oriented observer to the "subjective" world of the proverbial infant. Without arguing systematically for my position, however, I maintain that such empathic maneuvers are no different in kind from others in the domain of intersubjectivity. In a culture so dependent on verbal modes of communication, we (perhaps especially in academia) often seem to forfeit or denigrate our capacities for nonverbal modes of relatedness, so that the ability of the sensitive infant observer (including the mother) to intuit a child's responses is disavowed, and his or her formulations are branded as "adultomorphisms" because of an absence of verbal confirmation. No one who has spent time in the company of babies and preverbal children, however, can doubt their amazing capacity for agency, persuasion, and communion. It *is* possible, however—to make an analogy with Empson's remark about poetry—that one may need to enjoy them in order to bring this intersubjectivity about. (Analogies with the clinical situation follow suit.)

Likewise, no one who has ever been immersed in creative work in any medium of the arts—who has struggled and reveled in the world of the studio, felt its textures and muddle, its ambivalent persuasions, arrant abandonment of clock time, and the sudden elation (see Lewin, 1950) as the gap closes between imagination and reality—could be persuaded to doubt the connections between such work, such moments, and the earliest of life's experiences. However, from a psychoanalytic point of view, to make art, to experience art, is to sublimate drive, to engage the higher-level ego functions of organization, judgment, and so on, but it is also to reactivate our most basic awareness of self as body, self as receiver, and self as agent in a modally rich, affectively and perceptually charged world.

REFLECTIONS

Because psychoanalysis is not a unified system but a conglomerate of theories, not all of which can be happily reconciled, it is unclear how one goes about choosing which aspects will best suit the problem at hand. Indeed, depending on one's psychoanalytic orientation, one may conceive a problem quite differently. This dilemma is illustrated by Kutash's paper on postwar American abstract painting, in which I have noted some capriciousness about choice of theory, wondering whether object relations theory for example, might not have served her purposes as well as, or in tandem with, self-psychology. My own discussion of style is vulnerable to the same critique: Why choose ego psychology? Could not the theory of internalized object relations have provided an equally rich interpretative framework for the genesis and vicissitudes of an artist's style? Without a clear way of grounding the relations between a theory and its applications one runs the risk of producing a set of idiosyn-

cratic analogies with little claim to anyone else's attention. I have noted a similar problem with regard to Skura's eclecticism about theory.

In clinical work, at least during the training years, this problem also looms large, as the various major psychoanalytic authors are studied and their divergent views presented. Supervisees and analytic candidates are usually advised to choose a general theoretical orientation that feels comfortable and to stick with it. It is often pointed out to them that theoretical shifts on the analyst's part may confuse patients and disturb the working alliance of a particular treatment. In fact, analytic institutes in England actually have separate tracks according to whether one wishes to be trained classically, or as a Kleinian, or by the tenets of the so-called British Middle School.

I see this matter of theoretical diversity as a particularly thorny problem for interdisciplinary studies, where one is attempting to bring together two universes, as it were. The extraordinarily difficult task of doing work of this kind responsibly becomes formidable indeed when such diversity of viewpoints obtains. To make their task manageable, some scholars from other disciplines simply restrict their view of psychoanalysis to pre-1923 Freud. Unfortunately, in most examples of this type the choice to so limit one's horizons is made less out of genuine conviction that this perspective is the most fruitful among many competing models (including Freud's structural model) than out of ignorance of more recent developments in psychoanalytic thought.

How is one to go about making theoretical choices? Clinical practice suggests a two-step process: first, through a process that includes a knowledge of history and self-analysis, one assesses and feels reasonably convinced of the value of the ideas with which one is going to work; next, one conveys a fair sense of one's chosen perspective to one's interlocutor (audience, reader, or patient). "Fair sense" is vague; I mean to imply by it only that a lengthy defense of one's choices is not called for in most instances. One has to do what is needed to create a shared context, to give one's interlocutor a way of attuning to one's perspective so that interpretations can be heard. Even as I write these words, however, they sound reactionary. For why is it not equally plausible for "tonic incongruity" (Danto, 1964, p. 144) or "cognitive dissonance" to lead to insight by piercing through resistance and defense? How necessary is it to prepare the ground for interpretation? This question remains at the heart of technical disagreements between Kleinian and Freudian analysts.

The importance of theoretical choices cannot be underestimated in either the psychoanalytic or the aesthetic realm. As Danto says:

> What in the end makes the difference between a Brillo box and a work of art consisting of a Brillo box is a certain theory of art. It is the theory that takes it up into the world of art, and keeps it from collapsing into the real object which it is. . . . Of course, without the theory, one is unlikely to see it as art, and in order to see

it as part of the artworld, one must have mastered a good deal of artistic theory as well as a considerable amount of... history. (1964, pp. 141–42)

Early on, I suggested that psychoanalysis may be thought of as a heady mixture of knowledge and speculation; it would be pointless to debate here which predominates, although surely one's convictions about whether one is practicing an art or a science will color one's interpretative stance. Since all interpretation takes place in an interpersonal context, my effort has been to underscore the dynamic nature of such work and its contextual dependence—without, however, collapsing into more global relativism.

The present chapter raises related questions about appropriate units for interpretation. If, for example, we should choose to see a work of art as a piece of behavior (see Dewey, 1934), are we then entitled to try to analyze it in a vacuum? To do so would be to imply that one could similarly analyze other segments of behavior in a vacuum. (This reminds me of the joke about the analyst who, passing on the street a friend who waves to him, puzzles: I wonder what he meant by that?) To claim that the dream can be analyzed without the dreamer, the poem without the poet, the friend's wave without its context, is to borrow an argument from biology, where the analysis of one cell may yield important information about the whole organism from which it has been extracted. Even in biology, however, not one but usually several cells are examined and equivocal findings are subject to interpretation.

How, then, do we make decisions about the size, shape, length, and duration of units for interpretation? In applied psychoanalysis, we cannot avail ourselves of the benefit of years of transference, countertransference, and free association. Yet, to choose the unit is to determine the results. Isenberg (1973), for example, is careful to point out the folly of discussing aesthetic qualities apart from the picture that embodies them, and Danto (1964) goes further by claiming that aesthetic qualities come into being only in the larger context of the "artworld": for example, Duchamp's bicycle wheel, his bottlerack, and his urinal, all appear in a quite different light to those who have been initiated into this art world than to those who have not been so initiated. An interesting psychoanalytic parallel might be drawn here to the disputes among theorists of early development and the origins of the self: those who have taken the individual infant as their unit of study have developed a theory of primary narcissism and endogenous instinctual drive, whereas those who have chosen the infant-mother dyad as their unit have derived therefrom a theory of primary object-seeking and object relatedness.

With respect to the dynamic nature of interpretation, I have stressed the centrality of the notions of transference and empathy, emotional counterparts to the sort of rational understanding conferred by theory. These topics will be addressed in the next chapter, but it is important to remember that they play a role in every model, whether or not they are acknowledged.

The psychoanalysis of autonomous texts presents a host of puzzles, all of which can be related not only to one another but to the realms of art and psyche. Helpful with respect to these puzzles—how to define contexts, choose theories, determine interpretative units, and draw boundary lines—is Isenberg's radiant message: "meaning functions . . . so as to expand the field on which attention rests" (1973, p. 52). This message affirms the fluidity of contextual borders and the fact that our very realization of the choices is but part of the ever-expanding periphery of meaning. As Milan Kundera says, the issue is not to choose whether *Don Quixote* is "a rationalist critique of woolly idealism" *or* "a celebration of the same idealism" (1984, p. 15). The issue is that each novel (I would substitute: each work of art, each interpretation of the work of art, each psychoanalytic quest) must uncover a new dimension of existence. It must do more than confirm what has already been said. It must defy "the beetle of reduction [which] has always gnawed away at the fabric of life" (p. 17), and it must say to us again and again that things are not as simple as we think.

5

Psychoanalysis and
Aesthetic Experience

I do not know which to prefer
The beauty of inflections
Or the beauty of innuendoes,
The blackbird whistling
Or just after.
—Wallace Stevens,
"Thirteen Ways of Looking at a Blackbird"

Previous chapters have touched only in passing on the audiences of works of art: spectators, readers, or listeners. Yet, without them there can be no art. What has psychoanalysis to say about this third model: the audience plus the work of art? What insights can psychoanalysis offer with regard to our response to works of art? In this chapter, I shall address this topic from two perspectives: first, from that of developmental object-relations theory (drawing largely on the work of Mahler and Winnicott); and secondly, from the perspective of clinical technique (Ralph Greenson) and the application of such notions as transference, empathy, and "the working model" to various phenomena occuring in the aesthetic encounter.

Although my major questions here have to do with what happens in our moments of absorption into aesthetic experience, how it is that we respond as we occasionally do—with intense emotion and pleasure—to music, theater, painting, and literature, I will occasionally talk as well about creative experience. There are two reasons for this: first, like Kris, I am persuaded that [re]creative experience occurs optimally in audiences as well as artists, so that to speak about creativity is not necessarily to depart from the topic at hand; and second, all artists are themselves necessarily audiences: they are the first perceivers and critics of their own works. As a painter moves back and forth

from his canvas, looking and painting and then looking again, as a writer rereads yesterday's pages before moving on to new material, he serves as trial responder to his own work in progress. Thus, what is said in this chapter, though it primarily addresses the model of audience response to works of art, does not exclude the artist. Indeed, as Malraux (1953) claims, to be an artist one must first be a great lover of art, since artists may learn less from nature than from each other (see also Gombrich, 1960).

In thinking about the general nature of our encounters with works of art, it is necessary to move beyond (but not to dismiss) considerations of the artist's specific intentions, as realized in a given work or as motivating that work. Likewise, one must move beyond the endopsychic Freudian perspective of aesthetic experience as instinctual aim displaced by sublimation to enter a realm in which both inner and outer, self and other, personal past and interpersonal present are lost, rediscovered, and remade in a continuous dialectical process ("dialectical" here in its original sense of "talking between").

In the preceding pages, I have referred in passing to the point of view that works of art come into being only insofar as they are perceived. The extreme of such a position would be to hold that paintings on the walls of the Louvre, for example, simply cease to exist as works of art when the museum doors are barred and no one is there to observe them. Farfetched as this viewpoint may seem, it forces us to attend to the crucial role played by the responder in all forms of art, a role especially well known to performing artists, who are more immediately dependent on it than their counterparts in the visual arts and literature. As a case in point, immediately after his final appearance on Broadway as Willy Loman in *The Death of a Salesman*, Dustin Hoffman acknowledged the importance of the audience's role by appearing on stage to thank the entire house for their rapt participation, for "being with the cast" (as he put it) through the evening's performance. Something dynamic and reciprocal occurs between artists and audiences, not just in the performing arts but in all arts, and there are theorists who hold that we cannot legitimately speak about art without taking this dynamic into consideration. In whatever terms it is defined, it seems to occur in an extraordinary realm "between reality and fantasy" (Grolnick and Barkin, 1978). My interest, in this chapter, is to explore aspects of this phenomenon from perspectives offered by psychoanalytic developmental and clinical theory.

OBJECT-RELATIONS AND AESTHETIC EXPERIENCE

Object relations, like ego psychology, developed in response to a felt lack in the classical Freudian canon. In the case of ego psychology, it seemed clear (even to Freud, as early as 1923) that the understanding of repressed drives required a complementary and equally lucid account of the repressing forces, the defenses. Object-relations theory, on the other hand, grew out of a need

to explore in more depth than Freud had attempted (1) the infant's earliest ties to its first object, the mother, as well as preverbal and preoedipal development generally, and (2) the interactions between the endopsychic self and the external world. Object-relations theorists have been deeply concerned with such themes as symbiosis, separation, individuation, and rapprochement, loss and reparation, introjection and projection, and the broad question of boundaries between self and other. These concerns may be compared to the nature of aesthetic experience, aesthetic distance, the qualitative interactions between beholders and works of art, and (particularly for Winnicott) the phenomenological view that art works are mutually created and fashioned anew at every telling, hearing, reading, seeing, or performing.

Among the object-relations theorists who have contributed directly or indirectly to an understanding of aesthetic experience are, preeminently, Margaret S. Mahler, the originator of separation-individuation theory; Melanie Klein, who emphasized the roles of intrapsychic fantasy and reparation following aggression; Winnicott, who contributed the notions of "transitional object" and "intermediate space"; and Marion Milner, who applied some of the ideas of Klein and Winnicott to her own work as painter. Among other contributors who have utilized both Kleinian and Winnicottian theory in direct applications to the aesthetic are Hanna Segal (1952), Anton Ehrenzweig (1967), Simon Grolnick and Leonard Barkin (mentioned above), and Peter Fuller (1980).

Constraints of space prevent me from presenting a thorough review of the diverse, often controversial literature of object-relations theory as it bears on the aesthetic. What follows is confined mainly to a discussion of two central notions and their relevance to the topic at hand. The first of these, *symbiosis*, is a term used by Mahler that relates to a particular moment in aesthetic experience. The second, *transitional phenomena*, is a term originated by Winnicott in 1953.

Most object-relations theorists (not Melanie Klein) place primary emphasis on developmental issues and tend to view intrapsychic conflict from a perspective that emphasizes the input of internalized object relations rather than that of drive and defense. I have indicated that the data for much of this theory derives from the psychoanalytic treatment of young children, as well as from the psychoanalytically oriented observation of infants, mothers, and children. One of the lacunae in Freud's work is the relative lack of material on preoedipal development, and both Mahler and Klein are regarded as having taken up where Freud left off in this area rather than as radically departing from basic Freudian theory. Nevertheless, this point of view is itself controversial, and there are major disagreements between Kleinian and Freudian perspectives (for example, Klein's early timing of the oedipus complex, biphasic developmental stage sequence, and stress on the death instinct

as the source of powerful inborn aggression). Although it is clearly beyond the scope of this study to enter into intradisciplinary debates, because of this diversity of viewpoints even within the field of object-relations theory, I feel it is essential to my purpose to review briefly the course of preoedipal development as it is seen in Mahler's work.

THE PAST OF ILLUSION[1]

The mother's idiom of care and the infant's experience of this handling is the first human aesthetic. (Bollas, 1978, p. 386)

There is, as indicated above, an interdependence among the different modes of aesthetic experience. It is clear upon reflection that as audience and artist one must engage in similar activities: to respond, one must be capable of imagining, and to create, one must continually serve as one's first audience. Philosophers interested in understanding and describing the aesthetic encounter have sometimes distinguished these modes as experiencing the work from within and from without. And though it is clear that to judge and communicate critically one must experience the work from without as well as from within, most of us alternate between full absorption in the music or drama or poem and a return to clear consciousness of self. The "aesthetic distance" between ourselves and the work varies as we experience it. I shall be concerned with exploring this phenomenon later on, but what follows here has to do with those privileged moments of the aesthetic encounter when one seems transported fully "within" the work of art, when one feels fused with the aesthetic object, when illusion becomes "real" and one experiences a sense of power and magic.

Such moments are characterized by a deep rapport of subject and object, a state in which, as Christopher Bollas notes, "the subject feels captured in a reverential moment with an aesthetic object" (1978, p. 394) by a "spell which holds self and other in symmetry and solitude [in which] time crystallizes into space [and we experience] the uncanny pleasure of being *held* by a poem, a composition, a painting" (Bollas, pp. 385–86, emphasis added).

The child analyst Jeanne Lampl-de Groot reflects on a half-century of her personal experience with psychoanalytic technique and theory:

Little by little I became aware of the immanent importance of the early 'preoedipal' mother-child relationship. During the last decades I have become more and more aware of the deep and essential differences between the ex-

1. In part this section is adapted from my article of the same title in *The Journal of Aesthetic Education*, vol. 16, no. 1, 1982. Permission to include this material has been granted by the University of Illinois Press and is here gratefully acknowledged.

periential world of the little child and the experiential world of the adult. I believe that, at least in Western civilization, a part of the archaic grandiose experiential world continues to live on in the unconscious of every individual, though it is warded off, as are other parts of the preoedipal world. (1976, pp. 228–90)

During certain privileged moments of aesthetic experience, I would suggest, these very aspects of the unconscious, deriving from earliest childhood, are made available to us again, providing us with unique pleasure and a heightened sense of reciprocal structure, of being at one with the world.

Mahler originated her developmental stage sequences through extensive pioneering work with autistic infants. Although she and Winnicott were developing their ideas simultaneously and quite independently, Mahler's schema can be seen as forming a conceptual framework for the particular notions of Winnicott's that are most relevant to this inquiry.

Mahler (1968) describes a series of stages in what she later called "the psychological birth of the human infant" (1975). These stages include normal autism, symbiosis proper, and the process of separation-individuation, which is further divided into subphases: differentiation, practicing, and rapprochement. Mahler's theory pertains to the first three years of life (roughly), but it is important to realize that these stages overlap, that their earliest manifestations are variable and highly individual. Mahler notes the observable biological fact that the human infant is born unprepared to maintain life alone; he is completely dependent upon another being, a "mother" (who is usually, though not always, his biological mother.) Mahler quotes Freud to the effect that the human being remains, even "unto the grave," relatively dependent upon a mother (1972, p. 333).

This early stage of development—absolute dependence—Mahler calls the "normal phase of human symbiosis." She describes symbiosis as an intimate coexistence of mother and child, a "state of undifferentiation, of fusion in which the 'I' is not yet differentiated from the 'not-I' and in which inside and outside are only gradually coming to be sensed as different" (1968, p. 9). This symbiotic state involves the infant in the delusion that there is a common boundary between two separate individuals, and it continues through the first half year of life.

Mahler also posits a phase called normal autism. This occurs during the first few weeks of life, when the newborn sleeps for long periods of time. Waking periods characteristically center around the infant's attempt to achieve physiological homeostasis, to avoid painful tension. The mother's ministrations during these early weeks are an attempt to afford him pleasurable (good) rather than painful (bad) experiences; however, her efforts are undifferentiated from his own natural attempts to preserve equilibrium. Thus, in this

initial stage of mother-infant unity, the infant is wholly unaware of a mothering agent.

Gradually, as he awakens to a rudimentary sense of the existence of a need-satisfying object, he functions "as though he and his mother were an omnipotent system—a dual unity with one common boundary" (Mahler, 1968, p. 8). Any unpleasurable perceptions are projected outside the symbiotic milieu, thus protecting the immature infant's developing ego from stress and trauma. This symbiotic state of early infancy, prior to differentiation between inside and outside, "I" and "not-I," corresponds to the "oceanic state" described by Freud, the "original self" by Jung, the "true self" by Winnicott, and the "ideal state of self" by Mahler. It is a pleasurable state dependent upon the active, almost complete adaptation by the mother to her infant's needs, which then creates within the child an illusion of magical omnipotence.

The sense of fusion that the infant experiences with the "all good" mother who exists as a part of self, and his accompanying sense of well-being and pleasure, are analogous to what some philosophers have identified as aesthetic pleasure, aesthetic emotion, the privileged moment, or the sense of beauty.

In the closing lines of the *Phaedrus*, Socrates, in a natural setting of riverbank, plane trees, and afternoon sun, ends a long dialogue on the nature of love and beauty thus: "Beloved Pan, and all ye other gods who haunt this place, give me beauty in the inward soul; and may the outward and the inward man be at one." This desire for "at-oneness" and the prayer to a god who presumably has the power to grant it recall that stage of human life when equilibrium could be restored by the ministrations of an omnipotent other, not as yet fully distinguished from the self. What is desired is a sense of union, expressed again by Socrates, in the *Republic*: "And when a beautiful soul harmonizes with a beautiful form, and the two are cast in one mold, that will be the fairest of sights to him who has an eye to see it" (Book III, p. 401).

George Santayana (1898) echoes this wish for harmony between what is within and what is external. He identifies the sense of beauty with "the harmony between our nature and our experience . . . : When our senses and imagination find what they crave, when the world so shapes itself or so moulds the mind that the correspondence between them is perfect, then perception is pleasure, and existence needs no apology" (p. 269). These lines resonate with Mahler's account of adaptation by mother to child in symbiotic "dual unity." Santayana goes on: "The duality which is the condition of conflict disappears." In other words, in certain aesthetic moments, we may reexperience that state in which, as Mahler explains, everything painful is projected outside the symbiotic milieu to protect the embryonic ego. In a slightly later stage (rapprochement), separation from

the mother, duality, may be felt as more painful than exhilarating, so that repeated, ingenious (but ultimately abortive) attempts must be made to reestablish symbiosis.

Santayana describes the aesthetic ideal as a state of harmony in which

> There is no inward standard different from the outward fact with which that outward fact may be compared. A unification of this kind is the goal of our intelligence and of our affection, quite as much as of our aesthetic sense. Beauty is a pledge of the possible conformity between the soul and nature, and consequently a ground of faith in the supremacy of the good. (pp. 269–70)

One may read in this passage a powerful wish to return to a state resembling symbiosis with the "all good" mother.

Dewey traces the origins of aesthetic experience to even more fundamental, biological origins. He speaks of rhythm and the alternation of tension and equilibrium, but says that "the artist cares in a peculiar way for the phase of experience in which *union* is achieved." (1934, p. 15, emphasis added). He seems to grasp the unconscious aspects of the aesthetic moment, the working of primary process, when he speaks of the aesthetic ideal as dissolving categories of time and space, absorbing into itself memories of the past and anticipations of the future: "Art celebrates with peculiar intensity the moments in which the past reinforces the present and in which the future is a quickening of what is now" (p. 18). He speaks of "the moment of passage from disturbance into harmony that is of intensest life" (p. 17). A propos of states of serenity, he says:

> the experiences that art intensifies and amplifies neither exist solely inside ourselves, nor do they consist of relations apart from matter. The moments when the creature is both most alive and most composed and concentrated are those of fullest intercourse with the environment, in which sensuous material and relations are most completely merged. (p. 103)

This passage, as well as Santayana's notion of beauty as a pledge of "conformity between the soul and nature," may also be understood in terms of Winnicott's idea of the transitional object, a connection I shall return to below.

The aesthetic ideal, then, is like symbiotic fusion in that encounters with the beautiful may temporarily obliterate our sense of inner and outer separateness by drawing us into an orbit in which boundaries between self and other, and also categories into which we divide the world, dissolve. This occurs, perhaps, with the return to consciousness, the reavailability to us, during moments of creativity or responsiveness in the arts, of aspects of our preoedipal life, with its pleasurable sense of merging and union.

Illusion and magical omnipotence are also features of symbiosis. By adapting to her infant's needs, the mother creates in the child a sense of power and control that persists as long as she remains for him a part of himself.

Although Mahler discusses this phenomenon, Winnicott explains it most succinctly:

> The mother, at the beginning, by almost 100 per cent adaptation affords the infant the opportunity for the illusion that her breast is part of the infant. It is, as it were, under magical control. In another language, the breast is created by the infant over and over again out of the infant's capacity to love or (one might say) out of need. (1953, pp. 94–95)

Winnicott states that a subjective phenomenon which we call the mother's breast develops in the baby's mind and that the mother offers the real breast just at the point when the infant is ready to create it. In this way, the mother prepares for her child a situation in earliest infancy in which he can experience and trust his own creation of reality. Initially, he feels instinctual tension, discomfort; he cannot know what must be created in order to afford relief; at this point, the mother presents herself, thus giving him "the illusion that there is an external reality [which] corresponds to his own capacity to create" (p. 95).

Magical omnipotence, the sense of being able to create and re-create reality, has obvious connections with artistic experience. As Lampl-de Groot suggests in the passage quoted on pages 139, 140, something of this sense of omnipotence may live on in the unconscious of every individual; yet in artists and in those who are most responsive to the arts it persists to a marked degree—a point that recalls a passage in *Totem and Taboo* (Freud, 1913, p. 10) in which artists are compared with magicians. The artist's audience, in order to participate in what Coleridge calls "the willing suspension of disbelief"—to join in "the magic circle of creation" (Gombrich, 1960, p. 202)— must likewise tap an inner reservoir of unconscious preoedipal experience.

Plato, in Book II of the *Republic*, argues against the "lying poet" who falsely portrays the gods as magicians by transforming them into different shapes and thus deceiving us as to their true (and simple) nature. Those who create such fictions, he claims, thereby beguile and corrupt citizens of the state. It is the artist's *archaic grandiosity*, to use Lampl-de Groot's term, his presumption to create his own alternative, persuasive, and seductive realities, that Plato considers a threat to the state.[2] He is concerned also with notions of poetic madness and inspiration. To do what the artist does outside the aesthetic realm—to remake the world magically according to one's needs— is, of course, madness (psychosis) and perhaps ultimately a threat to society, which must depend on shared standards of truth and value as opposed to private versions. Winnicott would call an artist mad only if he "make[s] claims on us for our acceptance of the objectivity of his subjective phenomena"

2. It is perhaps not irrelevant to add that Plato advocated separating mothers from their babies in his ideal state.

(1953, p. 96). But Plato knew that, even without such an explicit claim, art by its very existence makes claims upon us, altering the ways in which we see the world.

In the *Ion*, Plato writes of the Muse who inspires and possesses the poet, empowering him to create:

> there is no invention in him [the poet] until he has been inspired and out of his senses, and the mind is no longer in him: when he has not attained to this state, he is powerless and is unable to utter his oracles . . . they [poets] are simply inspired to utter that to which the Muse impels them, and that only. (p. 534)

This ascription to the poet of a maddened state derived from his intimate relationship with a Muse is highly suggestive in the context of Mahler's thought. Plato continues: "And every poet has some Muse from whom he is suspended, and by whom he is said to be possessed, which is nearly the same thing; for he is taken hold of" (p. 536). As in the earliest interchange between mother and child, when the mother gives to the symbiotic infant the wherewithal to create illusion—an illusion that incorporates both her repertoire of mothering techniques and the mutual cuing between them—so it is between Muse and poet, according to Plato's myth. The Muse inspires the poet to utter that which she gives him and "that only."

In the same dialogue Socrates asks Ion whether he, as actor, as artist, is in his right mind when producing emotional effects upon the audience: "Are you not carried out of yourself, and does not your soul in an ecstasy seem to be among the persons or places of which you are speaking?" (p. 535). Ion answers in the affirmative: "That proof strikes home to me, Socrates. For I must frankly confess that at the tale of pity my eyes are filled with tears, and when I speak of horrors, my hair stands on end and my heart throbs" (p. 535).

This description corresponds to the fusion of inner and outer, of "I" and "not-I," that I have been considering. Here, however, the self is fused with the other: the actor "becomes" the character he is portraying. Pleasure in this particular kind of fusion may stem from what Mahler calls the primary method of identity formation during symbiosis, in which "the mother conveys—in innumerable ways—a kind of 'mirroring frame of reference,' to which the primitive self of the infant automatically adjusts" (1968, p. 19). Thus, the actor's identification with his character may have its origins in the so-called echo phenomenon, in which the child derives his earliest self from "the mutual libidinal mirroring" within symbiosis.

The magic of art is quintessentially dramatized in the myth of Pygmalion. According to Ovid, the sculptor, having fallen in love with the beautiful marble statue he has created, prays to the goddess Venus, who then transforms his statue into a living woman. This story, which has captured the imagination

of innumerable artists in a variety of media, contains the elements of symbiosis—the desire for fusion, the embodiment of illusion, the magical omnipotence—all of which Winnicott describes when he explains how a child comes to possess the illusion that there is an outer world corresponding to his deepest inner needs. This, as Gombrich says (1960, p. 94), is the promise without which there would be no art as we know it; this is Santayana's "pledge of conformity."

After providing her child, during symbiosis, with optimal opportunity for creating illusion, the mother's next task, during the developmental stage of separation-individuation, is to gradually disillusion the child. This is a step-by-step process in which her active adaptation to the child's needs decreases and the maturing infant's motor and perceptual abilities increase. Together, mother and child make it possible for the infant to expand beyond the symbiotic orbit. Weaning is the physical counterpart of this intrapsychic process, but the initiation of the latter, a process never fully completed, precedes the former by many months. In classical psychoanalytic terms, transition from pleasure principle to reality principle is never fully accomplished.

Disillusionment is not merely important but necessary to the child at this stage, for, as Winnicott points out, "close adaptation to need that is continued too long, not allowed its natural decrease," would be harmful "since exact adaptation resembles magic and the object that behaves perfectly becomes no better than an hallucination" (pp. 94–96). In other words, the mother's failure to adapt to the infant's needs forces him to perceive her as an external object. He must learn to give up his sense of magical omnipotence; in order to function in the real world, he must experience loss.

It is against loss that the infant bolsters himself. As Mahler puts it, "gradual growing away from the normal state of human symbiosis, of 'one-ness' with the mother is a lifelong mourning process" (1972, p. 333). In Winnicott's theory, it is the transitional object that helps to preserve for the child that special kind of relationship that he must grow beyond, that he must lose.

In his seminal paper of 1953, Winnicott describes how the small child, during the early phases of self-object differentiation, may attach to one object in his environs certain qualities of the intimate and soothing relationship with his mother that he is gradually losing. As I have noted, the term "transitional object" was introduced by Winnicott to designate an intermediate area of experience, before true object relations and reality testing are established, in which objects that are not part of the infant's body are used without being fully recognized as belonging to external reality.

Winnicott takes such cathexis of a transitional object to be normal and universal in infant development. From this attaching of special, personal significance to an object—arising from whatever reciprocal cuing has developed in the mother-child partnership during symbiosis—Winnicott derives the individual's later capacity to invest in cultural objects of all kinds,

to forge creative links between his inner and outer worlds. Later in child-hood, imaginative play will form a bridge between the primitive transi-tional object and adult involvement in cultural, specifically aesthetic experience.

Although much can be said about the transitional object as prototypic of the work of art, the point I want to stress here is that it is both actual and symbolic. Though not an internal or mental construct alone, it can come into being only as a result of the prior existence of an internal object. Unlike the internal object, it is not under the magical control of the child (likewise, the work of art is not under the absolute control of the artist); yet, the child assumes rights over it and fashions it into a highly personal object through such rituals as stroking, sucking, cuddling, and so on (as the artist shapes his clay or lovingly repeats his musical notes). Like the work of art, it comes into being during encounters with the child (artist), and it exists in what Winnicott calls the intermediate area of experience, in that "potential space between the subjective object and the object objectively perceived" (1966, p. 371). The transitional object (again, like the aesthetic object) preserves that which must be lost. It is the embodiment of illusion, a covenant between fantasy and reality, an external testament to inner experience. Thus, the small child singing to herself in the dark or hugging a "ba" is an archetypal Pyg-malion, learning to dwell in potential space, actualizing possibility. The three concepts I have identified with symbiosis—fusion, illusion, and magical om-nipotence—are elements once so pleasurable to the child that the transitional object serves to objectify.

Emphasizing the "thing-ness," the physicality of art, Dewey writes, "Only where material is employed as media is there expression and art" (1934, p. 63). In utilizing the notion of the transitional object as prototypic for later aesthetic experience, Winnicott provides a mode of understanding that com-prehends both the object-relatedness and the physicality of that experience, aspects which are peripheral to more classical psychoanalytic approaches but clearly central to encounters with works of art.

ON TRANSITIONAL AND AESTHETIC PHENOMENA

Winnicott's formulations concerning early child development, particularly his notion of transitional objects and phenomena, have proved fruitful for a number of writers concerned with the nature of the aesthetic.

Marion Milner, a British analyst and artist who attended Winnicott's lec-tures and clinics, appreciatively describes (1978, pp. 38–39) the diagnostic and therapeutic techniques that embodied his notions of potential space and transitional phenomena. In the "spatula game," for example, Winnicott would place a spatula on a table within easy reach of a mother and her baby to see what happened between baby and spatula. The baby's grabbing, mouthing,

sucking, and throwing behaviors all served for him as means of ascertaining the nature and qualities of the relationship between that particular baby and mother. In the "squiggle game" Winnicott would make collaborative drawings with his child-patients and thus actively use the space that comes into being "between two people when there is trust and reliability" (p. 39). Milner found such techniques and the perspective that gave rise to them meaningful in her effort to find her way through what she called "a maze of uncertainties about what a painter is really trying to do" (1957, p. xvii).

In a sensitive and intimately personal book, *On Not Being Able to Paint*, Milner describes her search for a way of drawing and painting that could encompass in pictorial imagery both her inner feelings and that which delighted her eye in the external world (1957, p. 3). In so doing, she made an independent discovery of potential or *intermediate space*, to use Winnicott's term—the sense of being both separate and together—as she gradually experienced a need to free herself from fixed intention and artistic convention and to learn, instead, to play. Realizing that "the stimulus of a strong conscious feeling about some external object" (p. 7) was not only unnecessary but even at times an obstacle to her artistic efforts, she took to producing scribble drawings. She soon realized that they began, while she worked on them, to evolve quite definite meanings and stories, which she likened to dreams (pp. 7–8).

Milner was deeply dissatisfied with the results of drawings she made according to the rules of linear perspective, for she wished to convey a sense of three-dimensional space, not only as it looked but as it felt. She wished, that is, to draw somehow the affective components of spatial elements such as closeness, distance, depth, and height:

> it was almost as if one might not want to be concerned, in drawing, with those facts of detachment and separation that are introduced when an observing eye is perched upon a sketching stool, with all the attendant facts of a single viewpoint and fixed eye-level and horizontal lines that vanish. *It seemed one might want some kind of relation to objects in which one was much more mixed up with them than that.* (p. 10, emphasis added)

This realization precipitated a conflict in her, however, arising from her worry that her wish to become more "mixed up" with objects might betoken a refusal to live up to the responsibilities of being a separate person in the real world (p. 10). But the ideal of complete separation and independence, or of utter submission to the "reality principle," ego autonomy, and fully "neutralized energy" arises from a classical psychoanalytic viewpoint on development, which sees less differentiated mental states as regressive, even pathogenic. Paradoxically, despite her initial embarrassment and discomfort, Milner actually experienced her new awareness of this desire to become more "mixed up" with objects as a revelation rather than a retreat. She felt it as a

need to go back to seek for something that—she was convinced—would have value in her adult life if only it could be recovered (p. 10).

What Milner conveys here is that, in object-relations terms, the artist or aesthetic perceiver must capture or retrieve a mental state vis-à-vis materials, subject, or works of art that approximates that of infant dual-union, in which self and nonself are not fully differentiated, because only in such mental states can creativity be experienced. The artist, like the young child whose world presents that which is needed or wished for, creates (symbols) by dissolving and transcending boundaries and discrete categories (compare Kant, 1790, pp. 175ff.), by returning to an acceptance of the fundamental human paradox of being both fully in and at the same time outside the world. Winnicott goes so far as to argue, contra Freud, that to resolve this paradox is to produce pathogenic defense mechanisms leading to what he has called the false self (1953, 1960).

Milner's term for this mental state is the two-way journey (1978), a term that emphasizes its simultaneous movement from inside out and from outside in. Her specific contribution grows out of her struggle to achieve and maintain such a two-way journey in her art. Through the exertion to free herself from the specific tyrannies of outline, linear perspective, local color, and other such pictorial conventions, she became aware that thus to become more "mixed up" with objects, to stop taking space for granted, to perceive blurring, merging colors, and masses rather than distinct shapes, to step out of the ordinary, utilitarian mode of experiencing the world—even in the relative safety of aesthetic encounters—was to risk intense feelings of anxiety, possibly even of terror or rage. However, to be capable of taking such risks was to be able to forgo the need for reinforcing ego boundaries from the outside, for holding on tightly to the self.

In this connection, Milner cites Blake, who referred to his state of "fear and trembling" while creating his visionary designs (p. 14). She quotes Cézanne as describing the loss of self involved in authentic response to painting:

> [A painting is] an abyss in which the eye is lost. All these tones circulate in the blood. One is revivified, born into the real world, one finds oneself, *one becomes the painting.* To love a painting, one must first have drunk deeply of it in long draughts. Lose consciousness. Descend with the painter into the dim tangled roots of things, and rise again from them in colors, be steeped in the light of them. (quoted in Milner, p. 25, emphasis added)

The oral imagery in this passage of drinking deeply and then losing consciousness is reminiscent of the infant's blissful experience at the breast. In fact, the entire passage can be compared with Lewin's description of the "oral triad," to eat, to be eaten, to sleep (1950).

To understand why such an experience can be frightening, one must remember that the reverse of the archaic grandiosity and magical omnipotence

of infancy (Lampl-de Groot, 1976) is utter helplessness, and that, in part, grandiosity and omnipotence develop defensively in the infant as a way of enabling him to cope with helplessness—as, in other words, a wish-fulfilling fantasy, the primitive roots, in classical terms, of the ego ideal (Lampl-de Groot, 1962). Hence, the fear of which Milner speaks is at core a fear of return not to the pleasurable state of symbiosis but to its counterpart—the chaos and incoherence of earliest infancy, with its cauldron of instinctual strivings and overwhelming stimuli.

To such fear Milner ascribes some of the resistance and hostility so frequently evoked in audiences by avant-garde experimentation in the arts: audiences sense the frailty of their hold on reason and sanity and hence recoil from the risks demanded by such art (p. 17). One might add, however, with Cavell (1969) and Wolfe (1975), that, with respect to some modern art, it may be necessary to invoke additional factors such as the manipulation of audiences by artists, the use of fraudulence, and the abuse of trust.

Milner attributes negative responses also to the seductive power of illusion, to the anxiety that, once merged with what is other in art, one may not find one's way back again to separateness. She cites the ubiquitous folk tales concerning innocent wanderers who, lost and lonely in dark forests, meet and join fairies at nocturnal revels, never again to return to home and hearth (p. 31). One is reminded here of Puck's disclaimer at the end of *A Midsummer Night's Dream* and also, of course, of Plato's fears about the proximity of art and madness.

Milner speaks of the bravery an artist needs to face such "spiritual dangers" (p. 26), which recalls Empson's similar implication that only the hardy can relish sensitive, long, and microscopic exposures to works of art (1957, p. 247). Milner claims that adults must have courage in order to be capable of play. Psychic strength is necessary to experience, in Kant's terms, "the free employment . . . the rapid and transient play of the imagination" (1790, pp. 179–180). Kant himself speaks of "boldness" (p. 181). And, as I have pointed out, to risk the transference of an analysis takes courage as well, because what is at stake is the experience of loss of self, the seductive pulls toward regressive modes of experience.

Where does such courage come from? According to Winnicott and the object-relations theorists in general, the answer lies fundamentally in the infant's exposure to "good enough mothering." An early "holding" environment productive of "confident expectation" (Benedek, 1938) enables him to internalize early in life secure feelings of comfort and trust and to create a rich, fertile inner space that allows the possibility later on of play, risk, and participation in aesthetic and cultural experience. From Winnicott's perspective, the capacity to create depends upon being able to continue to wish, and one can do this only when a giving and empathic mother has been internalized, when, consequently, one experiences the power to fulfill oneself, to

make at least some dreams come true, to at least partially transform the world.When a facilitating environment lies within, one is empowered to relinquish (momentarily) external boundaries. Because of benign presences within (so-called good introjects), one can tolerate ambiguity, accept paradox, dwell in potential space. One can, without paralyzing fear, relinquish self to participate in acts of creation or aesthetic re-creation.

One obvious problem with a theory of this sort is that it does not account for the many artists in all media whose early maternal environment was anything but facilitating. One wants to ask how Winnicott would deal with artists whose mothers were depressed, suicidal, indifferent, hostile, or simply absent. A ready answer might be to invoke another caretaker in infancy who supplied what the biological mother lacked, but surely this would be, in many cases, to stretch the theory beyond the bounds of credulity. One wants at some point to be able to invoke other factors, such as native endowment, and one wants to be able to consider the case of artists whose gifts grew out of needs to compensate and repair damage (Klein, Niederland) and to project into a world of material objects and imagination what was felt to be lacking or less vivid in the domain of available human relationships (Greenacre).

It is curious that Gombrich, while meditating on his celebrated hobby horse (1963), arrives at a notion very similar to Winnicott's transitional object (though he makes no direct reference to Winnicott's paper of 1953) and at the same time offers a contrasting perspective.

Gombrich points out that a child's ordinary hobby horse, a stick with a makeshift head, is neither an imitation of a horse nor a representation of a horse in the usual sense. Rather, "the stick becomes a horse in its own right" (p. 2) by virtue of the fact that the child can ride it. Thus, the hobby horse belongs to a certain class of " 'substitutes' which reach deep into biological functions that are common to man and animal" (p. 4). Gombrich analogizes:

> The cat runs after the ball as if it were a mouse. The baby sucks its thumb as if it were the breast. The ball has nothing in common with the mouse except that it is chasable. The thumb nothing in common with the breast except that it is suckable. As "substitutes" they fulfill certain demands of the organism. (p. 4)

As is the case with transitional objects, they are imbued with meaning according to the needs of the child. They are both made and found.

Gombrich concludes that for the hobby horse to be created out of a stick, only two conditions must be met: first, it must be ridable and, second, riding must matter to the child. When he speaks of the hobby horse as a "privileged" object, an "evocative" image, Gombrich remains close to Winnicott's description of the earlier developmental stage and the transitional object. However, when Gombrich boldly proclaims: "My hobby horse is not art" (p. 11), he and Winnicott part company.

The reason it is not art, Gombrich asserts, is that what the hobby horse actually means to its child-creator (and what the frayed blanket means to the infant) must remain forever hidden from us, its "way barred by the angel with a flaming sword" (p. 11). According to Gombrich, although we respect the child's world of illusion and tacitly agree not to challenge it but, rather, to corroborate it, still, we cannot ourselves enter into this particular illusionary world. Art, by contrast, according to Gombrich (and to Kris, 1952), communicates to an audience. Art involves not only illusion but shared illusion, not only "evocative" symbols (Sarnoff, 1983) but "communicative" symbols. The artist makes, as Tormey puts it, "an expressive object," an object that has the power to make others feel.

I am not entirely ready to follow Gombrich along this path and to agree without further examination that the hobby horse is not art. However, assuming for the moment that there *is* a significant discontinuity here, how can one explain it? How, as Freud wonders (1908), does the artist move beyond his self-satisfying (albeit to others tedious and solipsistic) daydreams to enchant us with stories, images, and melodies that stir and delight us? How does the artist create possible worlds into which we can enter with him and in which we can, for wonderful moments, actually dwell?

Gombrich answers this question by an appeal to the shared traditions, the conventions, the history, of art. He would have it that the mature artist (unlike the infant or young child), makes art by partaking in, though transforming, received cultural forms and traditions. In holding such a position he is in accord with Schapiro (1956) and is undoubtedly expressing his primary allegiance to the discipline of art history. But he moves thereby out of the realm of the subjective experience of the artist, or, at least, offers no means of explaining in any detail how this subjective experience develops from the transitional phase of infancy through the imaginative play of childhood to the adult experience of a shared and fully elaborated aesthetic.

Winnicott holds an altogether different perspective, for, if I understand him correctly, he would disagree with Gombrich's insistence that the hobby horse is not art. Winnicott was a practicing pediatrician as well as an analyst, and by temperament as well as by training he was exquisitely attuned to the inner life of children. Hence, unlike the learned and wordly art historian, he felt no corresponding need to distinguish so sharply between transitional and cultural phenomena on the basis of their capacity to communicate with *him*. He felt, in fact, that he could understand a great deal about what young children were communicating to him through gesture and play. Indeed, Gombrich's inability to appreciate more fully the continuity between transitional and aesthetic objects may be attributed to the fact that, unlike Winnicott, he stressed only the drive-related components of the latter, ignoring their object-relatedness. For Gombrich, the hobby horse satisfies a drive-

related need in the child, whereas for Winnicott it is the communicative aspects, the interpersonal qualities, of the child's earliest creative efforts that are more significant.

In his paper "The Location of Cultural Experience" (1966), Winnicott portrays transitional and cultural phenomena as directly continuous (p. 370), located in "the potential space between the individual and the environment" (p. 371). (Environment is understood first as the mother and then gradually expands to include a larger community.) In his view, good-enough mothering, which includes the initial creation of a holding, facilitating environment by almost complete adaptation to the infant and then a "graduated failure of adaptation," allows the child to experience his own creativity, to invest everything with a "first-time-ever quality" (p. 371). Thus, Winnicott assumes that good-enough mothering is a prerequisite for cultural experience in later life and, as a corollary, that, when the baby-child-artist is functioning in potential space, he is already within the realm of cultural experience because the ability to function in potential space assumes some rudimentary capacity to distinguish self from other.

In making these assumptions, however, Winnicott begs the question of how infantile transitional objects are transformed into works of art that communicate directly with other subjects. He assumes that the two realms are synonymous by definition, that because works arise from the potential space between subject and object they are ipso facto communicative. Although equally unwilling to dismiss the hobby horse as nonart, I also find Winnicott's position unconvincing. Indeed, it is difficult to discern whether he means by potential space to refer to a subjective experience (mental state) that is continually influenced by stimuli from without and impulses from within (which would be different from the Freudian view only in emphasis), or whether he means to connote that which arises between one conscious subject and another (as in the squiggle game) or between subject and inert object (as in the spatula game), or whether, as is most probable, he means to convey a sense of shared subjectivity.

My own view (in answer to Gombrich) is that intersubjectivity is both intermittent and elusive, and that it is thus an unstable criterion for any exclusions we might want to make from the realm of art. Equally precarious, however, is the use of intersubjectivity as a criterion for inclusions in the realm of art (my answer to Winnicott). Therefore, although I am persuaded that there are significant differences between a tower of blocks in the nursery and Frank Lloyd Wright's Robie House, between an eighteen-month-old child's scribbles and a Jackson Pollock or a Whistler, between one toddler's happy humming in the dark and a theme by Mendelssohn; nevertheless, I am less inclined to attribute these differences to putative degrees of communicability or shared experience. I am persuaded, furthermore, that any theory, psychoanalytic or otherwise, that seeks to explain the origins of cul-

tural experience must give an account of these differences. Winnicott's ideas, as far as he developed them, have opened up a plausible line of continuity between early and later experience, two poles that, as Gombrich rightly asserts, must not be equated. Yet Winnicott does not provide us with a satisfactory account of the significant gaps and transitions that occur among such phenomena as (1) a baby's stroking and cuddling with her "ba"; (2) a dauntless toddler riding his hobby horse into battle; (3) a solitary adolescent at the keyboard, passionately absorbed in working out motifs for a kyrie.

I would suggest that we study the relations among these stages of development in aesthetic experience as a developmental line with its own vicissitudes, including discontinuities, arrests, and changes of function, as in the manner of other major developmental trajectories (see A. Freud, 1963). To say that a small child is an archetypal Pygmalion is not to say that the small child *is* a Pygmalion or that rag dolls and hobby horses are equivalent to works of art, and because the matter is partly semantic, I prefer to leave it open.[3] On the other hand, it is well to bear in mind that less differentiated mental states derived from early infancy may recur and enhance aesthetic experience, but they do not constitute or exhaust such experience.

SOME IMPLICATIONS OF
CONTEMPORARY INFANT RESEARCH

Recent infant research has challenged some of the concepts I have been discussing, both concepts central to object-relations theory and concepts of underlying significance to psychoanalytic theory in general. It seems appropriate therefore, to take a closer look at these findings and arguments. I noted earlier that several distinguished thinkers in the psychoanalytic establishment would deny the relevance of infant research to psychoanalysis on the ground that psychoanalysis is an interpretative discipline that deals with psychical realities, with meanings for which the legitimate data can be obtained only through transference in the analytic situation. Further, current infant research is probably debatable on other grounds as well—for example, by recourse to data from similar research with a different (e.g., cognitive or behaviorist) construction on its conclusions and its implications for clinical theory. However, it is necessary to report on the findings of at least one eminent researcher in this field, if only to demonstrate that there may be even more open questions than previously thought.

Daniel N. Stern (1982) has recently called into question Mahler's concepts of normal autism and a normal symbiotic phase in infant development as

3. I am willing to speculate, for example, that for the very small girl or boy rag dolls and hobby horses may elicit experiences more akin to adult aesthetic experience than some art historians would care to admit.

well as the value of the general notion of drive theory. After citing a series of experiments in which babies were found to reach actively toward external stimuli, Stern writes that if by autism we mean primarily that the infant is uninterested in and does not register external stimuli, especially human stimuli, then we cannot claim that the infant ever was autistic: "He can't become less so. His intrinsically determined social nature simply continues to unfold" (1982, p. 4). Stern bases the suggestion that we abandon the notion of a stimulus barrier (Freud, 1920, p. 29) and a normal autistic phase (Mahler, 1968, pp. 7ff.) on evidence from research with newborns which demonstrates that, rather than view infants as passive in the face of overwhelming stimuli that may break through a so-called protective shield (Freud, 1920, p. 27), we must view them as maintaining some active control over physical stimuli and, in fact, as both seeking and maintaining stimuli up to certain apparently optimal levels: "the very young infant generally acts like someone at any age in that there are optimal levels of stimulation, below which the infant will seek more stimulation, and above which he will avoid stimulation" (p. 3).

Therefore, if, as Stern would have it, there are insignificant differences in how infants, children, and adults regulate the levels of external stimulation they receive (p. 4), then one can no longer speak with conviction of regression to a normal autistic phase of development. Insofar as this finding has relevance for aesthetic development, I think it informs us that the very small infant is already sensitive to environmental factors such as form, shape, color, sound, and light and has from the earliest moments of life the desire and capacity to respond to them.

Stern's argument against the existence of a normal symbiotic phase rests upon findings concerning early learning—the infant's capacity to make fine sensory discriminations and cross-modal transformations and to recognize causal relationships. If the infant is capable of such relatively complex cognition (complex in comparison with what was formerly held to be the case), it is unlikely, Stern argues, that he would linger "in a long phase of undifferentiation" in which he would tend "to consistently confuse self and other" (p. 11). To the psychoanalysts' counterclaim that symbiosis is an affective state concerning only the emotional aspects of experience, Stern responds by pointing out that in infancy all experience is affect-laden and that clear-cut distinctions between cognitive and affective spheres cannot be made until a later stage of development, when language-based semantic systems have been established (p. 11). Thus, Stern argues as follows:

> There is no reason to assert that the apperception of a distressed causal other is a less affective apperception than the apperception of a moment of merging. Both are cognitive and affective. And it appears that the infant simultaneously forms schemas of self with other (see Winnicott, 1958), and self alone (Sander, 1980). *The central point is that once the assumed "cognitive" incapacity and assumed "emotional" need to see self and other as a dual-unity has been deeply mitigated, then the central tenet of a "normal symbiotic" phase has been removed.* The infant need

not individuate from an initial symbiotic position. The infant can form, in parallel, various schemas of self, and of self-fused with other. (p. 11, emphasis added)

Stern goes on to point out that rather than view self-other states or un-differentiated moments as the stamp of a particular developmental stage to which one may regress (for example, in particular aesthetic moments), an alternative is to see such states as "continually forming and evolving positive and adaptive organizations of forms of self experience with another," p. 12). This way of understanding the phenomenon accords with my remarks earlier in this chapter on the range of distances one experiences when fully engaged with a work of art—from consciousness of self to full absorption in the aesthetic object. Stern suggests that such variability of self-object differen-tiation is present in rudimentary form in earliest infancy.

Finally, on the matter of drives, Stern argues that if research with young infants indicates that the regular functioning of pre-adapted capacities unfolds in an orderly way and includes the broad areas of perception, cognition, memory, and affectivity, then there seems to be much less point in thinking in terms of a general theory of global drives such as libido, which operates locally, in one anatomical zone, and then undergoes neutralization. Stern reports:

> now, our infant does not appear to be particularly mouth dominated or anything dominated. Vision, audition, smell, touch, memory, hunger-feeding, feeling, schema-formation and so on, each appear to be separate, thought related, areas of furious functioning. (p. 12)

He adds that those who adhere to libido theory in the face of this new evidence must at least now "picture libido as extremely fragmented anatom-ically and functionally from the very first minutes of life" (p. 13).

It would be well beyond the scope of this project to attempt to respond to Stern's challenges in terms of their far-reaching effects on psychoanalytic theory. Yet it is clear that, if we choose to adopt a developmental approach to aesthetic experience and take seriously the conclusions of Stern and his colleagues, some fundamental revisions are in order. For example, the psy-choanalytic notion of sublimation is founded on an energic model of the mind. If, as Stern nearly proposes, we abandon libido theory, must we also abandon the notion of sublimation or perhaps revise it in such a way as to tie it to current data about primary multiple functioning? And would such a revision be possible without our losing the meaning of the concept entirely?

In regard to the mother's early relationship with her child, what would replace Mahler's symbiotic model? How to account for phenomena that formerly seemed so well explained by separation-individuation theory? Stern offers a partial solution: he proposes a model based on what he calls "align-ment with potential states of being" or "alignment with the possible and the probable" (p. 22). In his research he has observed that mothers, in their

constant dialogue with their babies, relate in ways that reflect their own hopes, wishes, and fantasies as to what these babies will soon be like. Hence, Stern suggests that good early mothering should be seen as facilitating normal development; the mother serves as agent for change by empathically treating the baby as if he were already the person he "is likely to become" (p. 23). (There are rich implications here for clinical technique.) However, such a model, intriguing as it is, addresses the mother-child dyad largely from the point of view of the mother, whereas what Mahler is after, as well as Klein, Winnicott, and others, seems to me to be some grasp of the subjective experience of the infant.

All in all, I remain skeptical that Stern's research can dethrone Mahler's developmental-stage sequences, at least in their broadest outlines. Clearly there is a line of gradual differentiation that evolves biologically from intra-uterine zygote to embryo, then to neonate and eventually to semi-independent, semi-autonomous adult male or female human being. It is hard to believe that such a path is not accompanied by far-reaching psychological concomitants. Yet Stern's research does not address the psychological issues raised by this path of gradual differentiation. Therefore, although what he has brought to light may require modifications in Mahler's original formulations, his findings have not, in my view, eliminated the need to account for the very real phenomena that she addresses in parallel.

In an effort, however, to go beyond perceptual research to understand the developmental roots of empathy, intersubjectivity, and the communication of felt experience from one mind to another, Stern has noted the applications and implications of his work for aesthetics. One can recognize the connection readily whether one adopts Isenberg's definition of good art criticism as "bringing about communication at the level of the senses" (1948, p. 163) or Tormey's notion of the so-called expressive object (1971, p. 359), which, though not expressive of any specifiable emotion, nonetheless possesses qualities that evoke empathic responses in its audience.

Interested in tracing the origins of these kinds of communications to their preverbal roots in earliest infancy, Stern (1983) has devised an experimental milieu in which mothers and infants are studied and videotaped in their routine interactions. After many hours of concentrated observation of these mother-infant couples, he has isolated a behavioral modality that he terms "atunement" (a phenomenon not to be conflated with imitation or mirroring), in which some aspect of the presumed inner feeling state of the baby is matched, often cross-modally, by the mother. Stern claims that through this process, which is largely unconscious on the mother's part, the infant develops a sense of communion and continuity between inner and outer, a sense of "being with" another. As an example of such atunement, Stern offers the observation of a seven-month-old girl who on occasion opened her mouth to vocalize a sequence of pleasurable and excited "ahs," to which her mother

responded by shimmying with her body in an identical rhythm, thus replicating the original vocal pattern with a motoric one. Stern stresses that atunement is not imitation, and one grasps this readily if one returns to the aesthetic realm. I call to mind Martha Graham's solo *Lamentation*, which is, in Tormey's sense, a true expressive vehicle, not an imitation of grief or suffering (the dancer does not weep or groan) but, rather, in Stern's language, a cross-modal translation of feeling into form, a kind of atunement.

In watching his videotaped mothers and infants, Stern found that such atunement occurs with remarkable frequency (several times per minute) with babies in the second half of the first year of life, and that mothers, when questioned about it, seem to be quite unaware of what they are doing until they observe their own interactions on the screen. Stern has described a whole range of cross-modal atunements along the axes of intensity and time. He argues that it is the infant's capacity for experiencing the fluency and unity of the senses that creates the foundation for metaphor in language and for all later synaesthetic symbolization. (One is reminded also of René Spitz's earlier work on coanaesthetic response in infants, 1965.) It is apparent that Stern is dealing here with phenomena that have also been observed by aestheticians, notably Langer (1953), who has written of form as the symbol of feeling, of vital patterns and of virtual time, space, and gesture. For Langer, what is expressed and responded to in art is felt and lived experience transformed. What Stern is attempting to discover, as I understand it, are the earliest forms, the rules for such transformations and, in so doing, to derive the origins of aesthetic experience—both the making and the responding.

With respect to applications in the realm of the aesthetic, I think it is fascinating to place Stern's research side by side with Greenacre's pioneering work (1957, 1971), because it was she who first postulated a special sensitivity in infancy to the sorts of sensory stimuli of which Stern speaks. From the perspective developed in this study, Stern's work demonstrates the excitement and richness as well as the extreme difficulties inherent in cross-disciplinary scholarship. He reminds one by his challenges to concepts previously taken for granted that in science as in philosophy and art, there are no questions that may not be asked. The capacity to tolerate ambiguity while pursuing clarity seems to be the common destiny of artists, philosophers, and psychoanalysts.

AESTHETIC RESPONSE AND
CLINICAL PSYCHOANALYSIS

Since interactions with works of art are far more complex than the moments of fusion focused on in the previous section, I should like to turn briefly to other aspects of these responses. My aim here is merely to point out a few parallels between the views of such critics as Empson and Iser and the clinical

writings of Greenson and Brian Bird, not to probe these parallels in depth or to imply a simplistic equation between the world of the clinician and that of the literary critic. However, the value of clinical technique and process for interdisciplinary studies has been underestimated and deserves greater attention then it has previously received.

Alternations in Aesthetic Experience

The alternations in our aesthetic experience between being fully caught up in a work of art and pulling back to scrutinize it or feeling thrust outside of it have been noted by many contributers to this dialogue. Among them is Empson (1947, pp. 248–49), who speaks of this as an example of the antinomies fundamental to all human experience. He cites such antinomies—between passion and reason, sympathy and curiosity, closeness and distance—as having once caused the Russian Orthodox Church to forbid the use of medical textbooks on the dubious ground that bodies that could be regarded dispassionately could not also be considered worthy of being cured! But, as Empson protests: "the same body can effectively be considered both ways at once." Indeed, he goes on to say that "poetry is not like bodies, because the act of knowing is itself an act of sympathizing" (p. 248). In responding to works of art, Empson maintains, the literary critic must be both appreciative and analytical. He speaks of his own method as jumping the gap between two ways of thinking (p. 239). Indeed, his description of the critical enterprise often strikingly resembles Greenson's descriptions of what takes place in clinical psychoanalysis.

Another critic who also speaks about alternations in our experience with works of art and literature is Iser (1978). He opposes "effects" (of the work upon us) to "explanations" (about the work), "images" (of the work) to "discourse" (again, about the work), and speaks of aesthetic experiences as leading to nonaesthetic experiences. He emphasizes the tension that emanates from the multiple perspectives that arise in the interaction between reader and text, which include the self as reader, the everyday self, the system of perspectives designed by the literary text, including those of narrator, characters, plot, fictitious reader, and so on. Iser speaks of a "network of response-inviting structures" (p. 34), which might easily be compared with the inner representational world of the psychoanalytic patient, in which the analyst figures as a prominent character.[4]

Both Iser and Empson, and the psychoanalyst Greenson, seem to recognize a three-stage process with varying degrees of blending and merging. These

4. It is interesting to relate this notion to my earlier discussion (chapter 3) of the psychoanalysis of literary characters. Such characters might be compared to important objects in a patient's representational world, as well as to significant persons in the "here and now" of a patient's experience, persons with whom, as Greenson says, the analyst must also empathize in order to form a larger perspective (1960, p. 422). This way of experiencing characters adds another dimension, as the viewpoint of each character can then be taken as a way of critiquing the whole.

include: (1) an immediate emotional, perceptual, empathic experience; (2) an effort to understand that experience in several dimensions; and (3) an attempt to communicate that understanding to an interlocutor in such a way that it can be processed by him. In both the clinical and critical milieus, the degree of simultaneity or divergence in these related processes is highly variable.

Empathy or Emotional Knowing

Greenson, in one of his papers on clinical technique, tells us that intellectual understanding is insufficient for clinical work in psychoanalysis, that to work with patients entails "emotional knowing" (1960, p. 418). This is an epistemological claim similar to Empson's with respect to poetry. Even beyond emotional understanding, both writers feel the need for a positive orientation toward their material. Empson believes that "unless you are enjoying the poetry you cannot create it, as poetry, in your mind" (p. 248). Greenson maintains that "one cannot work well with a patient unless one likes him and is interested in him" (1978, p. 515).

Both Empson and Greenson regard a special mode of perceiving, "emotional knowing" or "appreciating," as prerequisite for work in their respective disciplines. Greenson defines "empathy," his term for such emotional knowing, as a temporary sharing of the feelings of another person, in which "one partakes of the quality and not the degree of the feelings, the kind and not the quantity" (1960, p. 418). These distinctions may prove relevant to aestheticians' puzzles over how and what one actually feels with respect to the imaginary worlds presented by works of art. Does one, for example, feel the same sort of horror and helpless rage at the murder of the poet Cinna in act 3, scene 3 of *Julius Caesar* as one would if a similar scene took place on a street outside the theatre after the play? (For Iser, the answer would be an emphatic "yes" because for him the sense of "having lived another life" is basic to the aesthetic experience.) Greenson stresses that empathy in the clinical situation is a temporary phenomenon, and its motive is to lead not to action or pleasure but rather to understanding. Empathy in the theatre, however, may not serve the goal of understanding but may, rather, constitute an end in itself, a pleasure which, were the clinician to give way to it, could seduce him into inappropriate countertransference reactions and seriously disturb his capacity to understand and help his patients. Yet the notions of quality and quantity Greenson offers are intriguing. Without much elaboration he attempts to draw a distinction both between empathy and vicarious experience (which he feels implies some element of agreement) and between empathy and identification (which he takes to be unconscious and permanent rather than preconscious and temporary, as is empathy). The possible application of these formulations to the domain of aesthetic response bears further examination; it might, for example, be useful for the practicing analyst to speculate on the similarities and differences between his empathic moments in the arts and in his work with patients.

Communication

Common to both analyst and critic is the need to convey understanding in such a way that it can be assimilated and used by another person. Again, both Empson and Greenson are aware of the difficulties attendant upon this task. Greenson speaks of errors in "dosage, timing and tact" (p. 418), and likewise Empson (pp. 248–56) engages in a lengthy discussion of what can go wrong between a critic and his reader. He describes an alternating process in which the critic must first convey to the reader *that* he appreciates the work at hand and then *what* he appreciates. You must show the reader how you feel about a particular poetical effect, says Empson, and he explicitly cautions against teasing the reader: you must not hint at subtleties (lest you humiliate him by implying that whatever you have noticed was obvious) or burden him with overly prolix explanations (thereby conveying the grandiose impression that there is nothing more to know). Such prohibitions make excellent clinical sense as well. However, Empson's caution has to do with his respect for the dignity of his reader, whom he wishes to avoid alienating or insulting, whereas Greenson, with therapeutic motives in mind, offers similar caveats in psychoanalytic terms: one must be ever mindful of the ego strengths of one's patient so as to present insights that can prove meaningful rather than traumatic. According to Greenson there are many analysts who overinterpret "as though the patient possessed a built-in mechanical comprehending apparatus" (1978, p. 515). I have mentioned earlier that this is also a common fault of applied psychoanalysts who fail to consider the receptivity of their readers but plunge blithely into conflict-laden interpretative material, which is destined to be resisted by their readers. Greenson speculates that such analysts do so in part to defend against their own emotional needs toward their patients (that is, out of unchecked countertransference reactions). The unfortunate results often range from the patients' consequent inability to relate with emotional intensity to the analyst to negative transference and stalemated treatments. Naturally, the one-to-one clinical situation offers live feedback lacking in the critical milieu; yet Empson's particular sensitivity bears comparison with that of a fine clinician. In Iser's phenomenological model the text itself is seen as entering into dialogue with the reader such that this distinction is deemed unnecessary.

Among factors that can cause communication to go awry are disturbances of empathy. Greenson notes that there are analysts who fail to experience empathy and thus to convey empathic responses to their patients. In such cases, interpretation often miscarries. Speaking of a parallel phenomenon in the critical sphere, Empson points out that a critic must convince his reader that he knows what he is talking about because he has had the experience in question. If he has not had the experience and/or cannot convey this to his reader, his interpretations will lack cogency; they will seem irrelevant. Conversely,

Greenson speaks of cases in which the analyst abandons himself to empathy, losing control of it so that it leads not to understanding but to inappropriate reactions (1960, p. 420). Empson offers a parallel phenomenon in the realm of the aesthetic, pointing out that if the critic abandons himself to being an appreciator, as he puts it, "he can never be sure that he has explained anything; [for] if he seems to have explained something, it may be because he has managed to do the same unexplained thing over again" (p. 250). In both cases, as Greenson explains, "understanding by empathy has become an instinctual temptation which is either a danger to be avoided or a pleasure to be enjoyed" (p. 420). When, however, such emotional knowing is used in the service of understanding, "the therapist is able to become both detached and involved— the observer and the participant—objective and subjective—in regard to his patient. Above all, the therapist must be able to permit transitions and oscillations between these two sets of positions" (Greenson, p. 420). Empson's description of optimal function in the aesthetic realm is strikingly similar:

> The process, then, must be that of alternating between or playing off against one another, these two sorts of criticism. . . . It may be said that the business of analysis is to progress from poetical to prosaic, from intuitive to intellectual, knowledge; evidently these are just the same sort of opposites, in that each assumes the other is also there. (pp. 250–51)

Empson is particularly sensitive to the vicissitudes of communciation between critic and reader, pointing out that the critic is not a teacher, is not there, that is, to instruct a pupil in the proper way (again, the parallel with clinical work is clear). Rather, Empson says, the critic first shows the reader what to look for by producing something similar to what was present in the original work, so that the reader will be able to return to the original and find it there for himself (p. 249). This is somewhat reminiscent of the transference neurosis in which the analyst and patient are involved in a second edition of a complex originally involving the patient and his earliest objects (see Bird, 1972, p. 281). As Empson puts it, the critic assumes that something has already been conveyed to the reader and endeavors to help him to understand—in terms of the reader's experience—why and how the work in question has had this particular effect on him (p. 248). This seems reasonably analogous to descriptions of classical psychoanalytic interpretation. In addition, Empson points out that the critic may actually prevent the same effect from being repeated. In saying this he appears to recognize the power of an interpretation when it is timed and framed in such a way as to be processed by a receptive and observing ego. Indeed, he seems to be claiming that criticism can at times function superficially, like good psychoanalytic interpretation, and produce similar results. Unfortunately, however, since the goals of dynamic therapy are not always coincident with those of literary criticism, such results may prove less positive in the critical sphere than in the clinical setting!

The Working Model

Greenson (1960, p. 421) offers a clue to how the analyst manages to keep this dialectical process ongoing: by creating within himself a sort of mental template, which he calls the "working model." He describes it as a replica or counterpart of the patient which is gradually built up in the analyst's mind as the therapeutic process unfolds. The working model consists of his observations of many aspects of the patient, from physical appearance to behavior patterns, to values, defenses, fantasies, and so on. He listens to the patient through this model, and in this way, his empathic responses grow out of a comprehensive understanding that has evolved over time. He shifts the working model into the foreground of his consciousness as he listens, and allows words and feelings to penetrate it so that responses to a particular aspect of the patient's material actually emanate from the working model itself rather than from countertransference. Greenson says,

> One begins to empathize with the patient as soon as one goes to open the door, even before seeing him. This might explain the special preoccupied look of the analyst . . . he is partly preoccupied with the working model of the present patient. . . . This might also explain the special startle reaction which happens to analysts when they find the wrong patient in the waiting room. It is more than the astonishment at the unexpected; there is something disorienting about it, due I believe to the cathexis of the internal working model. (1960, pp. 422–23)

This notion is extraordinarily apt when one transports it into the aesthetic realm and compares it, for example, to the experience of going to hear a new performance of an opera that has been heard previously and has therefore a prior ongoing existence in the mind. One resonates with each performance in terms of all the previous performances one has heard, and, like the analyst, one enters the opera house already preoccupied with anticipations based on a working model of the piece; likewise, one may experience chagrin and disorientation if the stage set or tempo of the overture does not fit with one's internal image. Greenson's working model also illuminates the question of how aesthetic experience is affected by repeated exposures to the same work of art. His notion suggests the view that numerous performances of *Tosca, La Traviata,* or *The Magic Flute* may enable one to gain a more comprehensive understanding as the nuances and idiosyncracies of each succeeding performance are assimilated into the internal working model.

And yet, there are significant differences between the clinical and aesthetic realms. Returning, for example, to Empson's image of the "maiden aunt" (see chapter 4, p. 114) who does not want to be bothered about meaning and who expects, rather, (I am embroidering his image here) to enjoy her opera from her usual box and then go home to a glass of madeira before retiring, one is forced to remember that not all who love the arts share the analytic bent, the relentless curiosity of an Empson. A curious question arises:

are the arts therapeutic in themselves? Or are they, for some of us, merely addictive, in the manner alluded to earlier in Empson's remarks?

Returning to the working model, Greenson's notion bears analogy with much that Iser has written under the heading of "Grasping the Text" (1978, pp. 107ff.). In describing the dynamic interaction between reader and text, Wolfgang Iser refers to what he calls "the wandering viewpoint," which comes into being because

> we are situated inside the literary text. The relation between text and reader is therefore quite different from that between object and observer: instead of a subject-object relationship, there is a moving viewpoint which travels along *inside* that which it has to apprehend. (p. 109)

Iser is concerned with the ways in which the literary text evokes our memories and expectations, and he speaks of "consistency-building as a basis for involvement in the text as an event" (p. 118). He identifies "gestalt" as a "product of the interaction between text and reader [which] cannot be exclusively traced back either to the written text or to the disposition of the reader." (p. 119) This notion of a gestalt that continues to change and interact with the text seems roughly comparable to what Greenson means by the working model. Iser also elaborates on the complex ways in which this gestalt can determine associations, sometimes evoking and sometimes suppressing them. Greenson makes a similar point about patients who consciously and unconsciously dread being understood (1960, p. 422) and who therefore produce frustration in their analysts. Such fears of being unmasked, devoured, or used up can also be detected in works of art, and often produce similar frustration, alienation, anger, awe, or feelings of inadequacy in their audiences. The two-way relationship implied by Greenson's notion of empathy is also, as we have mentioned, supremely relevant to the performing arts, where the quality of a performance may depend on the actors', players', or conductor's rapport with the audience.

Obviously there are many differences, gross and subtle, between Greenson's working model and the mental schemata that Iser elaborates—in detail and illustrated profusely with examples drawn from English literature. What is common to both, however, is the notion that something new and highly significant is created in the dialogue between analyst and analysand, reader and text, audience and work of art, and that this new and evolving construct, whatever one wishes to call it, is the product of joint authorship.

Transference

Greenson (1969, p. 28) defines transference as the experiencing in the present of feelings and fantasies derived from early object relations and displaced onto persons in the present. Transference phenomena occur outside conscious awareness and are characterized by their indiscriminate quality, inappropriateness, lack of selectivity, and distortion of reality. Yet, surely it is trans-

ference that, in moderate doses, imparts flavor and piquancy to life. How does transference work with respect to aesthetic experience? Transference can, for example, serve as a powerful regulator with regard to aesthetic distance. One may not be able to hear a piece of music beloved by a parent who has recently died in the same way that one might have heard it before the loss, and yet one may not quite understand why this particular performance fell flat or may attribute the failure to a more accessible, less painful cause. Curiously, whereas transference is usually considered (when it is encountered outside the analyst's office) to be maladaptive and unrealistic, it may be well to think of it in quite the reverse terms when it appears in the realm of the aesthetic, where associations are permitted to range widely, primitive pleasures to be experienced, and memories awakened.

In his paper on "The Non-Transference Relationship in the Psychoanalytic Situation" (1969), Greenson emphasizes the frame of "reality" that encloses the analytic relationship and permits the "full flowering and ultimate resolution of the patient's transference reactions" (p. 27). This frame may be likened to the formal qualities, the conventions and traditions, of art, which serve as a container for more amorphous and elusive content. The question arises as to what happens when this frame is altered. Modern art might actually be seen as a series of progressive steps in the alteration of the frame, where what has been played with, worked on, struggled with are the formal elements of art and not the thematic, narrative, or discursive content. Several rather daring analysts (few of them American) have considered the function of the psychoanalytic frame in the clinical situation and questioned what might happen if it were also tampered and wrestled with. In addition to Lacan, Bleger (1966), Baranger and Baranger (1966), Bion (1970), Pontalis (1980) and McDougall (1980) have written on this theme. The consensus seems to be that the frame serves not only to awaken, liberate, and contain the transference (as Greenson would have it) but also to inhibit and define it by imposing certain areas of collusion, certain unanalyzed bastions between analyst and analysand. Again, parallels with the aesthetic are in abundance: what is the qualitative difference between experiencing the works of an artist who works within an established tradition and one who strikes out to invent techniques and forms of his own; between listening (with a contemporary ear), for example, to Mozart and then to Crumb, to Bach and then to Cage? How much has to be constant? How little (or how much) can be taken for granted? If transference is defined as ubiquitous, indiscriminate repetition, can one not count on it to occur without special priming by the frame?

Brian Bird (1972), in a classic paper, stresses the dangers of transference, and it is these dangers that I feel are too often shied away from in applied psychoanalysis. Bird spells it out:

> Admittedly, many potential dangers attend the analyst's becoming involved in the patient's neurosis. The commonest would seem to be the analyst's unawareness of his own reciprocal transference reactions. A more subtle danger

threatens when the analyst, although understanding his own transference, gains his insights so exclusively from this inner source that he pays little or no attention to the possible inapplicability of these insights to the patient's current transference developments.... I have yet been unable to find evidence that a "safe" analysis in which such dangers do not arise has much chance of reaching the patient where he needs to be reached. (pp. 279, 280)

I would suggest that, just as the risks of the analysis must be shared by both analyst and analyzand, so the risks of art must be shared by artist, audience, and critic, all of whom must possess in some measure what Bird has called "skilled fortitude" (p. 279). It is my conviction that those authors who grasp the deep implications of the experiential aspects of psychoanalysis will be better able to work with it cogently and effectively in its applications to the arts.

In this third model, the work of art has been seen as conjointly constructed by and with its audience in an affective as well as cognitive dialectic that has many features in common with psychoanalytic process. Detractors of such a viewpoint are quick to argue that from this perspective the work of art is virtually lost, swallowed up between the encroaching hegemony of the artist's subjectivity on the one side and the perceiver's on the other. Phenomenological critics such as Iser attempt to answer this charge by pointing out that works of art are always experienced by perceivers and that though the resulting experiences are partially determined by the works perceived, they can never be completely so determined. Hence, "the relative indeterminacy of a text allows a spectrum of actualizations" (p. 24) such that all encounters with and judgments about art remain importantly subjective. And since "objective evidence for subjective preferences does not make the value judgment itself objective, but merely objectifies the preferences" (p. 25), one is justified in including the perceiver in the contextual model of the work of art.

I have moved from a model of pathography, which emphasizes the artist (in the Romantic tradition), to a model that emphasizes the work alone (in the formalist tradition), to a model that emphasizes the perceiver (in the phenomenological tradition). In each case, psychoanalysis offers both a contribution and a critique. Since my main emphasis has been on pathography, it is my hope that others will explore the second and third models in more detail than has been possible here. With regard to psychoanalytic theory, I have indicated the importance of fit between a particular theoretical perspective (for example, topographic theory, drive theory, ego psychology, object-relations theory) and the problem at hand. The question of criteria for choice of theory is still one of the thorniest problems in both clinical and applied psychoanalysis today, and, since it is a problem with far-reaching philosophical implications, the chances are that it will not yield to easy answers.

6

Conclusion

> How to keep—is there any any, is there none such, nowhere
> known, some bow or brooch or braid or brace, lace, latch
> or catch or key to keep
> Back beauty, keep it, beauty, beauty, beauty, ... from
> vanishing away?
> —Gerard Manley Hopkins, "The Leaden Echo"

Rather than review what has already been presented, I should like now to
address the scope of and prospects for a continuing dialogue between aes-
thetics and psychoanalysis in the context of cross-disciplinary scholarship,
and also offer a phenomenological addendum to my discussion of patho-
graphy. I hope that, from whatever synthetic function I am able to provide
here, themes for further exploration will suggest themselves, problems will
come into sharper focus, and connections among the various threads will
emerge with greater clarity.

CROSS-DISCIPLINARY RESEARCH

Cross-disciplinary research is fraught with perils, including changes in theory
in one or all of the fields involved. Another important difficulty is that of
terminology, alluded to earlier in connection with the differing ontological
status of art for the philospher of art and the psychoanalyst. Despite such
problems, however, I am convinced that bringing together the current think-
ing on common issues of several disciplines is catalytic to the scholarly en-
terprise, to our endeavors to learn more about ourselves and about the worlds
we have made and found.

Thomas Kuhn spoke to this issue, though from a philosophy-of-science
perspective, in a *New York Times* interview (March 13, 1983). Discussing
the discovery of genetically borne changes in bacteria, he said (to Joshua
Lederberg): "one reason your field didn't change earlier was because nothing
had rubbed the noses of bacteriologists and geneticists in each other's work."

However, he went on to add: "My guess is that if someone had brought those groups together earlier on without something substantive on which to focus and evidence that it was a good area to focus on, nothing would have happened." His point is that for fruitful interaction to occur the two disciplines must be at a certain stage of internal development. Lederberg countered by arguing for the general utility of providing a facilitating environment for interdisciplinary communication:

> Permissions for disciplines to meet one another aren't that easy to come by. Many institutional settings would not allow scientists to change the character and direction of an investigation or to enter fields in which they did not have credentials. I would argue that creating environments where these things are permissible, even if you can't force the two nuclei to fuse, is an important issue.

In this study, I have attempted to bring together the two disciplines of psychoanalysis and aesthetics over three substantive issues: the nature of the creative work and experience of the artist, the interpretation of works of art, and the nature and genesis of aesthetic experience. However, while writing, I became increasingly aware that current developments within psychoanalysis provide a favorable climate for an even more extended and richer dialogue than I had originally envisioned. These internal changes have been observed in the literature and witnessed at conferences, where analysts on the cutting edge of theory have recently begun to talk in aesthetic terms both about their ideas and about their practice.

A few examples will suffice. Robert Michels (1981) speaks of psychoanalytic theories as being similar to works of art and claims that they "can be appreciated and evaluated aesthetically as well as scientifically" (p. 8). In pointing this out he joins a group of contemporary psychoanalytic authors, including Spence and Schafer, who reverse the direction of the interdisciplinary dialogue I have been exploring by borrowing their terms and notions from aesthetics rather than applying psychoanalysis to issues endemic to the aesthetic domain. Spence, for example, describes analysts as "functioning as artists and storytellers in the analytic hour" (1982, p. 23), and he names "aesthetic finality" as an essential ingredient of any given explanation in treatment that contributes to the psychoanalytic cure (p. 31). In a sweeping statement, he claims that "[psychoanalytic] interpretation can be seen as a kind of artistic product, and as such, it becomes possible to consider its effect on the patient as a kind of aesthetic experience" (p. 37).

In a similar vein, Hans Loewald argued cogently, at a meeting of the New York Psychoanalytic Society (March 8, 1983) that the traditional psychoanalytic view of symbolism as the outcome of repression must now be amended to take account of the more inclusive and richer understanding of symbolism found in the works of such philosophers as Cassirer and Langer, who regard it as the distinguishing feature of the human mind. Loewald even suggested

that the traditional psychoanalytic view may, from this broader perspective, be seen as a *deficit* (impoverished) model, in which connections between signifier and signified are broken. Loewald suggested further that, if one takes such an interdisciplinary perspective on symbolism, one might be tempted to define the aim of psychoanalysis as enabling patients to increase their capacity for symbolization, as restoring their formerly crippled symbolic functioning, as bringing multiple connections back into consciousness and thus enriching their inner life of meaning.

Finally, in a broadly interdisciplinary and searching article, Alfred Margulies (1984), a psychiatrist, attempts to bring together his understanding of psychoanalysis and phenomenology. He juxtaposes Freud's and Husserl's methods of investigation by comparing the fundamental rule of psychoanalysis with phenomenological efforts to bracket previous habits of thought and habitual affirmations, to suspend judgment and to perceive the world afresh. Led by such parallels, Margulies ventures into considerations of imagination and creativity and discovers yet another parallel in Keats' notion of the so-called Negative Capability, that is, the artist's need to tolerate ambiguity, to live with "uncertainties, Mysteries, doubts, without any irritable reaching after fact and reason" (quoted by Margulies, p. 1029). Drawing sensitively upon a number of Keats' letters, he compares the self-annihilation of the artist, his suspension of positive identity, and blurring of boundaries between self and other with the tenuous role of the therapist who struggles to achieve and maintain both neutrality and empathy. He speaks at one point of the "poet/clinician," and tentatively concludes that empathy, whether clinical or artistic, must involve both deconstruction and construction of reality, both passive and active modes of experience. His article, ending with Hazlitt's words, "The extremest resources of the imagination are called in to lay open the deepest movements of the heart"(p. 1032), may well tempt readers in the psychiatric community to taste the riches and explore the potential fruitfulness of this dialogue between the worlds of art and psyche.

In view of such outreachings on the part of leading psychoanalytic thinkers into the domain of the aesthetic, it seems that the time is ripe for a flourishing exchange that includes applications and adaptations in both directions. American psychoanalysis may be ready to emerge from the nineteenth-century idealist philosophical tradition in which Freud developed his initial theories and prepared to investigate some of the philosophical trends of the twentieth century, particularly phenomenological notions and structuralist ideas. In any case, it will be interesting in the coming years to see how cataclysmic or superficial these borrowings prove to be, how this interdisciplinary dialogue will serve to challenge dearly held tenets in both fields, and whether new synthetic constructs emerge, as happened with the bringing together of genetics and bacteriology, or, in an analogy closer to home, in the juxtaposition of Gothic architecture and scholasticism (Panofsky, 1957).

Even Panofsky, the most erudite, scrupulous, and creative of art historians, demurs in the opening pages of his cross-disciplinary text. After pointing out the need for a historian to divide material into distinguishable groupings or "periods," he explains that

> if the historian wishes to verify this unity instead of merely presupposing it, he must needs try to discover intrinsic analogies between such overtly disparate phenomena as the arts, literature, philosophy [and so on, and that this effort leads] to a pursuit of "parallels" the hazards of which are only too obvious.... Few men can resist the temptation of either ignoring or slightly deflecting such lines as refuse to run parallel. (pp. 1–2)

He predicts that, consequently, his present work "is bound to be looked upon with suspicion by both historians of art and historians of philosophy" (p. 2). To the contrary, of course, his small book remains today a consummate model of interdisciplinary scholarship.

In sum, despite such animadversions and everpresent dangers, over which responsible scholars must maintain vigilance, it is exciting at this juncture to be in a position to report the auspicious prospects and expanding scope for a dialogue between psychoanalysis and aesthetics in the future.

A PHENOMENOLOGICAL ADDENDUM

As a postscript to my earlier discussion of pathography, I should like to cite a poignant essay by Merleau-Ponty entitled "Cézanne's Doubt" (1948). Here a philosopher, whose views have just begun to impact on modern psychoanalysis, presents his own idiosyncratic and valuable insights into Freud's *Leonardo*.

Merleau-Ponty believes that, in spite of what can be shown to be "arbitrary" in his narrative, Freud has in fact captured the essence of Leonardo's being in his interpretation. "Lack of evidence" does not faze Merleau-Ponty, for, he claims, such a lack cannot discredit Freud's "psychoanalytical intuition" (p. 24). Pointing out the non-falsifiability of psychoanalytic hypothesizing, which excludes all differential cases beforehand and thus deprives itself of any counterevidence, he suggests that psychoanalytic interpretation as exemplified in *Leonardo* offers us not a theory of necessary and sufficient causes but rather a theory of "motivational relationships which are in principle simply possible" (p. 24). In other words, psychoanalysis deals with the inescapable given that "in every life, one's birth and one's past define categories or basic dimensions which do not impose any particular act but which can be found in all" (pp. 24–25).

Thus, for Merleau-Ponty, psychoanalysis is uniquely equipped to reveal to us the meanings of our lives and, by extension, of the lives and works of the artists we cherish. He writes:

Whether Leonardo yielded to his childhood or whether he wished to flee from it, he could never have been other than he was. The very decisions which transform us are always made in reference to a factual situation; such a situation can of course be accepted or refused, but it cannot fail to give us our impetus. . . . If it is the aim of psychoanalysis to describe this exchange between future and past and to show how each life muses over riddles whose final meaning is nowhere written down, then we have no right to demand inductive rigor from it. The psychoanalyst's hermeneutic musing, which multiplies the communications between us and ourselves, which takes sexuality as the symbol of existence and existence as the symbol of sexuality, and which looks in the past for the meaning of the future and in the future for the meaning of the past, is better suited than rigorous induction to the circular movement of our lives, where everything symbolizes everything else. Psychoanalysis does not make freedom impossible; it teaches us to think of this freedom concretely, as a creative repetition of ourselves, always, in retrospect, faithful to ourselves. (p. 25)

In Merleau-Ponty's language, then, the artist's life opens out onto his work. Viewed in this way, with life and work, choice and conflict, flowing back and forth in a spiraling movement through time, Freud's enterprise, and pathography in general, are legitimized. In Merleau-Ponty's approach, the problems of "wild analysis" or inaccurate interpretation dissolve in the pursuit of a multiplicity of meanings, with truth experienced as complex and multivalent.

I believe that this phenomenological approach to pathography takes into account the context of the subject, the body (sexuality), as well as consciousness on various levels and intersubjectivity (the domain of psychoanalytic object relations); thus, it offers an alternative to the double bind described earlier, in which pathography was attacked either as counterfeit art criticism or as bastardized psychoanalysis. At the same time, the phenomenological approach preserves the fundamental paradoxes of pathography (for example, freedom versus determinism), but sees them as exquisitely appropriate, as advantages rather than liabilities.

Although philosophy, of which aesthetics is a special branch, is generally considered to have its own domain of content and investigative procedures, and psychology, of which it might be said that psychoanalysis is a special case, is held to have its own purview and methodology, I have tried in this study to point out areas in which these disciplines converge. The most urgent and the most eternal questions asked by men and women never fit neatly into the category of one or another discipline's hegemony but rather call for a polyvalent approach.

Thus, I hope to have delivered at least a semblance of what was promised at the outset, namely, a flexible structure into which the varieties of psychoanalytic interpretation of art can be fit. My claim is that the tripartite structure offered here will, with the proviso that certain hybrid examples be admitted,

encompass the existing literature. By associating each of three different theoretical orientations with a definition of text, a critical mode, and a particular set of aesthetic problems, I have sought to build a scaffolding for further interdisciplinary refinement. At the same time, however, with the skepticism equally endemic to artists, psychoanalysts, and philosophers, I have sought to shake this very scaffolding by revealing that contexts are in fact more complex and encompassing and elusive than they are often held to be. I shall look forward in the future to continuing this dialogue with all those who care passionately about art, fantasy, and dreams, about how and why we come to make them, share them with each other, destroy them, and make them anew.

References

Abraham, K. 1927. *Selected Papers of Karl Abraham*, trans. D. Bryan and A. Strachey. New York: Brunner/Mazel.

Abrams, M. H. 1953. *The Mirror and the Lamp*. New York: Oxford University Press.

Anthony, E. J. 1983. Vulnerability and Resilience in Children from High Risk Families. Grand Rounds Presentation, New York Hospital, Cornell Medical Center, Sept. 15, 1983.

Arnheim, R. 1954. *Art and Visual Perception: A Psychology of the Creative Eye*. Berkeley and Los Angeles: University of California Press, 1974.

Baranger, W., and Baranger, M. 1966. Insight in the Psychoanalytic Situation. *Psychoanalysis in the Americas*, ed. R. Litman, pp. 56–72. New York: International Universities Press.

Barchilon, J. 1971. A Study of Camus' Mythopoetic Tale "The Fall" with some comments about the Origin of Esthetic Feelings. *Journal of the American Psychoanalytic Association* 19:193–240.

Barchilon, J., and Kovel, J. 1966. "Huckleberry Finn": A Psychoanalytic Study. *Journal of the American Psychoanalytic Association* 14:775–814.

Beardsley, M. 1970. The Testability of an Interpretation. *Philosophy Looks at the Arts*, ed. J. Margolis. Philadelphia: Temple University Press, 1978.

Beck, J. 1982. Presentation to Discussion Group on Psychoanalysis and Art History. American Psychoanalytic Association. New York, Dec. 12, 1982.

Benedek, T. 1938. Adaptation to Reality in Early Infancy. *The Psychoanalytic Quarterly* 7:200–15.

Berenson, B. 1957. *The Italian Painters of the Renaissance*. New York: Meridian Books.

Bergler, E. 1945. On a Five-Layer Structure in Sublimation. *The Psychoanalytic Quarterly* 14:76–97.

Bion, W. 1970. *Attention and Interpretation*. New York: Basic Books.

Bird, B. 1972. Notes on Transference: Universal Phenomenon and Hardest Part of Analysis. *Journal of the American Psychoanalytic Association*, 20:267–301.

Blanck, G., and Blanck, R. 1974. *Ego Psychology: Theory and Practice*. New York and London: Columbia University Press.

Bleger, J. 1966. Psycho-analysis of the Psycho-Analytic Frame. *International Journal of Psycho-analysis* 48:511–19.

Bollas, C. 1978. The Aesthetic Moment and the Search for Transformation. *The Annual of Psychoanalysis*, 385–94.

Bouwsma, O. K. 1954. The Expression Theory of Art. *Aesthetics Today*, ed. M. Philipson and P. J. Gudel. Rev. ed. New York: New American Library, 1980.

Bowlby, J. 1969. *Attachment*. New York: Basic Books.

Brazelton, T. B. 1984. Early Interventions. Grand Rounds Presentation. New York: St. Luke's Hospital, June 5, 1984.

Brenner, C. 1955. *An Elementary Textbook of Psychoanalysis*. New York: International Universities Press, 1973.

Brooks, C. 1947. *The Well Wrought Urn*. New York: Harvest Books.

Bush, M. 1967. The Problem of Form in the Psychoanalytic Theory of Art. *The Psychoanalytic Review* 54:5–35.

Cavell, S. 1969. *Must We Mean What We Say?* Cambridge, London, and New York: Cambridge University Press.

Cennini, C. c. 1400. The Craftsman's Handbook: Il Libro dell'Arte, trans. D. V. Thompson, Jr. New York: Dover, 1960.

Cioffi, F. 1964. Intention and Interpretation in Criticism. *Philosophy Looks at the Arts*, ed. J. Margolis, Philadelphia: Temple University Press, 1978.

Dalton, E. 1979. *Unconscious Structure in "The Idiot": A Study in Literature and Psychoanalysis*. Princeton, N.J.: Princeton University Press.

Danto, A. 1964. The Art World. *Philosophy Looks at the Arts,* ed. J. Margolis. Philadelphia: Temple University Press, 1978.

———. 1981. Deep Interpretation. *Journal of Philosophy* 78:691–706.

Deri, S. 1978. Transitional Phenomena: Vicissitudes of Symbolization and Creativity. *Between Fantasy and Reality*, ed. S. A. Grolnick and L. Barkin, pp. 45–60. New York and London: Jason Aronson.

Dewey, J. 1934. *Art as Experience*. New York: Paragon Books, 1979.

Dickens, C. 1841. *The Old Curiosity Shop*. Garden City, N.Y.: Doubleday, 1961.

Donchin, A. 1982. Metameditations on a Hobby Horse: Comments on Ellen Handler Spitz's "The Past as Illusion: A Contribution of Child Psychoanalysis to Aesthetics." Unpublished manuscript read to the American Society of Aesthetics, Banff, Canada, Oct. 29, 1982.

Dutton, D. 1982. Why Intentionalism Won't Go Away. Paper read to the American Society for Aesthetics, Banff, Canada, Oct. 29, 1982.

Ehrenzweig, A. 1967. *The Hidden Order of Art: A Study in the Psychology of Artistic Imagination*. Berkeley and Los Angeles: University of California Press.

Eissler, K. R. 1953. The Effect of the Structure of the Ego on Psychoanalytic Technique. *Journal of the American Psychoanalytic Association*, 1:104–43.

———. 1961. *Leonardo da Vinci: Psychoanalytic Notes on the Enigma*. New York: International Universities Press.

Eliot, T. S. 1932. "Hamlet." *Selected Essays: 1917–32*. London. Reprinted New York: Harcourt Brace Jovanovich, 1950.

Emde, R. N. 1983. Trends in Developmental Research: Implications for Psychoanalytic Theory. Presented to the Discussion Group on Current and Future Perspectives on Psychoanalytic Developmental Theory, The American Psychoanalytic Association Fall Meeting, New York.

Empson, W. 1947. *Seven Types of Ambiguity*. New York: New Directions.

Erikson, E. 1963. *Childhood and Society*. New York: W. W. Norton.

Escalona, S. 1963. Patterns of Infantile Experience. *The Psychoanalytic Study of the Child* 18:197–244.

———. 1968. *The Roots of Individuality*. Chicago: Aldine Publishing Company.

Fairbairn, W. R. D. 1963. Synopsis of an Object-Relations Theory of the Personality. *International Journal of Psychoanalysis* 44:224–25.

Farrell, B. 1963. Introduction to S. Freud's *Leonard da Vinci and a Memory of His Childhood*. Harmondsworth: Penguin.

Feder, S. 1978. Gustav Mahler, Dying. *International Review of Psycho-analysis* 5:125–48.

———. 1980a. Gustav Mahler um Mitternacht. *International Review of Psycho-analysis* 7:11–26.

———. 1980b. Decoration Day: A Boyhood Memory of Charles Ives. *The Musical Quarterly* 46:234–61.

———. 1981. Gustav Mahler: The Music of Fratricide. *International Review of Psycho-analysis* 8:257–84.

Ferenczi, S. 1913. On Eye Symbolism. *First Contributions to Psychoanalysis*, trans. E. Jones. New York: Brunner/Mazel, 1952.

Foucault, M. 1983. *This Is Not a Pipe*. Berkeley: University of California Press.

Freud, A. 1936. *The Ego and the Mechanisms of Defense*. New York: International Universities Press, 1966.

———. 1963. The Concept of Developmental Lines. *The Psychoanalytic Study of the Child* 18:245–65.

———. 1981. Insight: Its Presence and Absence as a Factor in Normal Development. *The Psycho-analytic Study of the Child* 36:241–49.

Freud, S. 1894. The Neuro-psychoses of defense. *Standard Edition* (hereafter referred to as *S.E.*), 3:45–61.

———. 1900. *The Interpretation of Dreams*. *S.E.*, vols. 4 and 5.

———. 1905. Fragment of an Analysis of a Case of Hysteria. *S.E.*, 7:7–122.

———. 1905. *Three Essays on the Theory of Sexuality*. *S.E.*, 7:125–243.

———. 1907. *Delusions and Dreams in Jensen's "Gradiva"*. *S.E.*, 9:3–95.

———. 1908. Creative Writers and Daydreaming. *S.E.*, 9:142–53.

———. 1909. Family Romances. *S.E.*, 9:236–41.

———. 1910. *Leonardo da Vinci and a Memory of His Childhood*. *S.E.*, 11:59–137.

———. 1910. A Special Type of Object Choice Made by Men (Contributions to the Psychology of Love). *S.E.*, 11:164–75.

———. 1910. The Psycho-analytic View of Psychogenic Disturbance of Vision. *S.E.*, 11:210–18.

———. 1910. 'Wild' Psycho-Analysis. *S.E.*, 11:221–27.

———. 1911. Formulations on the Two Principles of Mental Functioning. *S.E.*, 12:215–26.

———. 1912. Recommendations to Physicians Practicing Psychoanalysis. *S.E.*, 12:111–73.

———. 1913. *Totem and Taboo*. *S.E.*, 13:1–161.

———. 1914. The Moses of Michelangelo. *S.E.*, 13:210–38.

———. 1914. On Narcissism. *S.E.*, 14:69–102.

———. 1915. The Unconscious. *S.E.*, 14:161–215.

———. 1917. Mourning and Melancholia. *S.E.*, 14:239–58.

———. 1918. The Taboo of Virginity (Contributions to a Psychology of Love III). *S.E.*, 11:192–208.

———. 1919. The 'Uncanny.' *S.E.*, 17:219–56.

———. 1920. *Beyond the Pleasure Principle. S.E.*, 18:3–64.

———. 1920. The Psychogenesis of a Case of Homosexuality in a Woman. *S.E.*, 18:146–72.

———. 1922. Two Encyclopaedia Articles: (A) Psycho-analysis. *S.E.*, 18:235–54.

———. 1923. *The Ego and the Id. S.E.*, 19:3–66.

———. 1925. A Note Upon the 'Mystic Writing-Pad.' *S.E.*, 19:226–32.

———. 1926. *Inhibitions, Symptoms and Anxiety. S.E.*, 20:77–174.

———. 1927. The Future of an Illusion. *S.E.*, 21:5–56.

———. 1927. Fetishism. *S.E.*, 21:149–57.

———. 1928. Dostoevsky and Parricide. *S.E.*, 21:175–96.

———. 1930. *Civilization and Its Discontents. S.E.*, 21:64–145.

———. 1937. Analysis Terminable and Interminable. *S.E.*, 23:216–53.

———. 1940. Splitting of the Ego in the Process of Defense. *S.E.*, 23:275–78.

Freud, S., and Breuer, J. 1893–95. *Studies on Hysteria,* vol. 2, *S.E.*

Friedman, L. 1958. Toward an Integration of Psychoanalytic and Philosophic Aesthetics. *American Imago* 15:371–88.

Fries, M. E., and Woolf, P. J. 1953. Some Hypotheses on the Role of the Congenital Activity Type in Personality Development. *The Psychoanalytic Study of the Child* 8:48–62.

Fuller, P. 1980. *Art and Psychoanalysis*. London: Writers and Readers Publishing Cooperative.

Gablik, S. 1976. *Magritte*. Boston: New York Graphic Society.

Gay, P. 1976. *Art and Act: On Causes in History—Manet, Gropius, Mondrian*. New York: Harper & Row.

Gedo, M. 1980. *Picasso: Art as Autobiography*. Chicago: Univ. of Chicago Press.

Gedo, M., ed. 1985. *Psychoanalytic Perspectives on Art*. Hillsdale, N.J.: Analytic.

Glover, E. 1930. Grades of Ego Differentiation. *International Journal of Psycho-Analysis* 11:1–11.

Gombrich, E. H. 1960. *Art and Illusion*. Princeton, N.J.: Princeton University Press, 1969.

———. 1963. *Meditations on a Hobby Horse and Other Essays on the Theory of Art*. New York: Phaidon.

Greenacre, P. 1971. *Emotional Growth,* vol. 2. New York: International Universities Press.

Greene, M. 1980–81. Unpublished lectures delivered at the Lincoln Center Institute.

Greenson, R. 1960. Empathy and Its Vicissitudes. *International Journal of Psychoanalysis* 41:418–24.

———. 1969. The Non-Transference Relationship in the Psychoanalytic Situation. *Explorations in Psychoanalysis*. New York: International Universities Press.

———. 1974. Loving, Hating and Indifference toward the Patient. *Explorations in Psychoanalysis*. New York: International Universities Press.

Grolnick, S., and Barkin, L., eds. 1978. *Between Reality and Fantasy: Transitional Objects and Phenomena*. New York and London: Jason Aronson.

Hampshire, S. 1952. Logic and Appreciation. *Art and Philosophy: Readings in Aes-*

thetics, ed. W. E. Kennick. New York: St. Martin's Press, 1979.

———. 1966. Types of Interpretation. *Art and Philosophy: Readings in Aesthetics*, ed. W. E. Kennick. New York: St. Martin's Press, 1979.

Hartmann, H. 1939. *Ego Psychology and the Problem of Adaptation*. New York: International Universities Press, 1958.

———. 1964. *Essays in Ego Psychology*. New York: International Universities Press.

Hoffer, W. 1949. Mouth, Hand, and Ego-Integration. *The Psychoanalytic Study of the Child*, 4:49–56.

———. 1950. Development of the Body Ego. *The Psychoanalytic Study of the Child* 5:18–23.

———. 1954. Defensive Process and Defensive Organization: Their Place in Psycho-analytic Technique. *International Journal of Psycho-Analysis* 35:194–98.

Holm, B. 1965. *Northwest Coast Indian Art: An Analysis of Form*. Seattle and London: University of Washington Press.

Hospers, J. 1959. Philosophy and Psychoanalysis. *Psychoanalysis, Scientific Method and Philosophy*. New York: Grove Press, 1960.

Isaacs, S. 1929. Privation and Guilt. *International Journal of Psycho-Analysis* 10:335–47.

Isakower, O. 1938. A Contribution to the Pathopsychology of Phenomena Associated with Falling Asleep. *International Journal of Psychoanalysis* 19:331–45.

Isenberg, A. 1973. *Aesthetics and the Theory of Criticism*, ed. W. Callaghan et al. Chicago: The University of Chicago Press.

Iser, W. 1978. *The Act of Reading: A Theory of Aesthetic Response*. Baltimore and London: The Johns Hopkins University Press.

Jones, E. 1955. *The Life and Works of Sigmund Freud*, 3 vols. New York: Basic Books.

Kafka, S. *The Complete Stories*, ed. N. N. Glatzer. New York: Schocken Books, 1976.

Kant, I. 1790. *The Critique of Judgement*, trans. J. C. Meredith. Oxford: The Clarendon Press, 1952.

Kernberg, O. 1976. *Object Relations Theory and Clinical Psychoanalysis*. New York: Jason Aronson.

Kivy, P. 1980. *The Corded Shell*. Princeton, N.J.: Princeton University Press.

Klein, M. 1933. The Early Development of Conscience in the Child. *Contributions to Psychoanalysis*. London: Hogarth Press.

Korner, A. 1964. Significance of Primary Ego and Drive Endowment for Later Development. *Exceptional Infant*. Vol. 1, *The Normal Infant*, ed. J. Hellmuth. New York: Brunner/Mazel.

Kris, E. 1952. *Psychoanalytic Explorations in Art*. New York: International Universities Press.

———. 1955. Neutralization and Sublimation. *The Psychoanalytic Study of the Child* 10:30–46.

Kris, E., and Kurz, O. 1979. *Legend, Myth and Magic in the Image of the Artist: A Historical Experiment*. New Haven and London: Yale University Press.

Kristeller, P. O. 1951. The Modern System of the Arts. *Art and Philosophy: Readings in Aesthetics*, ed. W. E. Kennick. New York: St. Martin's Press, 1979.

Kubie, L. 1953. The Distortion of the Symbolic Process in Neurosis and Psychosis. *Journal of the American Psychoanalytic Association*, 1:59–86.

Kuhns, R. 1983. *Psychoanalytic Theory of Art: A Philosophy of Art on Developmental Principles*. New York: Columbia University Press.

Kundera, M. 1984. The Novel and Europe. *The New York Review of Books*, July 19, 1984, 15–17.

Kutash, E. F. S. 1982. A Psychoanalytic Approach to Understanding Form in Abstract Expressionist and Minimalist Painting. *International Review of Psychoanalysis* 9:167–77.

Lang, B. 1982. Loooking for the Styleme. *Critical Inquiry* 9:405–13.

Langer, S. 1953. *Feeling and Form*. New York: Charles Scribner's Sons.

Lampl-de Groot, J. 1957. On Defense and Development: Normal and Pathological. *The Psychoanalytic Study of the Child* 12:114–26.

———. 1962. Ego Ideal and Superego. *The Psychoanalytic Study of the Child* 17:94–106.

———. 1976. Personal Experience with Psychoanalytic Technique and Theory during the Last Half Century. *The Psychoanalytic Study of the Child* 31:283–96.

Lewin, B. D. 1946. Sleep, the Mouth, and the Dream Screen. *The Psychoanalytic Quarterly* 15:419–34.

———. 1950. *The Psychoanalysis of Elation*. New York: Norton Press.

Lichtenberg, J. 1983. *Psychoanalysis and Infant Research*. Hillsdale and London: The Analytic Press.

Liebert, R. S. 1977. Michelangelo's "Dying Slave": A Psychoanalytic Study in Iconography. *The Psychoanalytic Study of the Child* 32:505–43.

———. 1979. Michelangelo's Early Works: A Psychoanalytic Study in Iconography. *The Psychoanalytic Study of the Child* 34:463–525.

———. 1982. Methodological Issues in the Psychoanalytic Study of an Artist. *Psychoanalysis and Contemporary Thought* 5:439–62.

———. 1983. *Michelangelo: A Psychoanalytic Study of the Man and His Images*. New Haven and London: Yale University Press.

Lowenfeld, V. 1957. *Creative and Mental Growth*. New York: Macmillan.

Mahler, M. S. 1963. Thoughts about Development and Individuation. *The Psychoanalytic Study of the Child* 18:307–24.

———. 1968. *On Human Symbiosis and the Vicissitudes of Individuation*. New York: International Universities Press.

———. 1972. On the First Three Subphases of the Separation-Individuation Process. *International Journal of Psychoanalysis* 53:333–38.

Mahler, M. S., Pine, F., and Bergman, A. 1975. *The Psychological Birth of the Human Infant*. New York: Basic Books.

Malcolm, J. 1983. Six Roses ou Cirrhose? *The New Yorker*, Jan. 24, 1983, 96–106.

Malraux, A. 1947. *Museum without Walls*. (Vol. 1 of *The Psychology of Art*). Garden City, N.Y.: Doubleday, 1963.

Margulies, A. 1984. Toward Empathy: The Uses of Wonder. *The American Journal of Psychiatry* 141:1025–33.

McDougall, J. 1980. *Plea for a Measure of Abnormality*. New York: International Universities Press.

Merleau-Ponty, M. 1948. Cézanne's Doubt. *Sense and Non-Sense*, trans. H. L. Dreyfus and P. A. Dreyfus. Evanston, Ill.: Northwestern University Press, 1964.

Metcalf, A. 1977. Childhood: From Process to Structure. *Hysterical Personality*, ed. M. J. Horowitz. New York: Jason Aronson.

Michels, R. 1981. The Scientific and Clinical Functions of Psychoanalytic Theory. *The Future of Psychoanalysis*. New York: International Universities Press.
———. 1983. Contemporary Psychoanalytic Views of Interpretation. *Psychiatry 1983: The American Psychiatric Association Annual Review*, ed. L. Grinspoon. Washington, D.C.: American Psychiatric Press.
Milner, M. 1957. *On Not Being Able to Paint*. New York: International Universities Press.
———. 1978. D. W. Winnicott and the Two-Way Journey. *Between Reality and Fantasy*, ed. S. A. Grolnick and L. Barkin. New York and London: Jason Aronson.
von Morstein, P. 1983. Magritte: Artistic and Conceptual Representation. *Journal of Aesthetics and Art Criticism* 41:369–74.
Niederland, W. G. 1967. Clinical Aspects of Creativity. *American Imago*, 24:6–33.
Nietzsche, F. 1886. *Beyond Good and Evil*. trans. M. Cowan. Chicago: Henry Regnery Company, 1955.
Noy, P. 1968. The Development of Musical Ability. *The Psychoanalytic Study of the Child* 23:332–47.
Panofsky, E. 1955. *Meaning in the Visual Arts*. New York: Doubleday/Anchor.
———. 1957. *Gothic Architecture and Scholasticism*. New York: Meridian Books.
Passeron, R. 1970. *René Magritte*. Chicago: J. Philip O'Hara.
Perri, C. 1984. Knowing and Playing: The Literary Text and the Trope Allusion. *American Imago* 41:117–28.
Plato. *The Dialogues of Plato*. trans. B. Jowett. New York: Random House, 1937.
Pontalis, J.-B. 1980. Boundaries or Frontiers. *Psychoanalysis in France*, ed. S. Lebovici and D. Widlöcher. New York: International Universities Press.
Putnam, H. 1983. On Truth. *How Many Questions? Essays in Honor of Sidney Morgenbesser*, ed. L. S. Cauman et al. Indianapolis: Hackett Publishing Company.
Quine, W. V., and Ullian, J. S. 1970. *The Web of Belief*. New York: Random House.
Rank, O. 1932. *Art and Artist*. New York: Knopf.
Rapaport, D. 1959. A Historical Survey of Psychoanalytic Ego Psychology. *Identity and the Life Cycle: Selected Papers by Erik H. Erikson*. New York: International Universities Press.
———. 1967. *Collected Papers of David Rapaport*, ed. M. Gill. New York: Basic Books.
Read, H. 1951. Psycho-Analysis and the Problem of Aesthetic Value. *International Journal of Psycho-Analysis* 32:73–82.
Reed, G. S. 1982. Toward a Methodology for Applying Psychoanalysis to Literature. *The Psychoanalytic Quarterly* 51:19–42.
Ricoeur, P. 1970. *Freud and Philosophy: An Essay on Interpretation*. New Haven and London: Yale University Press.
———. 1977. The Question of Proof in Freud's Psychoanalytic Writings. *Journal of the American Psychoanalytic Association* 25:835–71.
Rose, G. 1980. Some Aspects of Aesthetics in the Light of the Rapprochement Subphase. *Rapprochement: The Critical Subphase of Separation/Individuation*, ed. R. F. Lax, S. Bach, J. A. Barland. New York: Jason Aronson.
———. 1980a. *The Power of Form*. New York: International Universities Press.
Rothenberg, A. 1979. *The Emerging Goddess*. Chicago: The University of Chicago Press.

Rothstein, E. 1983. Discovering the Beethoven inside the Monument. *The New York Times*, Jan. 23, 1983.

Sachs, H. 1942. *The Creative Unconscious*. Cambridge: Sci-Art.

Sandler, J. 1960. On the Concept of the Superego. *The Psychoanalytic Study of the Child* 15:128–62.

Sandler, J., Holder, A., and Meers, D. 1963. The Ego Ideal and the Ideal Self. *The Psychoanalytic Study of the Child* 18:139–58.

Santayana, G. 1898. *The Sense of Beauty*. New York: Dover Publications, 1955.

Sarnoff, C. 1976. *Latency*. New York: Jason Aronson.

———. 1982. Psychoanalysis and the Structure and Function of Symbols. Lectures delivered at the Center for Psychoanalytic Training and Research, Columbia University, December 1982.

Schafer, R. 1970. An Overview of Heinz Hartmann's Contributions to Psychoanalysis. *International Journal of Psycho-Analysis* 51:425–45.

———. 1980. Narration in the Psychoanalytic Dialogue. *Critical Inquiry* 7:29–53.

Schapiro, M. 1953. Style. *Aesthetics Today*, ed. M. Philipson and P. J. Gudel. Rev. ed. New York: New American Library, 1980.

———. 1956. Leonardo and Freud: An Art Historical Study. *Journal of the History of Ideas* 17:303–36.

Segal, H. 1952. A Psycho-analytical Approach to Aesthetics. *International Journal of Psycho-Analysis* 33:196–207.

Shakespeare, W. *A Midsummer Night's Dream*. *The Collected Works of William Shakespeare*, ed. W. G. Clark and W. A. Wright. New York: Greystone Press, 1920.

———. *Henry IV, Part I*. *The Collected Works of William Shakespeare*, ed. W. G. Clark and W. A. Wright. New York: Greystone Press, 1920.

Shapiro, T. 1970. Interpretation and Naming. *Journal of the American Psychoanalytic Association*, 18:399–421.

Shapiro, T., and Perry, R. 1976. Latency Revisited: The Age 7 Plus or Minus 1. *The Psychoanalytic Study of the Child* 31:79–105.

Skura, M. 1981. *The Literary Use of the Psychoanalytic Process*. New Haven and London: Yale University Press.

Spector, J. 1973. *The Aesthetics of Freud: A Study in Psychoanalysis and Art*. New York: Praeger.

Spence, D. 1982. *Narrative Truth and Historical Truth: Meaning and Interpretation in Psychoanalysis*. New York: W. W. Norton.

Spitz, E. H. 1980. 'Ancient Voices of Children': The Challenge. Unpublished manuscript prepared for the Lincoln Center Institute.

Spitz, R. 1955. The Primal Cavity. *The Psychoanalytic Study of the Child* 10:215–40.

———. 1965. *The First Year of Life*. New York: International Universities Press.

Stang, R. 1965. *Gustav Vigeland: The Sculptor and His Works*, trans. A. Grosjean. Oslo: Johan Grundt Tanum Forlag.

Steinberg, L. 1984. *The Sexuality of Christ in Renaissance Art and in Modern Oblivion*. New York: Pantheon Books.

———. 1984. Shrinking Michelangelo [review of *Michelangelo: A Psychoanalytic Study of His Life and Images*.] *The New York Review of Books*, June 28, 1984, pp. 41–45.

Stern, D. 1982. Implications of Infancy Research for Clinical Theory and Practice. Unpublished manuscript, Department of Psychiatry, Cornell University Medical Center.

Stern, D. 1983. Infants' Intuition of Affect and Affective Rapport. David M. Levy Lecture delivered at the New York Academy of Medicine, March 1, 1983.

Stern, L. 1980. On Interpreting. *Journal of Aesthetics and Art Criticism*, 39:119–29.

Sze Mai-Mai. 1959. *The Way of Chinese Painting*. New York: Vintage.

Terr, L. 1979. Children of Chowchilla: A Study of Psychic Trauma. *The Psychoanalytic Study of the Child* 34:547–623.

———. 1983. Chowchilla Revisited: The Effects of Psychic Trauma Four Years after a School-Bus Kidnapping. *The American Journal of Psychiatry* 140:1543–50.

Thomas, A., and Chess, S. 1977. *Temperament and Development*. New York: Brunner/Mazel.

———. 1984. Genesis and Evolution of Behavioral Disorders: From Infancy to Early Adult Life. *American Journal of Psychiatry*, 141:1–9.

Thurber, J. 1943. *Many Moons*. New York: Harcourt, Brace and Co.

Torczyner, H. 1979. *Magritte: The True Art of Painting*. New York: Harry N. Abrams.

Tormey, A. 1971. Art and Expression: A Critique. *Philosophy Looks at the Arts*, ed. J. Margolis. Philadelphia: Temple University Press, 1978.

Waelder, R. 1936. The Principle of Multiple Function: Observations on Over-Determination. *The Psychoanalytic Quarterly* 5:45–62.

Waldheim, P. 1965. *René Magritte*, trans. A. Wainhouse. Brussels: André De Rache.

Weitz, M. 1956. The Role of Theory in Aesthetics. *Philosohy Looks at the Arts*, ed. J. Margolis. Philadelphia: Temple University Press, 1978.

Wimsatt, W. K., and Beardsley, M. 1954. The Intentional Fallacy. *Philosophy Looks at the Arts*, ed. J. Margolis. Philadelphia: Temple University Press, 1978.

Winnicott, D. W. 1953. Transitional Objects and Transitional Phenomena. *International Journal of Psycho-analysis* 34:89–97.

———. 1960. Ego Distortion in Terms of True and False Self. *Maturational Processes and the Facilitating Environment*. New York: International Universities Press, 1965.

———. 1966. The Location of Cultural Experience. *International Journal of Psycho-Analysis* 48:368–72.

Wolfe, T. 1975. *The Painted Word*. New York: Bantam Books, 1976.

Wolfenstein, M. 1966. How Is Mourning Possible? *The Psychoanalytic Study of the Child* 21:93–123.

———. 1969. Loss, Rage and Repetition. *The Psychoanalytic Study of the Child* 24:432–60.

———. 1973. The Image of the Lost Parent. *The Psychoanalytic Study of the Child* 28:433–56.

———. 1974. *The Past Recaptured in the Work of René Magritte*. Unpublished manuscript prepared for the Margaret S. Mahler Symposium, Philadelphia, May 1974.

———. The Man with the Bowler Hat. New Haven and London: Yale University Press, forthcoming.

Wolff, P. 1959. Observations of Newborn Infants. *Psychosomatic Medicine* 21:110–18.

Wölfflin, H. 1932. *Principles of Art History*. New York: Dover.

Wollheim, R. 1974. *On Art and the Mind*. Cambridge, Mass.: Harvard University Press.

Wordsworth, W. 1800. Preface to the Second Edition of "Lyrical Ballads." *Wordsworth: Selected Poetry*, ed. M. van Doren. New York: The Modern Library, 1950.

Index

Abrams, M. H., 26, 27, 42, 97–98; definition of Romantic view of art and artist, 29

Abstract painting, 19–20, 117, 118, 132

Adaptation: role of, in creative process, 49; artist's, to reality, 52

Adolescence: as "trial mourning," 79

Aesthetic response. *See* Audience response

Aggression, 71, 139; and artistic creativity, 45; role of, in sublimation, 48; role of slighted in early Freud, 62; in works of Magritte, 86

Ambiguity, aesthetic, 114; according to Kris, 15–19; according to Rose, 21–22; favored by Empson, 113

Anti-intentionalism, 33–35, 41

Art therapy, 28

Audience response: and object-relations theory, xi, 12; in Freud's aesthetic, 14–15; according to Kris, 16–19; perceptual encounters, 20; to a particular interpretation, 50; to psychoanalytic interpretations, 54–55

Barchilon, José, 51n, 111

Beardsley, Monroe, 30–41 passim, 115

Beauty: of an interpretation, 65; sense of, 141–42

Beck, James, 63, 92

Bergler, Edmund, 60, 62–63; on sublimation, ·47–49; the "analytic microscope" and "depth psychology," 49

Bird, Brian: dangers of transference, 161, 164–65

Body ego: discussed by Niederland, 46; experience of while painting, 47; and style in abstract painting, 117–19; and art, 123–27

Bouwsma, O. K., 33, 36; on art and children's play, 41n

Brooks, Cleanth, 99, 108

Bush, Marshall: "conflict free" ego sphere and art, 20–22

Cage, John, 2, 20

Catharsis, 22

Cennini, Cennino, 120, 127; definition of painting, 119

Cézanne, Paul: response to painting, 148

Character, 43; stemming from infancy, 43n; relations between style and, 121–22

Characters, literary, 111–12; compared to objects in patient's representational world, 158n

Child, Irvin: research on aesthetic preference, 4n

Child development, 42–43; and art, 43–44

Childhood: easel painting in, 19; experience recaptured in dance, 24; illusory, make-believe world, 41; reconstruction of experience of, 43–44, 50; reactions to death of parent in, 54, 76, 83, 93; memory of, in Freud's *Leonardo*, 62; of Michelangelo, 70; aspects of, made available again in aesthetic experience, 140; imaginative play in, 146

Cioffi, Frank, 33–39 passim, 115

"Collective alternates," 45

Communication: discussed by Kris, 8–10, 16–17; art as, in Freud's aesthetic, 14; in clinical and critical contexts, 159–61

Connoisseurship: psychoanalytic perspectives on, 3–4

Countertransference, 90, 93; in Kris's theory, 10; in Freud's *Leonardo*, 57–58; in the interpreter, 92; leading to interpretative errors, 160; and the working model, 162

Critical communication, 74

Critical relevance, 32

Cross-disciplinary research: complexities of, 166–69

Crumb, George, 2, 23, 130